Electrographic Imaging in
Medicine and Biology

Electrographic Methods in Medicine and Biology

I. FL. DUMITRESCU

Electrographic Imaging in Medicine and Biology

Edited by Julian Kenyon, MD

Electrographic Methods in Medicine and Biology

Translated by C. A. Galia

SUFFOLK
NEVILLE SPEARMAN

Originally published in Rumania under the title *Electronografia*
by the Scientific & Encyclopaedic Publishing House
BUCHAREST – 1979

In co-operation with:
IOAN MAMULAS
CARMEN GOLOVANOV

First published in Great Britain in 1983
by Neville Spearman Limited
The Priory Gate, Friars Street, Sudbury, Suffolk
© I. Fl. Dumitrescu 1983

ISBN 0 85435 045 4

Author's Address:
Dr. I. Fl. Dumitrescu, 71, Bd. Vauban, 59800, Lille, France
Typeset in Linoterm Times 10/12 by Keyset Composition, Colchester, Essex
and printed and bound by
The Camelot Press, Southampton

Synopsis of Electrographic Imaging in Medicine and Biology

by I. Fl. Dumitrescu

Edited by Julian Kenyon, MD

EDITOR'S FOREWORD		x
PREFACE		xiii
PART I	**THE BIOPHYSICAL BASIS OF ELECTROGRAPHIC METHODS**	1
Chapter 1	**History of Electrographic Exploration**	3
Chapter 2	**Electrographic Methods as Applied in Biology**	12
2.1	Introduction	12
2.2	Electrography by skin electrical measurements	13
2.3	Electrography by weight-motor effect	13
2.4	Electrography by electroluminescence	15
2.4.1	Electrography by high tension sparking gap	15
2.4.2	Kirlian Photography	16
2.4.3	Electronography	17
2.4.4	Microelectronography	18
2.4.5	Electroluminescent Spectrography	20
2.5	Electrography by electrostatic polarisation	20
2.6	Electrography by blocking the secondary light emission	21
2.7	Electrography using the thermal effect	22
2.8	Electrography using the electrono-optical effect	22
2.9	Electrography using electro-chemical effects	23
2.10	Electrography using transducer systems	24
2.11	Electrography using microwaves	24
Chapter 3	**The Physics of Electrography** (I. Mamulas)	33
3.1	The electron – an elementary particle	33
3.2	Electric charges in magnetic and electric fields	34
3.3	The electron within atomic and molecular structures	36
3.4	Conductors and Dielectrics	40
3.5	Ionic conduction within living structures	40
3.6	Interaction of radiation with substance	41
3.7	Phenomena of luminescence	45
3.8	Electrical discharges	47
3.9	Optoelectronic phenomena	49

Chapter 4 Electric Discharges in Gaseous Media
(Carmen Golovanov) — 53
- 4.1 The avalanche theory — 53
- 4.2 The autonomy condition of the discharge — 55
- 4.3 Theory of streamers — 57
- 4.4 Breaking through the electroinsulating interval between the electrodes when applying a high tension — 60
- 4.5 Corona discharge — 62

Chapter 5 Kirlian Photography (I. Mamulas) — 64

PART II ELECTRONOGRAPHY — 75

Chapter 6 Electronography. General Principles — 77
- 6.1 Definition — 77
- 6.2 General Characteristics — 80
- 6.3 Control of the electron emission — 83
- 6.4 Control of the electromagnetic field — 85
- 6.5 Electrono-optic Conversion — 85
- 6.6 Analysis of the electronographic image — 86

Chapter 7 Biophysical Basis of Electronography — 91
- 7.1 Electromagnetic investigation of the living organism — 91
- 7.1.1 The Biological electric medium as an active volume-conductor — 92
- 7.1.2 The part played by electrodermal activity — 94
- 7.1.3 The proximal electric medium in electronographic exploration — 96
- 7.2 The origin of the pellicular effect — 97
- 7.3 Effects generated by polarising the dielectric inside the recording device — 101
- 7.4 The role of electrode polarisation — 105
- 7.5 The part played by the composition of the gaseous medium within the dielectric space — 108
- 7.6 Effects of polarisation of living tissue — 109
- 7.7 The electromorphous effect — 110
- 7.8 The origin of colour in the electronographic image — 113

Chapter 8 Electronographic Investigation of the Body — 116
- 8.1 Technical principles in electronographic investigation — 116
- 8.2 Electronography of the limbs — 119
- 8.3 Electronography of the abdomen — 122
- 8.4 Electronography of the thorax — 123
- 8.5 Electronography of the head — 126

Chapter 9 Surface Electrical Measurement and Electronographic Images — 128
- 9.1 Introduction — 128
- 9.2 Electrodermal activity — 132

Contents

9.3	Electrodermal activity in pathological conditions	133
9.3.1	Local electrical changes	134
9.3.2	Electrodermal changes of a general character	135
9.3.3	Reflex electrodermal zone changes	135
9.4	Surface electrical modifications and their correspondence with electronographic images	136
9.4.1	Activation of electrodermal points	137
9.4.2	Electrodermal activation	138
9.4.3	Electrodermal inactivation	139
9.5	Correlations between thermographic recordings and electronographic images	139

Chapter 10 Electronographic Imaging of the Proximal Electric Medium 140
- 10.1 Introduction 140
- 10.2 Electronographic exploration of the proximal electric medium 141
- 10.3 Demonstration of the layer of adherent aeroions 144
- 10.4 Free aeroions 146
- 10.5 'Biological interference' radiation 148

Chapter 11 Electronographic Imaging of Acupuncture Points 151

Chapter 12 Experimental Modelling of Electronographic Effects 160
- 12.1 Physical conditioning of the pellicular effect 160
- 12.1.1 Electronographic images performed on experimental models 161
- 12.2 Physiological conditioning of the pellicular effect 166
- 12.2.1 Dependence of the pellicular effect on electrodermal activity 166
- 12.2.2 Dependence of the pellicular effect on the frame resistance and electrical tension (EDr and EDu) 170
- 12.2.3 Dependence of the pellicular effect on variation of resistance and skin electrical tension (ΔR and ΔU) 170
- 12.3 Dependence of the pellicular effect on peripheral circulation 173
- 12.4 Dependence of the pellicular effect upon central nervous control of electrodermal activity 175

Chapter 13 Exploration Using Transparent Electrodes and Dynamic Electronography 177
- 13.1 Introduction 177
- 13.2 Obtaining fundamental images in series 180
- 13.3 Use of transparent electrodes 180
- 13.4 Chemical photomultipliers 181
- 13.5 Photomultipliers 182
- 13.6 Methods of dynamic electronography 182
- 13.7 Electronovision 182
- 13.8 Results of investigations carried out using dynamic electronography 184

PART III OTHER ORIGINAL ELECTROGRAPHIC METHODS IN BIOLOGY 187

Chapter 14 Principal Electrographic Techniques Used in Study via the Electronographic Method 189
- 14.1 Electrography by high tension sparking gap (I. Mamulas) 189
- 14.2 Electrography by weight-motor effect (I. Mamulas) 190
- 14.3 Electrography by blocking the secondary light emission 196
- 14.4 Convertography – a method for examining biological systems 199
 - 14.4.1 General principles of the method 200
 - 14.4.2 Recording of convertographic image 202
 - 14.4.3 Significance of the convertographic image 203

Chapter 15 Microelectronography 205
- 15.1 Introduction 205
- 15.2 The microphotographic electroluminescent method 205
- 15.3 Microautography 206
- 15.4 Microautography by chromatic turning 209
- 15.5 Microelectronovision 210
- 15.6 Electrono-optical systems for enlarging an electroluminescent image 211
- 15.7 Microelectronographic Examination 211

Chapter 16 Electroluminescent Spectrography 216
- 16.1 Introduction 216
- 16.2 Spectral analysis of electroluminescence on normal subjects in physiological conditions 217
- 16.3 Spectral analysis of electroluminescence during measured physical effort in man 221
- 16.4 Causes of electroluminescent spectral differentiation in examination of the hand 221
- 16.5 Spectral modifications of electroluminescence in specific pathological states 222
- 16.6 New methods of complex spectral analysis of electroluminescence 225

PART IV ELECTRONOGRAPHIC INVESTIGATION OF ELECTRICAL BEHAVIOUR OF MALIGNANT TUMOURS 227

Chapter 17 Electromagnetic Behaviour of Malignant Tumours (I. Mamulas) 229

Chapter 18 Electronographic Examination of Experimentally Induced Malignant Tumours 235
- 18.1 General Principles 235
- 18.2 Orientative electronographic research on solid and semi-solid tumours (Dumitrescu, Celan) 236
- 18.3 Research on electromorphous effects in ascites 238

18.4	Research on experimental solid tumours	239
18.5	Microelectronographic research on malignant ascites cells	241

Chapter 19 Electronographic Exploration of Human Cancer — 242

19.1	Characteristic images resulting from electronographic examination of human malignant tumours	242
19.1.1	Modifications of the pellicular effect	245
19.1.2	Points and zones with electrodermal activation	245
19.1.3	The adherent aeroion layer	249
19.2	Differential diagnosis	249

PART V ELECTROGRAPHIC TECHNIQUES — 253

Chapter 20 Principles of the Electrographic Technique and the Electronography Apparatus — 255

20.1	General Principles of Electrography	255
20.2	Classical Methods of Electrography	256
20.2.1	Clidonography	256
20.2.2	Electrography in defectoscopy	257
20.2.3	Electrophoresis	258
20.2.4	Other electrographic techniques	259
20.3	High tension impulse generators in electronography (Carmen Golovanov)	259
20.4	Equivalent scheme for the investigation equipment (Carmen Golovanov)	272
20.5	Analytic estimation of the influence of the test scheme parameters in the intensity of the electric field applied to the body under investigation (Carmen Golovanov)	275
20.6	Apparatus for electronography	278
20.7	Processing and interpretation of the electronographic image	285

Chapter 21 Risks in Electrographic Techniques and Safety Precautions to Protect Against these Risks — 289

SELECTIVE BIBLIOGRAPHY — 294

GLOSSARY — 297

Editor's Foreword

I first came across Dr. Dumitrescu's work some six years ago, having worked for some time with Kirlian Techniques. I had become somewhat disenchanted by these methods and came to the conclusion that Kirlian Electrography produced images that were non-reproducible. I also came to the conclusion that many of the features seen in a Kirlian image are due to artefact, rather than to any real electro-physiological parameter of the biological system under investigation. Dumitrescu was one of the first scientific workers who also recognised this fact, and went further to carry out extensive research to unravel the reasons for the apparent non-reproducibility of Kirlian images. Dr. Dumitrescu's work not only gives an insight into these questions but has also produced a range of new, more accurate, less artefact-prone electrographic imaging techniques, which are all described in his original Rumanian book *Electronografia*. I was lucky enough to obtain a copy of this book and personally funded its translation and edited it in order to produce *Electrographic Imaging in Medicine and Biology*.

Dr. Dumitrescu brings an in-depth understanding of modern physics and mathematics to this area of investigation. This painstaking approach has been lacking in many other workers in this field, and it is only by a close application of these disciplines that we are able to make any further progress in electrographic imaging techniques. Dr. Dumitrescu is to be congratulated on having devised many original electrographic techniques, together with giving us the beginnings of a scientific explanation, in terms of physics and maths, as to what the underlying mechanisms are in the formation of these images.

Electrographic imaging of the body reveals the importance of electromagnetic events in and around the body. This in itself has far-reaching diagnostic and therapeutic implications. Main-stream medicine would appear to be bound up with structure (present-day imaging techniques are largely concerned with demonstrating structure in the body) and with biochemistry, yet the fact that all biological processes are fundamentally electrical is something which

Editor's Foreword

no doctor or scientist would deny. The areas of medicine which apply an electrical (energetic) view to the body are confined within the area of the medical alternatives, but techniques such as acupuncture, homoeopathy, etc., continue to lack credibility within main-stream medicine. This book goes some way to closing this credibility gap and to underlining the importance of small electromagnetic change, in and around the body, as being significant both in health and disease. Electrographic imaging also enables us, perhaps for the first time, to assess these techniques in an objective manner. So far it has not been possible to do this and therein lies the seminal importance of this work.

Modern medicine is undergoing a crisis of confidence world wide which in my own view is due to the inadequacy of basic concepts which underpin main-stream medicine. The concepts underlying techniques within the medical alternatives are more in line with those of modern mathematics and physics. An application of these disciplines to biological systems is long overdue and Dumitrescu's work is one of the few areas where these disciplines are so applied in a useful and enlightening way.

Electrographic Imaging in Medicine and Biology stands as perhaps the most important book to date in this new area of investigation. There is adequate information in it for research workers to develop any of the techniques which Dr. Dumitrescu mentions which they may feel are of value. I sincerely hope that the publication of this book in English will quicken such activity world wide.

In conclusion I wish to thank Dr. and Mrs. Dumitrescu for helping me achieve a correct and readable edition of Dr. Dumitrescu's original Rumanian book. I would also wish to offer a very special word of thanks to Elinore and Jacques Detiger for their support and for making this book possible. Thanks also to my secretary Mrs. Vicky Walker who painstakingly typed and re-typed the manuscript on a number of occasions.

Dr. Julian N. Kenyon.
Director,
The Centre for the Study of Alternative Therapies,
51 Bedford Place,
Southampton,
England. January 1983

Preface

In 1975 when I was finishing the work *Man and the Electrical Medium*, I was anticipating the wide field of biological electrographic techniques which were emerging, and becoming useful in laboratories where many of the exploration techniques for investigating surface electrical phenomena were developed. *Electrographic Imaging in Medicine and Biology* contains the results of my research carried out after the publication of my first book, being an argument for the hypothesis made in that book. The understanding of electrophysical phenomena which generate electrographic images and their modification in physiological and pathological conditions is based on data given by surface electrical phenomena.

In our view, these phenomena do not constitute the electrophysiological limits of living organisms, but represent a phenomenological interaction between the external electric medium, and the biological one, within and outside which life manifests itself through specifically correlated phenomena.

Electrographic images have revealed unknown aspects of the living organisms investigated. We could study, with their help, biological behaviour in different electromagnetic fields; the distribution of force lines of external electromagnetic fields around living organisms, the surrounding electric medium, and also inner and surface electrical characteristics. Because of difficulty in interpreting electrographic images, it was necessary to make many experimental models, and this has led to the study of a number of poorly understood physical and biophysical phenomena.

The perfecting of methods of electrographic exploration and the discovery of better methods which could clarify the phenomena under investigation, have made it possible for us to establish the possibilities and limits of this field of biological electrical exploration. Most of the methods shown here were developed in Rumania; this book being a collection of publications, inventions and papers carried out by us. We regularly come across research carried out by scientists from different countries, confirming our findings, but they do not

mention, we believe because of lack of communication, our own discoveries. Sometimes, regrettably, there are errors in interpretation, and our position regarding these is presented in this book.

The phenomena dealt with by us are normal biophysical phenomena, subject to the accepted laws of physics. We do not attribute any deviation found to paranormal phenomena which intrigue so many scientists and, even more, those outside science, but to those as yet 'blank spaces' of knowledge from which new scientific truth emerges. If our present work serves to enable a deeper understanding of living organisms, being of service to researcher and practitioner alike, then the credit goes to those who helped us in overcoming the difficulties encountered in our research work, as well as to those who, by refusing to accept our work, have stimulated our belief in the truths which had to be brought to the light of day.

PART I

THE BIOPHYSICAL BASIS OF ELECTROGRAPHIC METHODS

Chapter 1

History of Electrographic Exploration

Man has forever followed with interest, and fear, the electrical phenomena which surround him, and has attributed them to supernatural forces. At the beginning of history lightning was interpreted as a divine manifestation. Primitive man, impressed by the spectacle of a storm, interpreted lightning as a symbol of divine power over the earth.

In mythology, ancient peoples believed that lightning was a sign of the power of the gods. For instance, Indre, the god of war and thunder for Indians, Adhad in Assyrian mythology, Thor in Scandinavian legends, or Zeus and Jupiter in Greek and Roman mythologies, were the all powerful masters of nature, and of man whom they were punishing with the aid of lightning.

Miraculous discharges in the shape of blue flames which appeared around human beings in moments of mystical exaltation are mentioned in old biblical writings. These are described as flames seen by Moses on Mount Sinai or those around the heads of the Apostles.

In relation to these mysterious light phenomena, it is interesting that many primitive peoples were aware of static and tribo electric electricity, produced by rubbing dielectric materials together, as, for instance, amber and agate, as well as crystals, used as objects for prayer.

Fire became a possession of man, brought by lightning, and Prometheus' myth made its mark in antiquity as a symbol of man's emancipation from the tyranny of the gods.

The sparks which appeared when two hard stones were rubbed together, or struck against each other, taught man how to make fire, forcing him at the same time to think about the possibility of a new form of energy – electricity.

Amber, rock crystal or dried wood, when struck, acquired the property of attracting or rejecting other objects, and sometimes were seen in the dark to produce discharges similar to lightning. Thales of Miletus describes these properties for amber. The ancient philo-

sophers explained electrical discharges by the existence of an 'ethereal fire', released by the sun's fire by burning of clouds or air (Anaximandru, Heraclitus, Empedocles). Leucifus, Democritus and Epicurus explained the apparition of lightning by the combustion of fire atoms. The ancient mariners, as well as those from the Middle Ages, were sometimes accompanied at sea by mysterious fires which appeared around the metal reinforcements of the masts, known as the fire of Castor and Pollux, the fire of Fermie, or the fire of Saint Elmo. The electric discharges on the masts of ships seen when going through areas with dry winds were due to high tension charging of the metallic parts of the masts, insulated through wooden structures from the high conductivity of the sea. These phenomena influenced the imagination of men menaced by danger of shipwreck, interpreting them as the judgment of heaven.

Travellers who were going through dry deserts, where winds were blowing over hot sand dunes, often heard hollow sounds similar to thunder, and electrical discharges appeared between their hands and the dry skin of their camels.

Man has known from earliest times of the properties of certain species of fish with electric organs, like the torpedo-fish described by Aristotle, which had the ability to generate electrical discharges, and which could paralyse or kill other marine creatures.

The 16th century saw the development of an experimental basis of the study of electricity. The analysis of electrical phenomena became possible due to the electroscope, invented by William Gilbert (1540–1603). The electrostatic machine, discovered by Otto Querricke (1602–1686) and Hawksbee (1661–1713) has made it possible for electrical phenomena to be reproduced in the laboratory. The observation of electric discharges became commonplace, to such an extent that the experiments became a society-game in the aristocratic salons of Europe. Thus, due to knowledge from a terrifying phenomenon, electricity became a source of sensation and spectacle.

It is interesting to note that the parameters of the electric currents produced in the discharges of electrostatic machines were very similar to those, which later, after five centuries, would be used in order to obtain bio-electrographic phenomena. The electric discharges had very high tension values (of the order of tens of kV), but of low power because of weak currents. The use of graphic recording of the effects of these discharges would have made it possible to obtain the first electrographic image.

W. Watson (1715–1786) carried out interesting experiments; he considered (as far back as the 18th century) that there might be a connection between electricity and psychophysical phenomena, presenting as a result, on an experimental basis, a theory about the mind of man. Also in the 18th century, the invention of the Leyden Jar, by E. G. von Kleist (1700–1784) and P. von Musschebrock (1692–1761), gave great impetus to experiments with electricity. The discharges of the Leyden Jar condensers charged by electrostatic machines, and thus the first accumulation of electric energy, were carried out using human subjects. The sparks generated by the hands of the experimenters produced a sensation of shock. If these discharges had been recorded on photo-sensitive emulsions they would have been the first electrographs.

Of the greatest importance were the electrical studies carried out by Benjamin Franklin (1706–1790). He gave the first explanation of the human organism's polarisation in conditions of electrostatic charge, and studied visually discharges produced between differently charged organisms. The analysis of these discharges carried out by Franklin represents the first competent description of an electrographic effect in a living organism. In his celebrated experiment for the collection of lightning electricity, Franklin used a kite, whose string, when wet, became a good electrical conductor. He therefore produced a discharge of an electric current measured in mv.

The first electrographic records were obtained in 1777 by the German physicist, G. C. Lichtenberg. They were obtained by mobilising very fine powder. This is the so-called 'weight-motor effect', between two differently charged electrodes. These images were later recorded with the aid of the daguerreotype* process, the photographic recording superseding the graphic image produced by the weight-motor effect. This method was introduced using a high-tension technique on photographic film, the images being known as Lichtenberg images or clydonographs. The images differ according to the polarity of the source, and to the discharge conditions between the two electrodes.

The research carried out by N. Tesla at the end of the 19th century with high tension transformers showed that luminous discharges appear around the body when it is exposed to powerful high frequency electromagnetic fields.

* Jacques Daguerre; a French inventor (1787–1851), who perfected the photographic technique of Niepel.

The photographic recording of the radiations given out by the human body in these electromagnetic fields was called effluviography, and several medical doctors and physicists of that time were tempted to ascribe psychophysiological significance to these luminous discharges. These interpretations were encouraged by finding that certain people were able to change photographic films by hand contact, and were even able to do this through insulating opaque layers.

At the end of the 19th century, a time which marked the beginnings

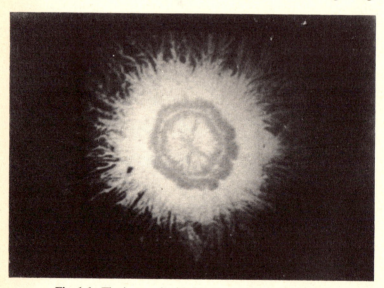

Fig. 1.1. The image obtained by the Lichtenberg method.

of electrophysiology, and radiology, experiments with bio-electroluminescent phenomena were rare, and electrical phenomena remained poorly explained. Luminous discharges in rarefied gases were studied at this time. Electromagnetic theory passed from the experimental stage, taken from Faraday, to a more mathematical formulation thanks to Maxwell's equations. The explanation of the wave-like nature of light, by Hertz, was understood much later and used when explaining electrical phenomena. In medicine and biology electrophysiology was dominated by the ideas of Virchoff and Claude Bernard. Research carried out by d'Arssonval, although looked upon with interest, did not succeed in convincing the scientific world.

At the same time the epoch-making discovery of Roentgen offered the possibility of visualising deep structures in the body. It is easy to understand why the structural image obtained with x-rays was easier to accept in those days than the functional electrographic image.

The first electrographic images using electroluminescence were obtained in 1892 by a Polish doctor and physicist, Jacob Jodko Narkiewich.

J. J. Narkiewich was born in 1898. He studied medicine, electricity and Fine Arts in Moscow and Paris. In 1892 he began experiments with high voltage discharges, publishing his first results on human behaviour. In 1896 he began his collaboration with Baraduc, a well-known researcher in the field of psychophysical phenomena, continuing in Baraduc's laboratories in Paris the experiments by which he obtained electroluminescent electrographic images. In 1904 he died, in full creative swing at a time when his research work was beginning to impress the scientific world. Sadly his findings were soon forgotten.

The apparatus used by J. J. Narkiewich was made up of a Rumkhorff coil, supplied by two 2 V. cells. The secondary of the coil was tied to the table in the room in which the experiment was being carried out, so that through the terminal left free a high frequency oscillating system was achieved. The free terminal was connected to a wire introduced into a glass tube half filled with dilute acid. If a person was in contact with the single pole electrode, and if this person was touched by someone else, electric discharges appeared at various points of minimum electrical resistance on the first person. The most luminous zones proved to be the palms of the hands, and other sudoriferous psychogenic zones.

This phenomenon was photographed for the first time by J. J. Narkiewich, in 1898, on various parts of the body. Photographs of hands obtained by this method were kept for documentary purposes. Narkiewich maintained that the radiation sent out by these discharges could be influenced by the persons experimented with (fig. 1.2).

Although there are mentions in the scientific literature of similar experiments carried out by M. Sabatinii and Baraduc (1892), no photographic records of these electrographs have been preserved.

The research carried out by J. J. Narkiewich was taken over by the Czech, B. I. Navratil (1845–1911).

The interest enjoyed in that period by the use of x-rays, tends to make us forget the discoveries of pioneers in the field of electrography.

At the beginning of this century, photographic images spontaneously printed by different people continued to attract the attention of psychologists and remained outside the field of scientific interest. The nature of these 'radiations' could be attributed to

electrostatic charges, facilitated by a dry skin and by clothing worn by persons used in the experiments, as well as by the ambient conditions in which they appeared.

In 1939, a Soviet engineer, S. D. Kirlian, observed by chance the appearance, on photographic films, of luminescent images obtained by exposing the body to high frequency electromagnetic fields. This observed fact remained without scientific use, and only came to the attention of researchers in 1959, who started using it for scientific studies. In 1961 the first patent for the invention was taken out by S. D. Kirlian and Valentina Kirlian, and in 1964 the phenomenon was presented under the description: 'high-frequency, high voltage photography'.

The scientific world thus again came into contact with electrography by electroluminescence, a method which had enjoyed a great deal of interest at the beginning of this century.

During the 1960s the phenomena of electroluminescence began to interest a group of American researchers who started experimenting in this field. In New York, the first Kirlian photography Congress was held where it was suggested that electroluminescent phenomena should be included in the term 'Kirlian photography'.

During the same year in which Kirlian was making known his discovery, in Czechoslovakia, the research work of S. Pratt and J. Schelmar (1939) was being looked at again. This work used a method similar to Kirlian's method. In 1962 Z. Rejdak used high tension photography when investigating psychophysiological phenomena.

Interesting research work carried out by V. Adamenko (1970, 1974) and Iniusin (1974) has been carried out using Kirlian's technique.

In Rumania, electro-physiological studies of the skin with the help of an electrometric method has enabled us to obtain electrical maps of the surface of the human body of both functional and diagnostic significance (1964–1969). The method was developed in principle from a dermometric method proposed by C. Richter (1929), and consisted of the electrographic transfer of several electrical parameters by simultaneous measurement.

This technique was called electrodermal exploration, and was developed as a useful diagnostic method (I. Fl. Dumitrescu and Carmen Golovanov). As a result of the skin electrical studies the electrical characteristics of traditional Chinese acupuncture points were found as having higher values of electrical potential, conduct-

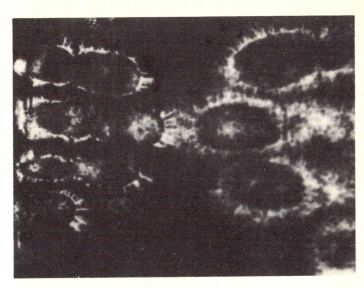
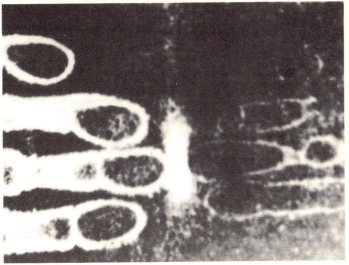

Fig. 1.2. Electroluminescent Electrographic images, obtained by J. J. Narkiewich.

ivity and capacitance as compared to neighbouring zones. These were found to increase considerably in conditions of ill health, on the points having a functional correlation with affected organs.

Starting from the principles of electrodermal exploration and from Kirlian photography, an original method different from all previously described methods was developed and given the name 'electronography' (1975). The main characteristics of this method consist in the control of the emission, propagation and conversion of the field energy of the electrons, resulting from a single impulse, in equipment used for the investigation of living organisms. In 1975 electronographic images of the whole body were obtained. In the same year the use of the phenomena of electroluminescence led for the first time to images at cellular and tissue level, with the aid of an original process called 'micro electronography' (I. Fl. Dumitrescu, Rela Herivan).

Many possibilities for electronographic exploration of living organisms were developed. In 1976, experiments were carried out with electrography using the weight-motor effect, electrostatic electrography; electrography by blocking of secondary light emission, electrography with liquid crystals and convertography.

Electrography is a scientific field whose origins lie with the discovery of biological electrical phenomena. The possibility of obtaining images with the help of electric current, which would show the structural and functional aspects of the body under examination, has interested man from early times. High tension electric current producing electroluminescence has been the simplest solution, but electrography must not be mistaken for electroluminescence, as it is only dependent on the characteristics of the electric current only so far as the effect requires.

Modern methods are attempting to obtain electrographic images using lower tension impulses.

The application of electrographic methods in the functional exploration of living organisms has led to the possibility of a new scientific discipline pertaining to the biological sciences; bioelectrography. The main advantage in the case of exploration of living organisms is the absence of any immediate or secondary interference of the exploratory technique and such organisms.

The electrographic methods which have been perfected in the last few years have considerably reduced risks involved in exposure to very high tension currents by limiting the exploration current, and by

using safety devices. In the case of ionising radiation the danger to the body has been considerably reduced due to the relatively low level of such radiation as currently used in radiology and nuclear medicine. Most recent work is investigating the possibility of bioelectrographic exploration using low tension exploratory current.

Chapter 2

Electrographic Methods as Applied in Biology

2.1 Introduction

Electrography is a transposition, in images, of one or several electrical characteristics of a body, physically investigated in pre-determined conditions, or continuously. The images obtained are determined by the characteristics of the exploring electric current, by the characteristics of the electrical environment in which the exploration is carried out, and by the electrical properties of the explored body.

Electrography, using high tension current, has been known for a very long time. The use of high tension sources as applied in this technique is known as clydonography. The use of electrographic images in the electrical exploration of living organisms, although mentioned in the literature as early as the end of the last century, has only attracted attention of research workers in the last few years.

Scientific interest in electrography has increased enormously through the findings made using Kirlian photography. This is why so many authors confuse electrography with photography by electroluminescence, using high frequency currents, known as Kirlian photography. We shall enumerate in this chapter the general principles on which the various electrographic methods are based, and techniques with their variants which are known to us. As a basic principle they use different electrical parameters, each of which explores a different aspect of the organism being studied.

The main factors underlying electrographic methods are as follows:

1. The dielectric penetration effect.
2. The weight motor, or electrophoretic effect.
3. The electroluminescent effect.
4. The electrostatic effect.
5. Electrothermal effects.
6. Specific electrono-optical effects.
7. Electrochemical effects.

8. The differential absorption of microwaves.
9. Convertographic effects.

The systematic study of these phenomena and their application in the field of biology led me to the perfection of some original methods for electrical investigation of living organisms.

It is therefore easy to understand why we consider that Kirlian photography (an application of electroluminescence in conditions of very high tension and at radio frequencies), represents only one aspect within the spectrum of electrographic methods and techniques. These techniques have many possibilities and applications in the exploration of living organisms.

We shall proceed to present the main electrographic methods which we have been experimenting with over the last few years. We believe that they will point to some new lines of research in the field of electrography.

2.2 Electrography by skin electrical measurements

This uses the transcription of values obtained by skin electrical measurements, with the aid of measuring equipment.

The electrodermal multimeric method of exploration developed by us has allowed us to obtain the first systematic observations regarding the electrical behaviour of the skin in conditions of health and disease.

The electrodermometric method has been introduced and scientifically investigated by Curt Richter in America, in the 1940s and '50s. Electrodermal exploration represented a step forward in techniques of skin electrical investigation. With its help we have systemised the electrical characteristics of the body, as well as cutaneous electrical changes which may occur in pathological conditions.

2.3 Electrography by weight-motor effect

This makes use of the space orientation and distribution of microparticles, achieved by their collision with an orientated flux of secondary electrons or ions derived from electronic collisions with molecules in the gaseous environment in which the microparticles are found.

Electrography by weight-motor effect has given us the first

Lichtenberg-type images, by subjecting neutral microparticles to the action of high tension electric current.

Later, when using this technique, the use of the weight-motor effect of discharges at very high tension was replaced by the use of a process of photographic recording of the electroluminescent effect with a similar disposition of discharge lines (fig. 2.1). The electrographic method by weight-motor effect was employed by us for tracing force lines on the body in conditions of exposure to different electric tension values and their correlation with the interaction of biological electromagnetic fields. Taken over and adapted to conditions for the exploration of the body, this method has made it

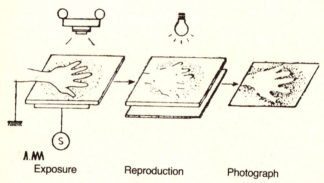

Fig. 2.1. Basic diagram of electrography by weight-motor effect (original).

possible for us to trace force lines which surround living organisms, applying the 'interaction fields' theory.

The weight-motor effect depends on the characteristics of the voltage source, of the organism being investigated, the factors connected with the micro particles subjected to migration (size, specific gravity, electrical permittivity, the disposition of electrostatic charges on its surface, etc.), and on the electrical factors of the environment in which the migration is taking place, i.e. temperature, humidity, ionic concentration with respective gradients in the direction of particle migration.

Biological electrography can be carried out using many parameters of exploratory currents providing that these electrical parameters are limited to values within biological tolerance. The graphic effects of

the method consist in the reproduction of force-lines in the vicinity of living organisms which show interrelations between these and the external electric environment.

2.4 Electrography by electroluminescence

This method is based on the effect of luminescent ionisation at the point of separation of two different electrical environments.

In the field of biological exploration electroluminescence was used for the first time by Jodko Narkiewich in 1898, then by Navratil in 1910, and by S. D. Kirlian in 1939 who used high-frequency high tension currents.

Biological electrography by electroluminescence has five different technical variants.

2.4.1 *Electrography by high tension sparking gap*

This is used in the technique of defectoscopy for examining insulating structures. Its principle consists in the direction of ionisation channels produced by very high tension currents through zones of minimum impedance in the dielectric medium placed in the electro-magnetic field. This method of electrography by sparking gap has been used by us for the detection of electrodermic points, knowing that their impedance differs from the surrounding skin (fig. 2.2).

Photographing, or graphic recording, of the discharge channels between the body and a flat exploring electrode with a uniform

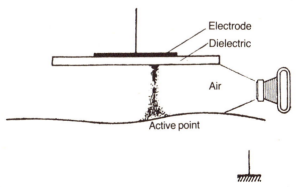

Fig. 2.2. Basic diagram of electrography by sparking gap in high tension conditions (original).

16 *Electrographic Methods in Medicine and Biology*

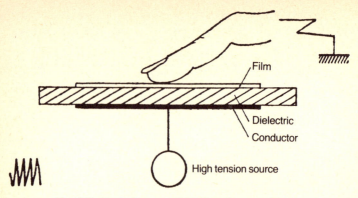

Fig. 2.3. Basic diagram of Kirlian photography.

distribution of electromagnetic field makes it possible to detect zones of minimum skin resistance.

2.4.2 *Kirlian Photography*

This is the method which introduced biological electrographic exploration to the scientific world. Kirlian photography is a method for the exploration of living organisms by electromagnetic fields generated using high tension electric currents at radio frequencies (fig. 2.3). The image is produced by the appearance of ionisation channels in the dielectric space in which the light detector (i.e. photographic film) has been placed at the point of separation of the electro-biological medium and the external electrical medium. Around the exposed organism a homogeneous discharge known as the pellicular effect appears (marginal aura). The presence of ionisation channels occurs in zones of low electrical resistance in the electrical medium surrounding the organism (the proximal electric medium)* as well as in its interior. Kirlian photography has proved of real value when exploring the body at the interface between the body and the proximal electric medium.

* Proximal electric medium – a term given by I. Fl. Dumitrescu (1976) to the space around the body within which biological electrical phenomena are manifest and which can be recorded by methods outlined in this book.

2.4.3 *Electronography*

This represents a variant of electroluminescent electrography in conditions in which the medium for the passage of the electromagnetic field is relatively compact (fig. 2.4a). The propagation of the electromagnetic field is made in one direction only and only once (single impulse).

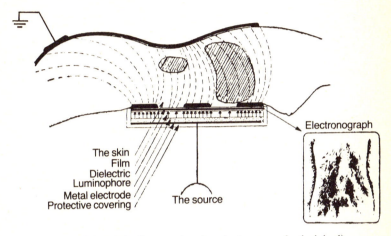

Fig. 2.4. Basic diagram showing electronography (original).

Electronography, which is an original method (I. Fl. Dumitrescu and collaborators, 1975), is characterised by three essential elements:

1. Measurement of the electronic emission.
2. The energetic differentiation of the particles in the electromagnetic field created.
3. The differential electrono-optical conversion with determination of the energy levels of the accelerated particles, by their proportional conversion to a luminous flux.

The electronographic method uses single impulses with controlled polarity, amplitude, active growth slope and energy. The tensions are in the range of tensions which generate a breakdown potential in the conditions of the total impedance of the electric circuit used (fig. 2.5).

The electronographic image is characterised by three distinct aspects, each of which can predominate depending on the method chosen.

18 Electrographic Methods in Medicine and Biology

(a) The pellicular effect or the marginal discharge effect which summated together with the repetitive character generated by the Kirlian technique produces the characteristic corona.
(b) The electromorphous effect generated by the distribution of the high tension electromagnetic field inside the volume-conductor represented by the body.
(c) Effects due to the proximal electric medium (the layer of adherent ions, free aeroions and other luminous emissions). Electronographic apparatus produces all of the above effects and is in this respect different from Kirlian photography.

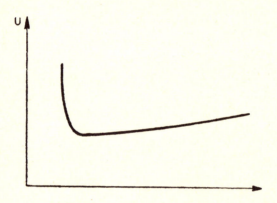

Fig. 2.5. Electronographic impulse with negative polarity (original).

Electronography, just like Kirlian photography, is one of many electrographic possibilities using electroluminescence.

2.4.4 Microelectronography

This is electroluminescent electrography at cellular level. It was developed in 1975 (Dumitrescu, Herivan), (fig. 2.6a and b).

The technique of microelectronography is much more demanding than electronography, and involves exposing a biological preparation as a monocellular layer to an electromagnetic field generated by a single impulse or by a series of impulses at an experimentally determined amplitude.

The resultant electroluminescence is recorded on photo-sensitive

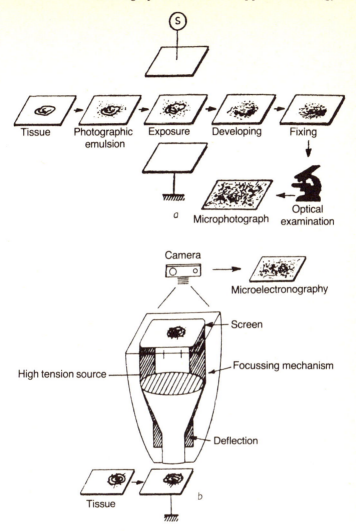

Fig. 2.6. (a) Basic scheme for microelectronography (original). (b) Electronooptical magnifying equipment used in microelectronography (original).

emulsion or by a photo-sensitive device, then enlarged and memorised using optical or electrono-optical devices.

The microelectronographic image is obtained either using a black and white or natural colour process, or changed into conventional colours so as to increase the contrast.

2.4.5 Electroluminescent Spectrography

This method has enabled the qualitative analysis of electroluminescent radiation. Electroluminescent spectrography (fig. 2.7) has provided interesting data regarding human bioenergetic behaviour. The method consists in the correlated analysis of the extreme bands of spectral radiations contained in the zone of marginal discharges, by recording with selective sensors.

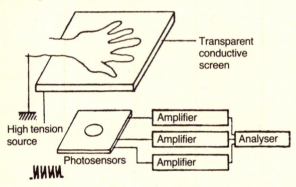

Fig. 2.7. Basic diagram of electroluminescent spectrography (original).

2.5 Electrography by electrostatic polarisation

The principle of this method depends on electrostatic charging of certain dielectric and semi-conductor materials, and also as a secondary effect microgranular pigment which is discharged onto a carrier with optical contrast (fig. 2.8). (This method was developed in 1975 by Dumitrescu and Celan.)

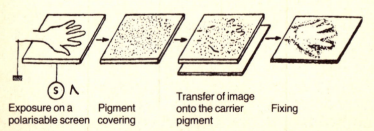

Fig. 2.8. Basic diagram of electrography by using an electrostatic effect (original).

A high tension source generates single monopolar impulses identical to those used in electronography. This principle of electrography by electrostatic charging has been used to reproduce electronographic images.

2.6 Electrography by blocking the secondary light emission

Blocking the phenomenon of secondary light emission by non-luminescent electrical discharges (noticed by Dumitrescu, 1976), is the antithesis of light emission which takes place in electroluminescent discharges. This first variant is the basis from which convertography has been developed.

The method uses a phosphorescent screen, previously excited by light or some other process which extinguishes, over the zones in which a transitory electromagnetic field (i.e. exploratory impulse) traverses the body, and interacts with the 'excited screen' (fig. 2.9). The darkness on the screen therefore reproduces the electrical characteristics of the body under study, just like the image obtained by electroluminescence.

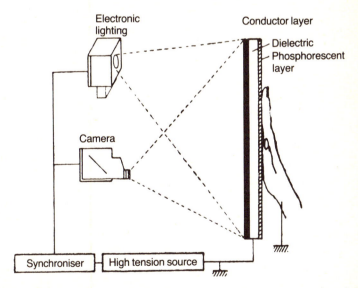

Fig. 2.9. Basic diagram of electrography by blocking of secondary light emission (original).

22 Electrographic Methods in Medicine and Biology

2.7 Electrography using the thermal effect

The thermal effect of high tension discharges passing through living organisms constitutes another possibility for electrical recording. The effect of the exploratory electromagnetic field is recorded by a special thermographic device, or by means of a layer of liquid crystals with a calibrated chromatic curve, or gathered using a thermovision circuit (fig. 2.10).

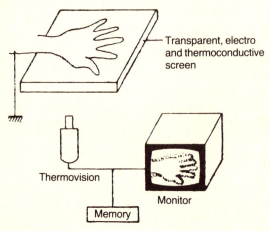

Fig. 2.10. Basic diagram of electrography using the thermal effect (original).

This possibility of electrographic exploration has been subjected recently to experiments by us and constitutes another method, different from Kirlian photography.

2.8 Electrography using the electrono-optical effect

In this method the image which represents the electrical characteristics of an organism is produced by the conversion of certain electronic phenomena into luminous images (fig. 2.11). Two different methods are used:

(*a*) Methods making use of two different types of crystal, one thermostable and sensitive to electromagnetic field variations, and the other thermosensitive and stable to electrical changes.
(*b*) Methods making use of phosphors which are excited electrono-optically. This enables electrographic exploration to be carried

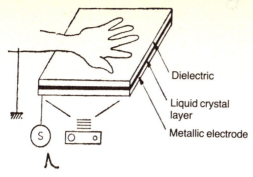

Fig. 2.11. Basic diagram of electrography using the electrono-optical effect (original).

out using values of electrical tension far lower than with electroluminescent electrography.

2.9 Electrography using electro-chemical effects

Other groups of methods which have enabled force lines around the body exposed to a particular electromagnetic field to be photographed are electro-chemical effects. One of these methods is based on sensitising a photo-sensitive emulsion containing silver chloride, having first exposed the film to light, using an electromagnetic field to sensitise the light-exposed photographic emulsion (fig. 2.12).

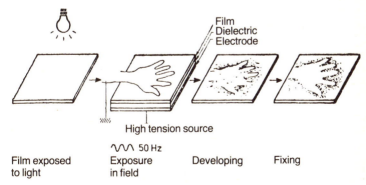

Fig. 2.12. Basic diagram of electrography using electrochemical effects (original).

2.10 Electrography using transducer systems

This method consists of obtaining an image using point transducers which explore one electrical characteristic of the organism under investigation and the subsequent reconstitution of the image by resynthesising, point by point, the distribution of the explored parameter. The display system used in this method is usually a video camera (fig. 2.13).

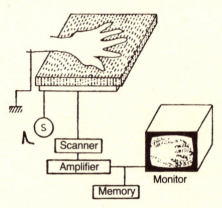

Fig. 2.13. Basic diagram of electrography using transducer systems (original).

2.11 Electrography using microwaves

The exploration of living organisms with the aid of microwaves makes a new type of biological electrography possible. As far as microwaves are concerned the body appears as a volume-conductor with a non-uniform distribution of impedance, with zones which will reflect more or less the incident microwave beam. Imaging of organisms using microwaves makes it possible to obtain morpho-functional data: the distribution of active electrodermal points, the differential thermal behaviour of the radiated tissues, and the diagnosis of pathological states.

In this brief introduction to electrographic techniques I have tried to explain and clearly define electronography as being one of these biological electrographic techniques.

Electrography is a new scientific field with many possibilities regarding the investigation of living organisms, both for diagnosis and to assess therapy.

We believe that the division of electrographic methods according to the fundamental effects of the electric current, and not according to the type of electrical sources and the method used for recording the image is justified, and will contribute to real progress in the practical application of the methods outlined here.

We must not forget that a methodology, however perfect, has no other value than the scientific truth on which it is based.

We hope that the principles of electrography will generate many variants, just as electronography finds its direct application in photography using high frequency electric current.

We believe that of all the methods we have experimented with up to now, electronography has given the best results, and offers most possibilities for immediate use. With due respect to the history of the development of electrography as a science, the majority of the methods presented here represent original contributions attested by patents and publications.

Synoptic table of the characteristics of the main electrographic methods experimented with.

Type of electrography	Variant	Authors & date of experiment	General characteristics	Characteristics of the source of tension	Characteristics of the recording device	Graphic effect	Uses
0	1	2	3	4	5	6	7
1A. Electrography by weight-motor effect.	Clidonographic method.	Lichtenberg, 1777.	The migration and orientation of micro particles in an electro-magnetic field.	High tension and very high tension monopolar impulses.	Migration of certain fine powders under the discharge electrodes.	Showing the force lines between electrodes. The black/white process or in the colour of the particles.	For tracing force lines around living organisms.
1B. Electrography by weight-motor effect.	A technique for biological exploration.	I. Fl. Dumitrescu, 1976.	Migration and orientation of micro particles under the action of an electro-magnetic field generated by very high tension currents.	Very high tension – monopolar impulses.	Migration of micro particles with known characteristics inside a capacitor.	Showing the force lines in the biological environment. White-black process or in the colour of the micro particles.	Exploration of the biological field.

Electrographic Methods as Applied in Biology 27

Type of electrography	Variant	Authors & date of experiment	General characteristics	Characteristics of the source of tension	Characteristics of the recording device	Graphic effect	Uses
0	1	2	3	4	5	6	7
2A. Electro-luminescent electrography.	Electrography by sparking.		Sparking through minimum resistance points and zones.	Very high tension and very high frequency.	Sparking dielectric electrode on the explored surface.	Discharge channel photographed.	Defectoscopy. The detection of acupuncture points.
2B. Electro-luminescent electrography.	Kirlian Photography.	S. D. Kirlian.	Biological electro-luminescent phenomena at the limit separation of different electrical media.	Very high tension, radio frequency.	Capacitor with the formation of ionisation channels.	Marginal discharges at the limit of separation of the exposed media (black/white or colour process).	Biological investigation of surface bio-electric phenomena.

Type of electrography	Variant	Authors & date of experiment	General characteristics	Characteristics of the source of tension	Characteristics of the recording device	Graphic effect	Uses
0	1	2	3	4	5	6	7
2C. Electro-luminescent electrography	Electronography.	I. Fl. Dumitrescu.	Quantification of electronic emission. Differentiation of particles in the field. Differential electrono-optical conversion.	Very high tension. Single monopolar impulse, positive or negative.	Capacitor screen with dielectric. Differential electrono-optical conversion.	Marginal discharge (pellicular effect). Effect of volumetric distribution of the electro-magnetic impulse. Effect of ionising the gaseous molecules in the proximal electric medium (black/white or colour process).	The exploration of bio-electric surface phenomena. Electro-functional diagnosis. Locating and photographing of acupuncture points. Biological and industrial investigation.

Electrographic Methods as Applied in Biology

Type of electrography	Variant	Authors & date of experiment	General characteristics	Characteristics of the source of tension	Characteristics of the recording device	Graphic effect	Uses
0	1	2	3	4	5	6	7
2D. Electro-luminescent electrography.	Micro-electrono-graphy.	I. Fl. Dumitrescu and Rela Herivan.	Electro-luminescence at cellular level.	Very high tensions. Trains of positive or negative impulses.	Exposure of a monocellular layer of the biological preparation covered with photo-sensitive emulsion.	The impressing of photo-sensitive emulsion at microscopic level, using a black/white or conventional colour process.	Cytological investigation. The study of energetic passage points at cell and tissue level.
2E. Electro-luminescent electrography.	Electro-luminescent spectrography.	I. Fl. Dumitrescu, 1976.	The spectral analysis of electro-luminescent light emission.	Very high tensions. Trains of positive or negative impulses.	System of multisensors sensitive to specific zones of the radiations collected in the vicinity of the discharges.	Curves or numerical data corresponding to the spectral zone analysed.	Biochemical investigation. Clinical diagnosis.

Type of electrography	Variant	Authors & date of experiment	General characteristics	Characteristics of the source of tension	Characteristics of the recording device	Graphic effect	Uses
0	1	2	3	4	5	6	7
3.	Electrography by the blocking of the secondary light emission.	I. Fl. Dumitrescu.	Blocking of phosphorescent emission by autoelectronic emission.	High tension and very high tension. Sinusoidal or impulsional-type current.	Capacitor screen with secondary light emission.	Dark image with luminous absorption gradation relative to the electrical characteristics of the organism. Black/white or colour process.	Experimental.
4.	Electronography by electrostatic polarisation.	I. Fl. Dumitrescu, 1975, E. Celan.	The electrostatic charging of a semiconductor plate.	High tension. Single monopolar impulse positive or negative.	Dielectric screen with semi-conductor polarisable layer.	Contrast image with electronographic characteristics, black/white or colour process.	In experimental stage.

Electrographic Methods as Applied in Biology

Type of electrography	Variant	Authors & date of experiment	General characteristics	Characteristics of the source of tension	Characteristics of the recording device	Graphic effect	Uses
0	1	2	3	4	5	6	7
5.	Electrography using the thermal effect.	I. Fl. Dumitrescu, 1976.	The transformation of the thermal effect of high tension discharges into a luminous image.	Very high tension and high frequency sinusoidal and impulsional-type current.	Capacitor screen with thermal sensor or with thermal radiation.	Image with shade graduation. Black/white or conventional colour process.	Biological investigation. Electro-functional diagnosis.
6. Electrography by electro-optical conversion.	Technique using phosphors or using liquid crystals.	I. Fl. Dumitrescu, 1977.	The excitation of layers of converting substance such as a phosphor.	Any type of electric current.	Screen with phosphors or liquid crystals.	Image in black/white or colour.	In the experimental stage.
7. Electrography using magnetic effect.		I. Fl. Dumitrescu, I. Mamulas, 1978.	Transformation of the magnetic effect of the exploratory electro-magnetic field into an image.	Sinusoidal or impulsional A.C., high frequency.	Capacitor screen with iron filings which can be moved or magnetisable foil.	Image obtained by the distribution of the micro-particles.	In the experimental stage.

Type of electrography	Variant	Authors & date of experiment	General characteristics	Characteristics of the source of tension	Characteristics of the recording device	Graphic effect	Uses
0	1	2	3	4	5	6	7
8. Electrography using electrochemical effects.		I. Fl. Dumitrescu, I. Mamulas, 1978	Exposure of electro-sensitive films.	Low, medium and high tension currents, low frequency.	Incomplete capacitor screen.	Black/white image of the distribution of equipotential lines.	In the experimental stage.
9. Electrography using electrometry.		I. Fl. Dumitrescu, Carmen Golovanov, 1967.	The collection of electric parameters by cutaneous transducers and the reconstitution of the distribution.	Low tension either from the endogenous source or from the exploratory source.	Multi-transducer system.	Distribution Map.	Electro-physiological exploration.
10.	Converto-graphy. a. Photonic pre-excitation convertography b. Photonic post-excitation convertography c. Synchro-convertography.	I. Fl. Dumitrescu, 1977.	Conversion of transitory electro-magnetic fields by photonic stimulation (x, u.v. and visible) by means of different special phosphorescent substances.	Low to high voltage sources.	Capacitor screen with converter layer.	Dark images against luminous background, or TV recording.	Medicine, biology, electronics.

Chapter 3

The Physics of Electrography

3.1 The electron – an elementary particle

Experimentally it is found that in certain conditions, physical bodies can be charged, and that the medium surrounding the body (which also possesses an electric charge), is in fact an electric field. This field is the medium through which interactions between charged bodies take place. It can be shown, on an experimental basis, that the electric charge of every body is a multiple of an elementary electric charge, that being the charge of an electron.

The existence of the electron as a constituent particle of matter was shown by J. J. Thomson in 1897. By various measurements, it was found that the absolute value of the charge of an electron is $e = 1.60210 \cdot 10^{-19}$ C and the resting mass, $m_0 = 9.1091 \cdot 10^{-31}$ kg.

Electrons are elementary constituent parts of atoms contributing side by side with protons and neutrons, to the formation of the electrically neutral atom. As far as present thinking is concerned, the atom is thought to be made up of a nucleus (where the positive charge is to be found, and which contains nearly the whole mass of the atom), and an outer electron shell (where the negative charge is found). 'Atomic superstructures' called molecules can be formed through the interaction between two electron shells of different atoms.

When studying the physical phenomena in which electrons participate, two states can be determined in which electrons are found; bound electrons and free electrons. Examples of states in which electrons are bound are: atomic structure, molecular structure, the emission and absorption of light, etc. Free electrons appear in states such as: acceleration systems, electric discharges, thermo electronic emission, etc.

3.2 Electric charges in magnetic and electric fields

Unlike a magnetic field, an electric field is a field with a source which is created by a charged body. If the charge and the position of the charged bodies are not variable in time, the electric field is called an 'electrostatic field'.

Two point charges with the charges Q_1 and Q_2 respectively interact through an electrostatic field, the force (F) between them being given by Coulomb's law:

$$\vec{F} = \frac{Q_1 \cdot Q_2}{4\pi\epsilon} \cdot \frac{\vec{r}}{r^3} \qquad (3.1)$$

where r is the distance between the two bodies in mm and ϵ the electric permeability constant of the medium between the two bodies, called the dielectric constant or the relative permittivity of the medium.

The same interaction force could also be expressed as follows:

$$\vec{F} = Q \cdot \vec{E} \qquad (3.2)$$

where \vec{E} is the intensity of the electrostatic field, created by Q_1 at distance r and:

$$\vec{E} = \frac{Q_1}{4\pi\epsilon} \cdot \frac{\vec{r}}{r^3}. \qquad (3.3)$$

Electric potential is another way of characterising the electrostatic field of charge Q, at a point at distance r, and has the value of:

$$V = \frac{Q_1}{4\pi\epsilon r} \qquad (3.4)$$

The potential difference between the two points, V_1 and V_2, is:

$$U = V_1 - V_2. \qquad (3.5)$$

In the case of uniform electric fields, the intensity of this field is:

$$E = \frac{U}{d}, \qquad (3.6)$$

where d is the distance between the two points situated on the same field line, between which there exists a potential difference U.

A magnetic field is another form of field, and is characterised by the fact that it has no sources and does not act except on moving charges. The force with which a magnetic field acts upon a body with

an electric charge Q and a speed \vec{v} can be expressed thus, by using the intensity of the magnetic field \vec{H}:

$$\vec{F} = \mu Q \vec{v} \times \vec{H}, \qquad (3.7)$$

where μ is the magnetic permeability of the medium, and the operation between the two vectors is the vectorial product operation.

By introducing value $\vec{B} = \mu \vec{H}$, called the magnetic induction, we can express the force with which an electric field and a magnetic one act simultaneously on a body with the above characteristics:

$$\vec{F}_L = Q(\vec{E} + \vec{v} \times \vec{B}), \qquad (3.8)$$

where \vec{F}_L is called the Lorentz force.

Knowing the Lorentz force, the law for the movement of the above body can be determined by integrating the equation which expresses the second non-relativistic law of dynamics:

$$m \frac{d^2 \vec{r}}{dt^2} = \vec{F}_L, \qquad (3.9)$$

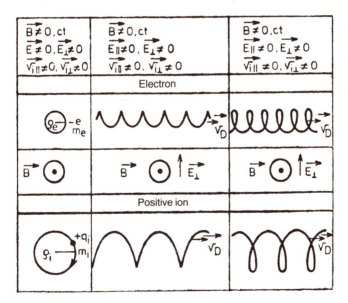

Fig. 3.1. The movement of electrified particles and the drift speed v_D in the magnetic field B and in the electric field E (at right-angles to each other).

where m is the mass of the body. From the laws of motion, the trajectory of the body into the system of fields examined by us can be determined (fig. 3.1).

Electric and magnetic fields represent two aspects of an electromagnetic field. A temporarily changing magnetic field creates an electric field, and a changing electric field generates a magnetic field. The force lines of the electric and magnetic field are at right-angles to, and also encircle each other, and this shows that, mathematically, the electromagnetic field is a rotational field.

The wavelength of the electromagnetic field is equal to the distance with which the electromagnetic field propagates during one cycle. Light, infra-red radiation, ultra-violet radiation, etc., are electromagnetic radiations differing according to wavelength.

3.3 The electron within atomic and molecular structures

By studying the dispersion of radioactive particles on metallic foils, Rutherford established in 1911 that the positive charge of the atom and nearly all its mass are concentrated within a nucleus with measurements of the order of 10^{-13} cm. After his experiments, Rutherford proposed a planetary model of the atom, according to which the atom consists of a positive nucleus with electrons gravitating round it on closed orbits. The charge of the nucleus is equal in absolute value with the sum total of the charges of the electrons, so that the atom, as a whole, is electrically neutral. At the same time, the mass of the electrons is very small, which means that nearly the whole mass of the atom is concentrated in the nucleus. This planetary model explains the experiments on scattering of particles in matter, establishing at the same time that the number of elementary positive charges contained in the nucleus is equal to the number of Z orders of the respective element in the periodic table of Mendeleev. In spite of all this however, the planetary model, in its initial form was incompatible with classical electrodynamics. Applying the laws of electromagnetism showed that the spectrum of the atom should be continuous, a fact which led, due to the continuous loss of energy, to the 'falling' of electrons into the nucleus and to the ceasing of the existence of the atom as a planetary system. On the other hand, however, experiments show that atoms are stable, and that they have discrete emission and absorption spectra.

In order to solve the contradiction, Niels Bohr introduced the first

quantum elements regarding atomic structure, completing the planetary model with the following postulates:

1. Electrons move around the nucleus on stationary orbits, the movement taking place without any energy emission or absorption.
2. On the stationary orbits, the orbital kinetic moment of an electron is a multiple of $h/2\pi$, h being Planck's constant.

 Therefore:
 $$m \cdot v \cdot r_n = n\frac{h}{2\pi}; \quad n = 1, 2, 3\ldots, \qquad (3.10)$$

 where m is the mass of the electron, v the speed on orbit h, r_n, the radius of the orbit and $h = 6.625 \cdot 10^{-27}$ erg·s. Formula (3.10) represents the quantifying condition of the orbital kinetic moment.
3. When an electron passes from one orbit to another emission or absorption of an energy quantum occurs. The quantum of energy emitted or absorbed ($h\nu$) is equal to the absolute value of the difference of energies E_k and E_m, corresponding respectively to orbits k and m:
 $$h\nu = |E_k - E_m|. \qquad (3.11)$$

E_k and E_m are also called energy levels. If E_k is greater than E_m, emission of a quantum of energy occurs, and if E_k is smaller than E_m, absorption of the same quantum of energy takes place. On an experimental basis, we find that the passage from one energy level to another can also be achieved by multi-photon emission or absorption. In this case, the sum of the energies of the photons emitted or absorbed is equal to the difference between the corresponding energies of the two levels of the transition.

The atomic model of Bohr explains fairly well the spectral behaviour of the hydrogen atom, and of hydrogen ions, but it proves to be unusable in the description of the structure of multi-electron atoms. In this case, according to the laws of quantum mechanics, the very notion of the trajectory of an electron within the atom must be revised. The classical concepts of trajectory, of locating the electron, are not usable any more at atomic and subatomic dimensions. On the basis of the uncertainty principle by Heisenberg, it is not correct to talk about the trajectory of an electron, but rather to talk about an

electron 'cloud' in which the electrons are to be found with a certain amount of 'probability'. The fundamental element of Bohr's theory – the existence of discrete energy levels in the atom – is retained, but other values are quantified which characterise the state of the electron in the atom. Thus, an electron from an atom is characterised by four quanta.

1. The main quantum number n, on which depends essentially the energy of the electron in the atom. It has positive values from 1 to infinity. Electrons with the same number make up what is called an electron blanket.
2. The orbital quantum number 1, which determines the orbital moment of the electron impulse, and which has positive values from 0 to $n-1$, where n is the main quantum number.
3. The magnetic quantum number m_l, which characterises the orientation of the orbital magnetic moment of the electron in an external magnetic field. It has positive or negative values from -1 to $+1$, including 0.
4. The quantum number of spin m_s, which expresses a particular quality of elementary particles just as important as mass or electric charge. As far as the electron is concerned the spin can only take two values: $+1/2$ or $-1/2$, according to orientation in an external magnetic field.

Within an atom electrons are placed in such a way as to satisfy the following conditions:

(*a*) Two electrons cannot have four identical quantum numbers, which means that the state of the electrons in the atom is distinct. This is a statement of the Pauli exclusion principle.
(*b*) In its basic rest state, the atom and its electrons are in a state of minimum energy.

The physical and chemical properties of chemical elements are determined by the electron orbits of their respective atoms, there existing a direct connection between the structure of the electron orbits of an atom and its place in the periodic system of Mendeleev.

In certain conditions, atoms can associate, forming structures called molecules. Generally speaking, a molecule consists of a number of heavy centres (the nuclei of atoms and ions) around which electrons gravitate. Just as in the case of atoms, one can also talk here about an electron cloud. Due to the great difference between the

mass of the electrons and the mass of the nuclei (for instance a proton is 1,840 times heavier than an electron), we can take into consideration, within a first approximation, the resting nuclei compared to the movement of electrons. Therefore, if we wish to study the movement of the molecule, as a whole, good results can be obtained with approximate values of the quanta which characterise the properties of movement of electrons within the molecule.

The distribution of electric charges (one of the important specific properties of molecules) is completely characterised if both the distances between nuclei and the electron charge density are known. It can happen that the centre of the positive electric charge of the nuclei and the centre of the negative charge of the electron cloud coincide, just as they coincide in the case of every atom. But more often than not, the two centres do not coincide, which implies, as far as the molecule is concerned, the existence of a permanent dipole moment, given by the ratio:

$$\vec{P}_0 = \sum_i \overline{e\vec{r}}_i, \qquad (3.12)$$

where \vec{r}_i are the position vectors of the nuclei and the electrons, the bar expressing the mediation over the moment of the electrons, the total including all nuclei and all electrons.

In an electric field, the molecule is deformed, and thus, even if it has not got a permanent dipole moment, one is induced. In a first approximation the induced dipole moment is linear with the growth of the intensity of the electric field \vec{E}.

$$\vec{p} = \alpha \vec{E}, \qquad (3.13)$$

where α represents the polarisability of the molecule. Just like atoms, different electron states exist in molecules which can be discerned by the specific character of emission and absorption spectra.

Of forces which act at molecular level, both intramolecular forces (limit forces, which determine the cohesion of the molecules) and intermolecular forces (forces which act between molecules) can be distinguished. Intramolecular forces can be divided into three main types which establish three different sorts of bond: ionic bonds, covalent bonds and metallic bonds. Usually, atoms which combine in order to form molecules have a stable electronic formation of the same type as that found in inert gases. The way in which it achieves this formation determines the type of bond made.

In the case of ionic bonds, the molecular atoms form positive and negative ions, the bonding force being of an electrostatic nature.

Experiments have shown that the covalent bond, which characterises the biatomic molecules of the H_2, N_2, O_2, Cl_2 types, as well as some organic compounds, like CH_4, is usually associated with the presence of an electron pair which belongs simultaneously to both of the constituent atoms of the molecule.

The metallic bond present in 'crystal gratings' of metals has not been fully explained up to now. When examining the metallic bond, the fact that metals are an assembly of positive ion cores consolidated by movement of quasifree electrons must be considered, and this movement enables metals to act as good conductors.

Van der Waals' forces, which are intermolecular forces, appear as a result of the reciprocal deformations induced by molecules, or deformations which produce dipole moments, therefore causing interaction between respective molecules. These bonds are much weaker than ionic or covalent bonds.

3.4 Conductors and Dielectrics

Conductors are substances which are good electrical conductors, unlike dielectrics (insulators) which do not conduct electric current. Conductors can be classified into two categories. In the first category belong metals, where the charge carriers are free electrons, and to the second category belong those substances where the movement of electric charge is accompanied by a movement of substance. The molecules of a dielectric are relatively widely separated, so that the electrons, being closely bound by atoms, cannot move in the dielectric volume. A dielectric introduced into an external electric field polarises itself, and charges of one sign, and on the opposite side charges of the opposite sign, appear at the dielectric surface. Dielectrics which have a remanent polarisation, after the elimination of the external electric field, are called electrets.

3.5 Ionic conduction within living structures

Electric currents passing through electrolytes (liquid conductors) have charge carriers which are either positive ions, called cations, or negative ions called anions. When two electrodes are introduced into

an electrolyte, and are at different potentials, then directional movement of ions in the electric field thus created takes place.

If the electrolyte contains n_1 molecules of the dissolved substance to the total volume, and η is the degree of dissociation of the substance, then the electrical conductivity of the electrolyte is:

$$\sigma = n_1 \eta (k_+ + k_-) q, \qquad (3.14)$$

where k_+ and k_- represent the mobilities of the two types of ions, and q – the positive ion charge. Therefore, the intensity of the electric current which penetrates area A is:

$$I = \sigma \cdot EA, \qquad (3.15)$$

where E is the intensity of the electric current applied across the two electrodes. The intensity of biocurrents in living cells, or tissues, is of the order of 10^{-4} to 10^{-1} A. Such a current is accompanied by a substance transporter and is called a convection current, and has the same direction of movement as the positive ions.

In living organisms electrical conduction takes place via the ions. Injured tissue has an increased negativity. Between an intact zone of skin and one which has been injured a potential difference of between 3 and 50 mV can be measured, which then becomes less as the skin heals.

Muscles conduct electricity 6–7 times better than subcutaneous fat. The electrical resistance of the human body is provided by the resistance of the skin, and the impedance of deep tissues, and differs according to the points between which it is measured.

At high tensions (40–90 kV), and low tensions, applied locally in the form of a spark, effects appear similar to static electricity, and these ultra-short waves exert their action upon deep tissues, contact with electrodes becoming unnecessary.

3.6 Interaction of radiation with substance

High energy radiation produces similar effects to that produced by less energetic radiation, like that of ultraviolet or light in the visible spectrum. An effect which is characteristic of high energy radiation is the ionisation of the medium through which it passes, similar to the effect produced by electric discharges. In certain energetic conditions high energy radiation splits the molecules of the medium into free radicals. The interaction of energetic particles with electric charge with the electrons of the absorbent material, leads to the

transfer of energy and excitation of atoms and molecules. Ionisation takes place when the transferred energy exceeds the ionisation potential of the atoms and molecules.

The loss of energy per unit distance x, by a particle (heavier than electron) of z charge, E energy and v speed in an absorbent medium of Z atomic number with N atoms per cm^3 is:

$$-\frac{dE}{dx} = \frac{4\pi e^2 z^2 NZ}{mv^2} \ln \frac{2mv^2}{V_e}, \qquad (3.16)$$

where e is the charge of the electron, m the mass of the electron and V_e the median potential of excitation of the absorbent atom, assuming that all the electrons of the absorbent medium take part in the process. Absorbent materials differ according to the logarithmic term of the above relation. As far as positive ions are concerned, the loss of energy is independent of the mass of the particle and depends only on their speed and charge.

The interaction between high energy radiation and matter generates energetic particles with a charge (electrons or heavy particles), which in their turn produce ionisation and excitation around the trajectory of the initial particle. The linear transfer of energy grows as the speed of the particle drops towards the end of its path. Due to irradiation, colourless or slightly coloured solids can show marked absorption in the visible or ultraviolet parts of the spectrum, which makes the use of colourmetric or spectrophotometric methods possible for their study.

Very short lived processes (microseconds; nanoseconds), can be followed with the aid of absorption spectroscopy. Thus, the variation of optical density by photographic or photoelectric methods can be measured, even during irradiation with electrons. By using such methods, the hydrated electron can be shown as well as its reaction with different products in watery and organic media irradiated with electrons or with gamma radiation.

Energetic electrons dissipate energy in small groups (approximately 10^2 eV), separated by a distance of the order of $10^2 \mu$ in gases with a density of 1 mg/cm^3, for instance, air at atmospheric pressure. Secondary electrons generate excited molecules and ions for a distance of approximately 1μ around the primary ion.

Electrons not bound to individual molecules can exist in several states. A quasi-free electron offers weak interaction with the environment, and can move between two collisions at distances of a few

molecular diameters. These states are produced in gases which do not attract electrons, so as to form negative ions. The localised electron scatters through the medium at a speed near to that of a molecular ion. This state is produced in liquid and solid phases which do not attract electrons in order to form negative ions. In liquids with a low dielectric constant most of the secondary electrons are attracted back to the parent ions, and in the gaseous state, at atmospheric pressure, a large proportion of the secondary electrons leave the electric field of the parent ions.

By braking the electrons previously accelerated on a target made from a heavy material, braking radiations can be generated (Roentgen). The maximum frequency of the photons is given by the relation:

$$h\nu\mathrm{max} = eU, \qquad (3.17)$$

where U is the acceleration tension of the electrons. The lower frequencies are obtained due to the fact that electrons can lose part of their energy by ionisation, or due to the fact that one electron can produce two or more photons. The braking radiation has a continuous spectrum, independent of the nature of the target. The braking is made to appear if the acceleration tension of the electrons exceeds a certain critical value.

By using various interaction methods with the substance, the beam of particles (photons or particles with a rest mass) can be attenuated as it penetrates the substance. The methods used are those of scattering (deviation of the particles from the primary direction), and of absorption. Scattering can be elastic or non-elastic, according to the kind of collision undergone by the particles of the beam. Through absorption, the particles lose their energy and velocity completely (sometimes their total energy), either due to a single interaction, or through several, producing an exponential attenuation.

The attenuation of a beam can be determined by the reduction of its intensity. The attenuation of a beam of electrons represents the middle case between the ones described above.

In the case of exponential attenuation the intensity of the radiation depends on the distance x (the distance of penetration in the absorbent) according to the law:

$$\mathrm{I} = I_0 e^{-\mu x}, \qquad (3.18)$$

where I_0 is the initial intensity (at $x = 0$) of the beam. The attenu-

ation coefficient μ is the reverse of the thickness for which the intensity is reduced by e times (e is the natural logarithmic base), and it depends on the density and physical state of the medium.

When an electromagnetic radiation interacts with the substance, the electrons oscillate with the same frequency as that of the incident wave, and return the energy received in the form of an electromagnetic radiation of the same frequency (Thomson effect).

Electromagnetic radiations can interact with matter, through a direct collision between a photon and an electron. An electron removed from the atom, called a photoelectron, can be extracted from any electron layer. The kinetic energy of the photoelectron is:

$$T = h\nu - L, \tag{3.19}$$

where $h\nu$ is the energy of the incident photon, and L is the bonding energy of the electron in the atom. This process can take place only if $h\nu$ is greater than L. A photon cannot interact in such a way with a free electron.

Whilst the above effect (the photoelectric effect) can take place only with a bound electron, the Compton effect can take place with a free or weakly bound electron. In this process of interaction, after it sets an electron in motion (a Compton electron), a photon of $h\nu_0$ energy disperses itself with a lower energy, $h\nu(\nu < \nu_0)$.

The formation of pairs is the effect obtained by the interaction of photons, with energies greater than 1·02 MeV, with atomic nuclei. The photon disappears, and an electron and positron appear. Sometimes, the process of forming an electron-positron pair can take place in the field of an electron, and in this case, three particles are set into motion; the electron-positron pair and the primary electron. This process is called triplet formation. The energy threshold for triplet formation is of the order of 2·04 MeV.

As regards the attenuation of electron beams, an electron loses more energy as it moves in the gaseous state than in the solid or liquid state of the same substance, the probability of losing energy through braking radiation being so much greater (in relation to the probability of losing energy through ionisation), the greater the kinetic energy of the electrons and the Z number of the substance.

Charged particles moving in a medium are deflected as a result of their interaction with the electric field of the nuclei, and of the orbital electrons. The electrons, having a small mass, are easily deflected,

being highly subject to elastic scattering. Thus, for small thicknesses, the square of the mean deflection angle in air is:

$$\overline{\beta^2} = 7 \cdot 10^3 \frac{d}{T^2}, \qquad (3.20)$$

where d is the thickness of the layers in centimetres, and T is the incident electron energy in keV. The angle β is measured in radians.

By the interaction of photons with living tissues, the same processes occur which take place as in the absorption processes in non-living matter. Electrons freed from molecules as a result of primary ionisation, can possess sufficient energy in order to produce in their turn, secondary ions (secondary ionisation). In living bodies the irradiation leads to chemical changes, which determine the partial or total destruction of the cells. The cell can no longer fulfil its function, and consequently the tissue to which it belongs becomes functionally deranged.

3.7 Phenomena of luminescence

As we have already shown, molecules of any substance emit radiation when passing from high to low energy levels. Bringing molecules to excited energy states can be achieved in several ways, according to the type of energy supplied: i.e. light energy, electric energy, chemical energy, etc. The de-energising of molecules of a substance produces a radiation specific to that particular substance, a radiation which extends for a period longer than 10^{-10} s from the moment when the source which produced it ceases to act.

In these conditions we speak of the phenomena of luminescence. According to the way in which the excitation was produced, we can distinguish the following types of luminescence: photo-luminescence, electroluminescence, chemoluminescence and tribo-luminescence.

When luminous radiation is absorbed by matter, it can happen that the energy absorbed is re-released in the form of radiation with a spectrum generally different from that of the light which produced the excitation, this being the case in photoluminescence. From the spectral point of view the released light is found, generally speaking, to be nearer to the red end of the spectrum, in relation to the spectrum of the incident light (Stoke's law) (fig. 3.2). Also, the intensity of the released light is proportional to the intensity of the absorbed light. If when passing to a lower energy level, the emission

takes place at the same frequency as the frequency at which excitation has occurred, we are dealing with the phenomenon of optical resonance. When, after excitation, the molecule loses part of this energy through collisions with other molecules, the remaining energy is transmitted as photons with a lower frequency than the frequency of light which had caused the excitation, there occurring the phenomenon of fluorescence. The fluorescence spectrum is specific for every molecule. If the molecule, excited by luminous radiation, passes through metastable levels, the re-emission takes place after a long delay which, at normal temperatures, is of the order of hours or days. This phenomenon, which can be observed in certain organic substances in solution, as well as in certain inorganic ones (zinc

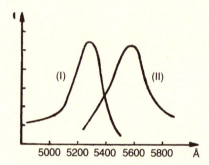

Fig. 3.2. Absorption spectra: (I) Fluorescence spectrum; (II) Stokes radiation

sulphide, calcium sulphide, uranium salts, etc.), is called phosphorescence. The phosphorescence spectrum is similar to the fluorescence spectrum, and the intensity of the emitted radiation drops exponentially in time, and is dependent on temperature.

The luminescence resulting from electrical discharges is called electroluminescence. This is the luminescence observed during electrical discharges in gases, as well as the luminescence produced by certain substances placed in variable electric fields. In the case of electroluminescence the excitation energy is of an electrical nature. The electric field applied during the discharge supplies energy to the molecules or atoms and raises the energy levels of the constituent electrons, the return to lower energy levels being accompanied by photon emission. In discharge tubes in which low-pressure discharges take place, a luminescence due to the flux of electrons strongly

accelerated by the existing field in the discharge tube, can be observed which hits the cathode, producing a cathodic luminescence.

The radiation which appears after chemical changes which a substance may undergo is called chemoluminescence. This type of luminescence accompanies some chemical reactions in which part of the released energy is emitted outwardly in the form of luminous radiation (photons). In this case, the excitation energy is chemical.

3.8 Electrical discharges

Beginning with Dr. Wolf (1698), who obtained a spark 'nearly an inch long', the study of electrical discharges in gases has undergone continuous development on a theoretical, experimental and applied basis. During this century, and especially over the past few years, the study of electrical discharges is taking its place as a new research tool in the medical world, making it possible to look at the body from a new point of view.

All the processes (elementary) which occur in the so-called plasma state are bound by the ionised state of the substance. These multiple processes have been divided into volume processes and surface processes, according to whether they occur in the volume or on the surface of the discharge column. In their turn, volume processes can be inelastic or elastic, according to whether the internal energy of the particles changes or does not change, as a result of collisions. Inelastic processes too are divided into direct or indirect processes if, as a result, absorption or release of energy takes place.

Elastic processes include the collisions of electrons with neutral atoms of an element, collisions between ions and atoms of the same gas, and collisions of ions with atoms of another element.

Direct inelastic processes include: excitation of the atom as a result of an electronic collision, excitation with positive ions, ionisation through electronic collision, ionisation with positive ions, photo-excitation of negative ions. Indirect processes include recombination of an ion-electron pair accompanied by photon emission, the capture of the electron by an atom or a neutral molecule, by photon emission, resonant transfer of charge between an ion and an atom of the same type, acceleration of the electron by collisions of the second type with an excited atom.

The superficial elementary processes include: thermoelectronic emission, secondary electronic emission, photoelectronic emission, etc.

J. S. Townsend has given the first complete theory of the mechanism of discharge (the avalanche theory), which assumes that electrons emitted at the surface of the cathode will ionise in their path a number of atoms, generating positive ions and electrons. In this way the number of electrons grows rapidly, leading to an avalanche of electrons and, on the other hand, the positive ions which move in the opposite direction, form an avalanche of positive ions.

Experimentally, Townsend's theory does not explain a series of discharge phenomena when the product of pd exceeds 200 cm mmHg. (where p represents the pressure and d is the distance from anode to cathode).

As a result of research carried out with the aid of the Wilson Camera, we found that, initially, discharge takes place by the formation of avalanches, after which channels appear (streamers) which contain ionised particles in much greater number than those present in avalanches.

Explanations of streamer formation have been given by Raether (negative streamer) and Meek and Loeb (positive streamer). Raether considers that free electrons formed as a result of ionisation during the primary avalanche, determine the appearance of new electrons which form an intense electron streamer. Meek and Loeb start from the hypothesis that, after the frontal electrons have been absorbed by the anode, under the influence of the field created by the positive ions (from the initial channel), secondary avalanches (formed as a result of photoionisation) are also attracted, producing the positive streamer. Thus, the potential of the anode 'extends' through the channel formed by the positive ions determining its intensification by the capture of the newly formed avalanches. Through this model the bifurcation and ramification of the positive streamer can be explained. Meek and Loeb give two conditions for the existence of the positive streamer, the first one referring to the ratio between the intensity of the external field and that of the field produced by the charges, and the second one relating to the number of photons formed in the frontal part of the avalanche.

The Townsend discharge is characterised by currents of the order of 10^{-15} to 10^{-16} A, after which, when the currents grow, the effect of the space charge begins to be felt and the discharge passes to a stationary phase. This phase is the one in which discharge takes place – the corona discharge characterising the non-uniform electric fields with high local gradients. By increasing the current and in conditions

of high pressure, the discharge passes either into a luminescent discharge (10^{-3} to 10^{-1} A), and then into an arc (1–10A), or into the penetration of the gas explained by the streamer theory. The luminescent discharge is maintained by electrons emitted through the bombardment of the cathode with positive ions, photons, metastable atoms, rapid neutral atoms, etc. The luminescent discharge is characterised by several zones called the first cathodic light, the Aston dark space, the cathodic dark space, the negative light, the Faraday dark space.

The arc discharge is characterised by high currents in the discharge column, small drops in tension, great electrical conductivity, and a high gas pressure. The arc discharge can occur due to thermoelectronic emission (due to external heating or due to the discharge), or due to autoelectronic emission (the electronic current appears as a result of extraction of electrons from the cathode by a powerful electric field).

High frequency discharge appears when the electrons in the gas are subjected to a potential difference varying in time of sufficiently high frequency. At present there is no complete theory regarding high frequency discharges.

3.9 Optoelectronic phenomena

The way optical and electrical phenomena develop depends on the media in which they occur. This dependence is directly bound both by the internal structure of the respective media and by the physical conditions in which the respective phenomena take place.

Relatively recently, in the field of optoelectronics, side by side with semi-conductor materials, certain substances have taken their place with special structures and properties, and these are being increasingly used in electrono-optical devices. These substances, known as liquid crystals, appear in intermediary states of aggregation (mezzophases) between the isotropic liquid state and the crystalline solid state. We must state that, for the same mezzo-morphous substance, the liquid state, the mezzophase state, and the solid state, are present at particular well-defined temperature ranges.

From a structural (chemical) point of view, liquid crystals are aromatic organic compounds in which the benzene rings are bound with rigid chains.

Generally speaking liquid crystals can be classified as thermotropic

or lyotropic according to the way in which they were made. Thermotropic liquid crystals are obtained by heating, and lyotropic liquid crystals are obtained by using solvents with polar molecules.

Depending on the existing molecular orientation the two main types of liquid crystals can be further subdivided. Thus, in the case of thermotropic liquid crystals there are several possible physical states; the nematic state, the sinectic state, and the cholesteric state. The molecules of liquid crystals have a longish shape, and tend to line up with their longitudinal axes parallel to one another.

The preferential direction of orientation can be expressed by a vector unit \vec{n}, called a directional vector. The most important consequence of such an orientation is the powerful anisotropy of liquid crystals in several of their properties; electrical permittivity, magnetic susceptibility, electrical conductivity, viscosity, etc.

In the case of nematic crystals, the molecules have chance positions, maintaining however a parallel orientation according to their long axes (fig. 3.3a). Because of this molecular disposition the nematic liquid crystals have a strong optical bifringence, ten times greater than quartz.

The cholesteric liquid crystals have a structure similar to that of the nematic ones. Having one or more asymmetric carbon atoms, the molecules of the cholesteric crystal have a twisting disposition as compared to the nematic state (fig. 3.3b). This twisting produces a helical type of structure, the dimension of the helix being relatively big (6000 A) compared to the molecular dimensions. Such a configuration rotates the plane of light polarisation three times more than the rotating power of quartz. Also, the periodic structure of the cholesterics implies selective reflection of light. In this way a cholesteric illuminated by white light appears to be coloured, the colour depending on the angle of observation and the dimensions of the helix. The dimensions of the helix can be easily modified according to the ambient physical conditions (pressure, temperature, electric and magnetic fields), which gives cholesterics a large number of uses as transducers.

Smectic liquid crystals possess the most orderly structure, being closer to the solid state. The molecules are stratified in layers of 20–30 A thickness, and inside the layers the molecules have a preferred direction (fig. 3.3c).

According to whether the molecules are symmetrical or not, by heating these substances the following succession of states occurs:

The Physics of Electrography 51

The structure of nematic crystals

The structure of cholesteric crystals

The structure of smectic crystals

Fig. 3.3. The structure of liquid crystals.

solid-smectic nematic-isotropic liquid for the symmetrical molecules, and solid-smectic cholesteric-isotropic liquid for asymmetrical molecules.

True liquid crystals do not have perfect structural arrangements as described above, but have, like real crystalline solids, defects when subjected to external forces. These faults become mobile and can interact amongst each other or can change amongst each other.

By applying an external electric field reorientation effects in liquid crystals can be produced. Liquid crystal molecules have dipole movements which orientate themselves in line parallel with the applied electric field. According to whether the molecular dipoles arrange themselves in a line parallel, or perpendicular to the axes of the molecules, they show positive or negative dielectric anisotropy. If a potential difference of less than 5 volts is applied across nematic crystals molecules line up in the direction of the field, the crystals remaining homogeneous and transparent. At tension values greater than 5 volts faults appear, causing the de-homogenisation of the nematic crystals. Macroscopically the liquid crystals are no longer transparent, and diffuse light in all directions. This phenomenon, discovered in 1968 by G. Heilmer, is called 'dynamic dispersion', and appears both in direct current and alternating current. Dynamic dispersion, which obscures mezzo-phasic substances according to the applied electrical field, is used when building tele-display units and screens with variable transparency.

Chapter 4

Electric Discharges in Gaseous Media

4.1 The avalanche theory

The avalanche theory attempts to explain the discharge processes in gases by successive ionisations produced by electrons accelerated in the electric field. Although it is oversimplified, the theory makes it possible to gain some knowledge regarding the mechanism for the production of discharges at relatively low pressures.

Let us assume that a continuous tension, $U = E \cdot d$ is applied (fig. 4.1) between two electrodes, cathode K and anode A situated at distance d. Initially, the cathode has a number n_0 of free electrons. Due to the acceleration taking place in the electric field, each of the n_0 electrons will lead to ionisations. The electrons resulting from the ionisation processes and the initial electrons are accelerated again in the field. New ionisations take place, the process developing into an avalanche, so that there will be n charge bearers against the reference plane P, situated at distance x from the cathode, and there will be $n + dn$ charge bearers against plane P, situated at the $x + dx$ distance from the cathode. The growth in the number of charge bearers, in the

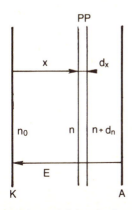

Fig. 4.1. Diagram used for explaining the formation of avalanches.

interval between the reference planes P and P', is due to ionisations produced by the n charge bearers in the dx distance (fig. 4.1).

If we take into account only ionisations produced by the electrons accelerated in the field, we have:

$$dn = n\alpha\, dx, \qquad (4.1)$$

where x is the ionisation coefficient.*

By integrating the relationship between the limits $n_0 - n$, respectively $0 - x$, we obtain:

$$\int_{n_0}^{n} \frac{dn}{n} = \int_{0}^{x} \alpha\, dx \quad or \quad n = n_0 e^{\alpha x} \qquad (4.2)$$

The relation (4.2) is valid only if one does not take into consideration the phenomenon of attachment of electrons to neutral particles.

If one uses n as denoting the coefficient of attachment of electrons to neutral particles, the number of active electrons is obtained by the relation:

$$n = n_0 e^{(\alpha - \eta)x} \qquad (4.3)$$

In order to create an avalanche it is necessary to fulfil, in the respective zone, the condition $\alpha > n$ (the two coefficients depending on the field, the avalanche developing only if the field exceeds a certain value (Emin)). (For air in normal conditions Emin = 30 kV/cm.)

It is found from the relationship 4.2 that if a number n_0 of electrons departs from the cathode, $n_0 e^{\alpha d}$ charge-bearers will reach the anode and because of the avalanche, space charges appear in the space between the electrodes: high mobility electrons at the head of the avalanche and reduced mobility positive ions, which remain practically immobile, in the space between the electrodes. Therefore, a deformation of the initial electrical field E_0 appears (in the absence of space charges); the field is strengthened in the zone at the head of the avalanche, then reduced in the following zone, and we find again a strengthening of the field behind the avalanche (fig. 4.2).

* The coefficient of ionisation of neutral molecules by electrons is defined as being the number of ionisations produced by an electron by its movement through a unit length in the direction of the field.

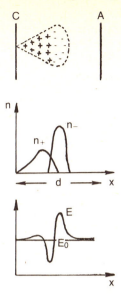

Fig. 4.2. Changes caused by space charges in the initial electric field between the electrodes.

4.2 The autonomy condition of the discharge

In order to develop an avalanche between two electrodes, at least one free electron should exist. In the space between electrodes, as a result of the development of the avalanche, electric charges appear which are carried to the electrode with opposite charge and are neutralised. Thus, the discharge ceases.

In order to establish the autonomy condition of the discharge, the development of the phenomenon has to be analysed step by step.

If, at the cathode there are n_0 free electrons, at the anode end, as a result of ionisation, $n_0 e^{\alpha d}$ electrons will arrive where α is the ionisation coefficient and d the distance between electrodes. Thus, in this first stage, in the space between the electrodes, there will be a number $-n_0 + n_0 e^{\alpha d} = n_0(e^{\alpha d} - 1)$ of electrons and positive ions respectively, and therefore newly formed charges.

Positive ions formed in the space between the electrodes move towards the cathode and lead, by its bombardment, to the formation of $\gamma n_0(e^{\alpha d} - 1)$ electrons, γ being the superficial ionisation co-

efficient.* Thus, conditions for the further development of the discharge process are created.

A number of electrons reach the anode. This number is given by the relation:

$$n_A = \frac{n_0 e^{\alpha d}}{1 - \gamma(e^{\alpha d} - 1)}. \tag{4.4}$$

The expression is valid only if

$$1 - \gamma(e^{\alpha d} - 1) > 0. \tag{4.5}$$

Thus, the autonomy condition of the discharge:

$$\gamma(e^{\alpha d} - 1) \geq 1. \tag{4.6}$$

The expression 4.6 has clear physical significance because $(e^{\alpha d} - 1)$ represents the number of positive ions formed in the interval d, due to the departure from the cathode of a single electron, and $\gamma(e^{\alpha d} - 1)$, the number of electrons freed by these ions at the cathode. The equality $\gamma(e^{\alpha d} - 1) = 1$ means that the positive ions which were formed as a result of one electron having left the cathode, also freed an electron from the cathode.

The autonomy condition expresses thus the need for every electron which leaves the cathode, during discharge, to lead to the appearance at the cathode of at least one electron.

In these conditions the discharge will be maintained at a constant intensity in the absence of an external ioniser.

The avalanche theory formulated by Townsend, is the first quantitative theory of discharges in gases, making it possible to explain the passing process, depending on the presence of an external ioniser to the independent process, and the establishment of the autonomy conditions of the discharge.

Examples of independent discharges are: the luminescent discharge, the corona phenomenon, the arc, the electric spark.

In the case of a uniform field the autonomous or independent discharge means penetration of the gas between the electrodes.

The tension at which the production of an independent discharge takes place, and which leads to the penetration of the gas, is called the discharge tension.

* γ is defined as being the number of electrons freed by the cathode, by its bombardment with a positive ion.

An important conclusion of Townsend's theory is that the discharge tension is a function of product $p \cdot d$:

$$U_d = f(pd), \tag{4.7}$$

in which p represents the gas pressure, and d the distance between electrodes. The previous relation was established empirically in the first place, based on data from experimental work by Paschen, and later on confirmed by Townsend's theory. However, the avalanche theory has a series of deficiencies when applied to discharge processes, amongst which are:

(a) The speed of development of the discharge, calculated on the basis of Townsend's theory, is much shorter than that found experimentally.
(b) Experience has shown the importance of the phenomena of volume photo-ionisation, ignored by Townsend's theory.
(c) The irregular and branched shapes of the discharges is difficult to reconcile with Townsend's theory.

Thus, it became necessary to formulate a theory which would correspond more closely to the experimental findings.

4.3 Theory of streamers

Streamer theory succeeds in explaining the mechanism for the production of a discharge. It was put forward in 1940 by Meek and Raether, independently of each other, and later elaborated on by Loeb, Meek and Raether.

According to this theory the multiplication of ions in the space between the electrodes is due to the volume ionisation of the gas through electronic collisions, and photo-ionisations, and within the theory of streamers the effect of the space charge is also taken into consideration.

As we have already shown (fig. 4.2) the appearance of an avalanche in the space between the electrodes leads to a big deformation of the electric field, an intense field appearing in the zone at the head of the avalanche. In this zone of field intensification the ionisation intensity grows, leading to a rapid increase in the number of charge bearers in the avalanche (the ionisation coefficient depends on the intensity of the electric field). In the zone with a weak field, behind the avalanche, the conditions appear for the formation

of an electro-ionic plasma which is a good conductor of electricity. In practice electrons reaching the reduced intensity zone of the electric field reduce their speed and attach themselves to neutral particles, therefore forming practically immobile negative ions which, together with the existing positive ions in the avalanche, lead to the appearance of a plasma channel.

Fig. 4.3. The formation of negative streamers.

Due to the high energy of the electrons accelerated in the intense field at the head of the avalanche, excitations are possible in the deep layers of the atom, causing high energy photon emission at return. The photons propagate in all directions, and through space photo-ionisations will lead to the formation of new electrons, called photo-electrons. These will lead to the appearance of a new avalanche in the space between the electrodes (fig. 4.3).

Let us follow the phenomena which take place on the preferential path (maximum field path).

As a result of the deformation of the electric field by the avalanches (I and II) (fig. 4.3a), the electrons formed at the head of the first avalanche (I) reduce their speed and attach themselves to neutral particles creating negative ions. The positive ions at the tail of the second avalanche (II), whilst moving towards the cathode, create, together with the negative ions, a plasma channel (streamer). After the second avalanche (II) develops at a $d_2(d_2 - d_1)$ distance at the head of the avalanche – due to the deformation of the field by its own charges, and by the plasma channel – the energetic conditions appear, i.e. a powerful intensification of ionisation which allows the emission of photons capable of space ionisation. These photons will lead to the appearance, in space, of at least one photoelectron, which will enable the development of a third avalanche (III) (fig. 4.3b). Just as in the preceding phase, the channel behind this avalanche begins to fill with positive and negative ions. Thus the plasma channel develops from the cathode towards the anode (negative streamer).

If the speed of variation of tension is reduced, the discharge becomes a positive streamer.

The initial avalanche develops until the opposite electrode where the electrons are neutralised (at the head of the avalanche).

The existence of positive charges in the space between the electrodes leads to the deformation of the field in the sense that near the anode, a strong reduction of the field occurs, and in the remaining space the field intensifies. In the zone where the intensification of the field is greatest energetic conditions appear allowing emission of photons capable of space ionisation. These photons will determine the appearance of photoelectrons, which will start avalanches off. On their way towards the anode, on reaching the reduced field zone, the electrons at the head of these avalanches attach themselves to neutral particles and become negative ions. Thus, a plasma channel begins to take shape near the anode.

The existence of the plasma channel leads to the intensification of the field, and thus to the creation of the energetic conditions necessary for the production of new photons capable of ionisation. These photons will lead to the production of new photoelectrons which, in their turn, will start the development of new avalanches. As in the previous stage, in their movement towards the weak field zone of the plasma channel, the electrons at the head of the avalanche

become negative ions. The plasma channel advances towards the cathode. Due to the direction of development, the plasma channel thus formed is called a positive streamer.

4.4 Breaking through the electroinsulating interval between the electrodes when applying tension

If a tension impulse is applied between two electrodes (fig. 4.4) at the moment t_1, corresponding to tension U_d, the autonomy condition of the discharge is fulfilled. Although the autonomy condition is fulfilled at this moment, t_1, the discharge may not start because it is necessary for an effective electron to exist in space – in other words, an electron

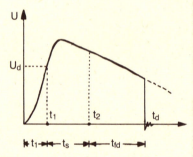

Fig. 4.4. High tension impulse – duration of transmission.

able to ionise and which would lead to the development of an avalanche.

The appearance of this first electron able to ionise is a chance phenomenon, so that the moment t_2 when the discharge process starts effectively has a value which can be calculated on the basis of statistical probability. The time interval $t_{si} = t_2 - t$, is defined as being the statistical duration of time lapse, because it represents the time interval between the moment when, between the electrodes, the autonomy condition of the discharge is fulfilled, and the moment when the first effective electron (able to ionise) appears. Starting from moment t_2, the process which leads to the discharge between electrodes develops, a phenomenon which will take place at moment t_d.

Electric Discharges in Gaseous Media 61

The time interval $t_{fd} = t_d - t_2$ is defined as being the time for the production of the discharge, and has three components:

$$t_{fd} = t_a + t_s + t_{dp} \qquad (4.8)$$

- Time t_a (the time of the avalanche) represents the duration of the development of the avalanche (corresponds to the distance d_1 in fig. 4.3a).
- Time t_s (the time of the streamer), corresponds to the time for the streamer to reach the opposite electrode (the time in which the plasma channel between the two electrodes is formed).
- Time t_{dp} (the time of the main discharge), corresponds to the duration of development of the main discharge in the plasma channel.

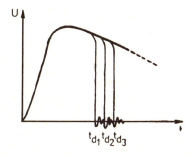

Fig. 4.5. The statistical character of the discharge.

Due to the high speed of propagation of the main discharge, t_{dp} is negligible in relation to the other terms.

The time for the production of the discharge, t_{dp}, is like the statistical duration of time lapse, a statistical quantity due to the following reasons:

- The development of the streamer is determined by the appearance, in space, of a large number of avalanches. The appearance of each avalanche requires the existence of an effective electron (able to ionise), and this phenomenon is a chance happening. Nevertheless, this time is much shorter than the statistical duration of time lapse, bearing in mind the fact that the secondary avalanches appear in conditions in which there took place, in the intervening space, ionising phenomena, and therefore the electric field shows

appreciable deformations and, because of return to the initial state, an intense emission of light quanta takes place.
- The place of appearance in space of the photoelectrons which create the secondary avalanches is a chance occurrence.

Due to the statistical character of the time component t_d, it follows that by applying to an insulating interval, tension impulses of the same amplitude and shape, the time of discharge will differ at every trial (fig. 4.5).

4.5 Corona discharge

The corona discharge is an autonomous incomplete discharge, characteristic of non-uniform fields. The discharge starts at the electrode with the greatest curvature, the moment where, at this electrode, the autonomy condition of the discharge is fulfilled. Due to the rapid reduction in intensity of the electric field, the streamer which develops from this electrode does not reach the opposite electrode and thus the discharge is limited to a small zone around the electrode with the greatest curvature.

In normal atmospheric conditions, the critical value of the field (value corresponding to the corona discharge) is of the order of 30 kV/cm.

In the case of a conductor of negative polarity, the avalanche develops from the conductor toward the exterior and stops at a certain distance, precisely defined, where the field has not sufficient value to ensure the multiplying effect (26 kV/cm).

In the case of a conductor of positive polarity, the avalanche starts in the surrounding space and develops towards the conductor. The electrons are captured by the conductor, leaving behind them a much less mobile cloud of positive ions; the phenomenon takes place as if the conductor were extended with a positive tip, which makes possible the formation of a new avalanche a little advanced in space compared to the previous one.

In order to establish the critical field (the appearance field of the corona discharge) in the case of a cylindrical conductor, the Peek formula is generally used.

$$E_c = 31 \cdot \delta \cdot \left[1 + \frac{0.308}{\sqrt{\delta r}} \right], \qquad (4.9)$$

where E_c (kV/cm) is the maximum value of the critical field (in AC);

r (cm) – the radius of the conductor; $\delta = 3.92p/(273 + t)$ the relative density of the air; p – pressure; t – temperature; ($\delta = 1$, $p = 76$ cm Hg and $t = 25°$C).

The state of the surface of the conductor is of great importance; the preceding relationship cannot be verified except where the surfaces are perfectly smooth.

When applying an increasing alternating tension, the following successive stages of corona discharge appear:

(*a*) the corona discharge localised in isolated points of the electrode where the critical value of the electric field, for relatively small tensions, is exceeded;
(*b*) the corona discharge generalise over the whole surface of the electrode under tension due to exceeding the critical value for the configuration (shape) which is being analysed;
(*c*) the corresponding pre-discharge of the applied tension close to the discharge tension between the electrodes.

The phenomena specific to the corona discharge appear frequently when electrographic methods by electroluminescence are used. Thus, in the Kirlian technique, the images obtained are determined by corona-type discharges which have a morphology and chromatic characteristic which can be correlated with the electrical and non-electrical properties of the structure under investigation.

Chapter 5

Kirlian Photography

Photography using high frequency currents, commonly called Kirlian photography, is one electrographic method used in the exploration of biological systems. It is based, in essence, on electroluminescent phenomena produced by electrical discharges in gases. The Kirlian photographic method differs from the electronographic method in the parameters of the exploratory current used, and of the mechanisms which produce the image of the object under investigation.

Kirlian photography is carried out with a mounting made up of a high tension, high frequency source, an exposure device and equipment for visualising and recording the image.

Wave trains with frequencies of the order of hundreds of kHz up to MHz, and with an amplitude from 20 to 100 kV are characteristic of impulses used in Kirlian photography.

Depending on the nature of the structure under investigation and on the aim in view, the object is placed in one of the following ways:

1. A metallic electrode with dielectric protection, connected to the power source, the object being grounded.
2. The object is placed in a dielectric space (air) between electrodes connected to the power source.

The various methods of taking an exposure are variants on these two modalities. Exposure devices using transparent electrodes are also often used.

An important factor in the Kirlian technique is the correlation between the dielectric space in the exposure device and the amplitude of the waves generated by the high tension, high frequency source. The critical distance between the electrode plates and the object under investigation has a minimum tolerance of $5-10\mu$.

The images obtained through this method are recorded on black-and-white or colour film. Also, the method of visualising and recording the image can be improved by using various electro-optical devices.

The possible dangers when using this method limits its use for the study of the body. Because of this, the vast majority of pictures obtained using the Kirlian method are pictures of fingers, palms or soles of the feet, but not of parts of the body which could be damaged by the exploratory technique used such as the heart, brain, abdomen, etc.

The efficiency of the Kirlian method depends also on the humidity and atmospheric pressure, as well as on temperature. Also Kirlian photographs are affected by the chemical composition and the ionic concentrations of the air in the room in which the recordings are made.

A hypothesis explaining the images obtained using the Kirlian method has been proposed by V. M. Inushin and involves the concept of bioplasma. According to Inushin, a flux of sub-atomic particles (which constitutes the bioplasma) enter and leave living tissue, producing the image made on the photographic emulsion in the Kirlian technique.

In the last few years a series of research projects has begun to investigate the possibilities offered by the Kirlian technique for biological and medical investigation.

Just like other electrographic techniques by high-frequency photography, the electrical and non-electrical properties of living structures can be explored and their relationship to the functional state of the organism can be investigated.

By using high frequency photography changes in the physiological state of plants can be observed. These changes appear on the images as differences in luminosity and extension of discharges.

An interesting effect discovered by Soviet researchers is the so-called phantom leaf effect (fig. 5.1). If a relatively small portion of a leaf is cut and put to one side, the whole leaf appears on the subsequent Kirlian photograph. In order to explain this effect various scientific arguments have been proposed, as well as explanations without any scientific backing. The 'phantom leaf' effect can be explained using strictly biophysical considerations.

If a small portion of a fresh leaf is put to one side, the stomata will close, so as to reduce water loss. By placing the leaf onto the Kirlian camera and pressing it onto one of the electrodes a number of microscopic water droplets will be squeezed out over a distance of a few millimetres. These microscopic water droplets become, when applying a voltage, centres for causing discharges on the photo-

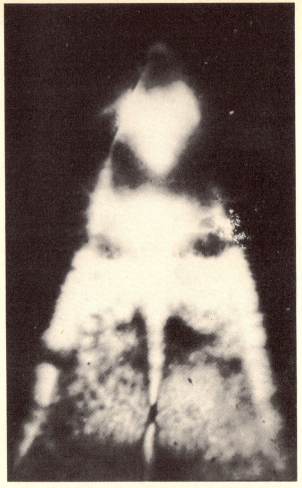

Fig. 5.1. The image of a leaf with the 'phantom effect' taken by Kirlian technique (by courtesy of Thelma Moss).

graphic plate, therefore the cut portion of the leaf also appears in the image.

The most exhaustive research work regarding the applications of the Kirlian technique have been in the field of medicine. As we mentioned above, the phenomena of electroluminescence in gases is the principal mechanism for the production of the image in Kirlian

photography. Electrical non-homogeneities on the surface, or in the vicinity of the object exposed in the field generated by the power source, are transposed into images by luminescent discharges in ionised gases, due to the very high applied potential.

Due to repeated trains of impulses, a summation effect appears and the marginal discharges are halved, and the details of the image are poorly differentiated. The electronographic method has shown clearly that the corona obtained by the Kirlian method is a chance summation of a large number of fundamental images, generating the pellicular effect, each of which is different depending on the polarity of the applied field. Therefore, due to numerous impulses, the clear image definition obtained when using the electronographic method becomes blurred and non-homogeneous when using the Kirlian technique, and, at the same time, many of the details from the inside of the organism merge into each other and are consequently obliterated (fig. 5.2).

Characteristic discharge channels are produced by mechanisms which bring about streamers. The field applied by the source produces an acceleration of the electrons from the dielectric space filled by air. When the tension is applied, and the space interval corresponds, 'bunches' of positive ions created by the avalanche of electrons acquire a critical charge density in which its electrostatic field is great enough to attract a sufficient number of electrons. The re-combinations of positive ions and electrons generate the emission of electromagnetic radiation which produces an image on the photo-sensitive emulsion. For air which behaves as a discharge gas, visible light comes from the re-combination of the nitrogen ions with electrons, generating photons in the blue-violet band.

The discharge channels are initiated especially by the protuberant shapes of the electrodes (of which one can be the object exposed for investigation), due to the intensification of the electric field at any point as opposed to flat areas of the object under study (figs. 5.3 and 5.4).

According to S. D. Kirlian, Valentina Kh. Kirlian and V. Adamenko the auto-ionic and autoelectronic emission can effect photographic emulsion in a manner analogous to electromagnetic radiation.

The geometry, colour and dynamics of the image depend on the object. If an inanimate object shows dielectric and conductive non-homogeneities, then the density and distribution of the discharge

68 *Electrographic Methods in Medicine and Biology*

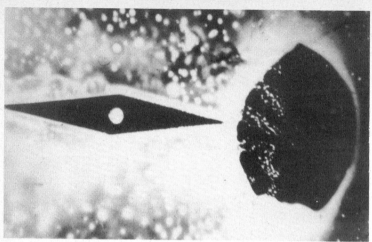

Fig. 5.2. Reciprocal interaction in streamer formation between a magnetic compass needle and a leaf (by courtesy of Thelma Moss).

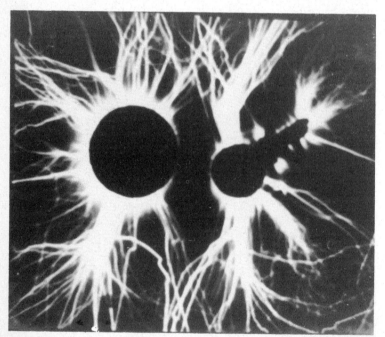

Fig. 5.3. Reciprocal interaction in streamer formation between two metallic objects subject to a very high tension field (80 kV) (original).

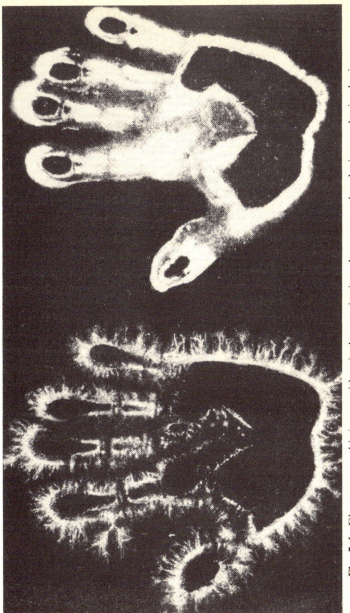

Fig. 5.4. Electronographic image with a single negative impulse compared to the image obtained using the same impulse repeated 30 times as in a Kirlian technique (original).

channels are influenced by these structural non-homogeneities. If the object has a homogeneous structure, and isotropic homogeneous electrical properties, then on the film, only the outline of the shape will appear (figs. 5.3 and 5.4).

The electrical structure of a living organism is not constant in time but dynamic, depending on the vital processes which ensure survival. These vital processes translate into successive images, all of them different, of the same structure explored by the Kirlian technique.

The high and very high frequency currents used in the Kirlian technique tend to travel over the outer surface of the biological volume conductor (skin effect). In general, high frequency currents have small physiological effects, except when the power dissipated in the tissues becomes sufficiently great in order to produce excessive heating, or when the secondary effects of luminescence cause dehydration.

When using Kirlian photography for medical purposes the fleshy part of the thumb is usually used because of its convenience, and in order to prevent accidents due to the high tension power source. The anatomical structure of the skin in which the epidermis has the role of electrical protection is of major importance in Kirlian photography.

The physiology of the sweat glands is influenced by the following factors:

– thermal sweating over the whole surface of the body;
– sweating due to emotional states, produced especially on the palms, soles and axillae;
– apocrine perspiration, in axillae and the pubic region.

The images obtained using the Kirlian method have been correlated with the psycho-physiological and pathological states of subjects under investigation. The changes observed in various functional states of the subject can be ascribed to the dermal activity which reflects the internal vital processes of the organism.

In states of relaxation the sweat glands secrete very little (Kuno), and this results in the Kirlian photograph showing a partial corona. During emotional stress, sweating is increased, with consequent reduction of the discharge and the image shows a reduced corona due to streamer amortisation in the water vapour present.

On the other hand, in relaxation, the sodium chloride content of the sweat gland secretion increases, and as a result more ions have the chance to recombine with electrons, therefore more photons are

generated and the luminosity of the corona grows.

Stress, fear, anger, or visceral pain can cause partial hypohydrosis, thereby reducing the luminosity of the corona. Factors which cause hyperhydrosis such as anxiety, pain, etc., produce an intensification of the luminosity of the corona.*

Another factor affecting Kirlian photography, brought to light by W. Konikiewicz, is skin pH, and this plays an important part in the conduction of electronic flux towards the areas of sweating. Photographs taken using Kirlian techniques on fingers brushed with different pH solutions show a diminution of the corona as the pH value increases (fig. 5.5). Human tissue removed surgically shows an intensely luminous corona, whilst tissue removed from cadavers produces a reduced corona. This diminution in the corona is due to the increase in pH due to chemical decomposition.

The colours of the Kirlian image can also show physiological activity of the sweat glands. A high sodium content of sweat gland secretion produces a yellow-orange colour, characteristic of the spectral lines in visible light of sodium and its compounds. A reduction in the concentration of potassium in perspiration produces an orange-red colour.

L. W. Konikiewicz studied the relationship between Kirlian electrography and the menstrual cycle, and found that it is possible to correlate the corona image of the fingers, and the menstrual phases. The same author has carried out investigations using Kirlian photography on fingers of patients suffering from fibrocystic disease. The images thus obtained show coronas with abnormal morphologies, according to the salinity of sweat gland secretions and the age of the patient. These specific changes seem to be determined by the sweating abnormalities found in fibrocystic disease.

Various researchers have tried to use the Kirlian technique in order to find acupuncture points. With the help of this method certain points and channels have been found which the authors consider to correspond to the acupuncture points and meridians. On direct viewing these appear as points which flicker and go out periodically, and can be fixed or mobile with colours ranging from yellow to dark blue. Electronographic research shows that they are not necessarily

* These explanations given by various authors are only partially true because the physiological explanation of electrodermal activity involves many other factors. (See 'Man and the Electric Environment', by I. Fl. Dumitrescu.)

72 *Electrographic Methods in Medicine and Biology*

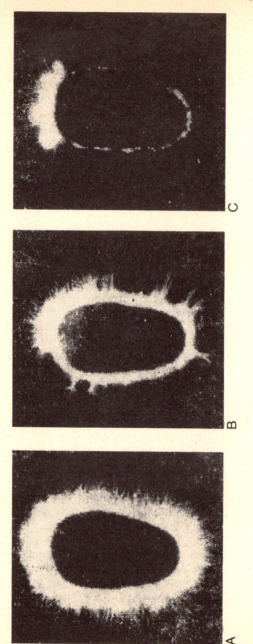

Fig. 5.5. Kirlian photographs showing the effects of pH: A – pH = 6; B – pH = 7.5; C – pH = 8.

characteristic of acupuncture points, the dots appearing according to the electrical conductivity of the tissue. Up to now no convincing Kirlian photographs have been published showing electrodermic points, these phenomena having only been described by authors on direct viewing.

The disadvantages of photography using high frequency current consist of the mixture and super-imposition of many separate images, the number depending on the number of waves used. This explains why, when using such a high frequency current, the electrodermic points tend to fade and disappear as the number of waves used is increased. This explains also the much vaunted appearance of so-called 'auras' which constitute an artefact generated by the technique.

In the context of studies concerning the clinical application of Kirlian photography, investigations were carried out in the field of oncology. S. Mallikarjun has shown that Kirlian electrographs obtained from fingers of healthy subjects show cyclic changes, whilst in cancer patients an intense luminosity is found with no cyclic change.

R. S. Stepanov has shown that there are significant differences between high frequency images obtained from cancerous cells, and images obtained by the same technique from normal cells. The authors claim that by using the Kirlian method the spread of metastases can be followed as well as the growth of the primary tumour. V. M. Inushin used Kirlian photography following laser stimulation of acupuncture points in patients with asthma and hypertension. He was able to analyse the reactivity of these patients using this method.

Soviet researchers have also investigated the possibilities of applying Kirlian techniques in agriculture. Thus, by using a device fitted with a high-frequency Tesla coil, it has been possible to reduce by 30/40 times the analysis time required for optimum gamma irradiation of seeds for culture.

PART II

ELECTRONOGRAPHY

Chapter 6

Electronography. General Principles

6.1 Definition

Electronography is a method of electrographic exploration, with the help of the phenomenon of electro-luminescence in which the image is controlled via a complex system which follows the electron emission, the propagation of the electromagnetic field, and the differential conversion of its distribution into luminous energy. The exposure is made in a transitory electromagnetic field achieved by a single high tension impulse.

The first electronographic images were obtained in 1975 (I. Fl. Dumitrescu, C. and N. Golovanov), with the help of very high tension equipment within the laboratory of the Polytechnic Institute in Bucharest.

A single polarity impulse was applied to the biological preparation, covered with two layers of photographic film, insulated in their turn by two glass plates from metallic electrodes. Therefore, the arrangement was one of a condenser with the object under investigation being placed between the dielectric plates. By using this simple technique we succeeded in obtaining the first useful images, from an electrical point of view, of biological structures. It has thus been demonstrated that electrography by electroluminescence is possible not only using impulses at radio frequencies, as in the case of Kirlian photography, but also by a single high tension impulse with an ascending and descending slope sufficiently abrupt to give the surface electrons a critical acceleration to produce ionisation. We have also obtained images of better quality than Kirlian-type photographs, even with a single 'function-step' impulse (fig. 6.1).

Subsequent research has indicated the possibility of controlling the image by modifying the parameters of the high tension impulse, which has led to a method for the control of the emission of electrons. This is the first characteristic of the electronographic method.

Also in 1975, the first electronography apparatuses using single

78 *Electrographic Methods in Medicine and Biology*

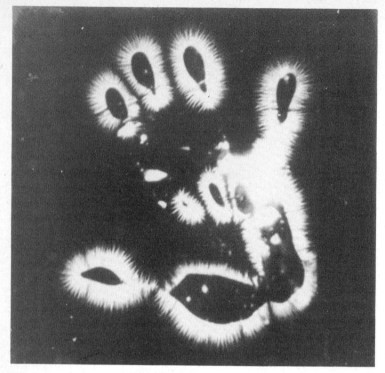

Fig. 6.1. Electronographic image with a regular positive streamer by unipolar impulse-step (original).

impulses were produced (Dumitrescu, in co-operation with Eng. C. Cojocaru).

Simple solutions for obtaining a single high tension impulse were used when constructing this apparatus, and this has made it possible to use the method in many different fields.

An intermediary fluorescent foil was added to the recording device which was a 'complete condenser' type, and this was attached to the dielectric layer (fig. 6.2). The luminophore layer used for this purpose had different sensitivities according to the energy of the incident particles.

In parallel with electronographic research carried out on biological macrostructures, we started a series of research programmes in order to obtain electroluminescent images at cellular level. The first microelectronographs were obtained in July, 1975, with the help of

ordinary photographic film. Subsequently, we have used nuclear autographic emulsion as a light sensor, a method which gave better results. The images obtained with the help of the electronographic method were shown for the first time at the International Congress of the World Academic Society of Acupuncture in Montreal, and at a Conference held at the International Cancer Research Institute, New York, in November, 1975.

In order to be able to explore the body electronographically we have put together a recording device of the incomplete condenser

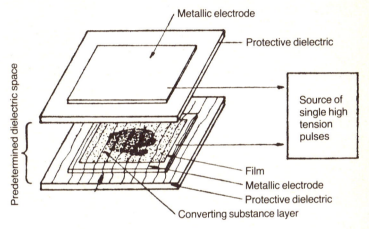

Fig. 6.2. Diagram of an electronographic device of the complete condenser type (original).

type, as well as a series of devices attempting to reduce the risk of exposure to high tension currents. These methods have made it possible to undertake a complete electronographic investigation of the body.

A series of new methods of investigation by electroluminescence were added to the original electronographic techniques. These were new electrographic processes such as electrography by blocking the secondary light emission, convertography, electrography by weight-motor effect, thermo-electrography, electrography with liquid crystals, electrography with a multi-sensor system, etc. All these are original possibilities, useful in the investigation of living organisms, and especially, of the human subject. Electronography is a technique which has been subject to exhaustive experimental investigation and

it has a methodology of its own, with effects of particular functional and clinical interest.

6.2 General Characteristics

Electronography reproduces the electrical characteristics of biological systems and is based on three fundamental principles:

1. The quantification of the electron emission by applying a high electric tension in the form of a single impulse with known parameters.
2. The control of the electromagnetic field created by the high tension impulse in the space between the electrodes, a control obtained by determining the dielectric composition and its modification for the purpose aimed at, either by accelerating or braking the electrons through various homogeneous media, or by interactions with other fields (magnetic, electric or electromagnetic).
3. The differential conversion of the energy of the electrons and of secondary particles, determined by their collision with the structures interposed in the device for recording in a visible form with the help of phosphors or liquid crystals.

The electronographic apparatus can be considered as a linear and uni-directional particle accelerator. The accelerator space can be either virtual and includes the light sensor, or real with a free vacuum space or dielectric plate. In principle, the living organism under investigation is placed on a table over the high tension power source, or it is introduced between two electrodes and polarised in the electromagnetic field thus created.

The basic layout of the recording device can be modelled on the circuit shown in Fig. 6.3.

The light sensor is made up of a black-and-white or colour film, or an electrono-optical device such as a video camera or a photo-multiplier.

The high tension impulse generates an orderly movement of electrons in a condenser, on both sides, at the armatures.

The electronic flux generated on one of the armatures is transmitted by a movement of electrons onto the opposite armature. If one of the armatures is the skin of a human subject, this has a non-uniform electrical energy distribution, due to the processes for

the attenuation of the electromagnetic field on the surface or inside the living organism, this distribution is then transferred onto the other armature (metal) of the condenser, on the surface of which is placed the photographic film or phosphor covering. The movement of electrons and secondary micro particles pulled between the two armatures will cause the appearance of different zones of luminosity

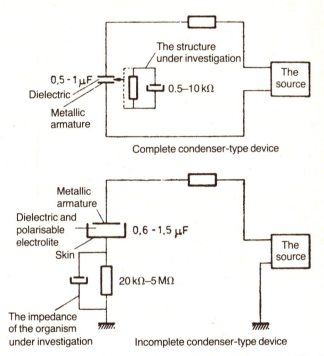

Fig. 6.3. The layout of: (*a*) a complete condenser device (original); (*b*) an incomplete condenser device (original).

in the recording material (i.e. films or phosphorescent layer), according to the energy of the particle which traverses it. In this way, an image is obtained which reproduces the non-uniform distribution of the potential over the surface of the skin; this non-uniformity resulting both from the distribution of the electromagnetic field through the living organism, and from the interactions with the biological electromagnetic fields of the different organs and tissues which are in series in the exploratory circuit. At the same time, the

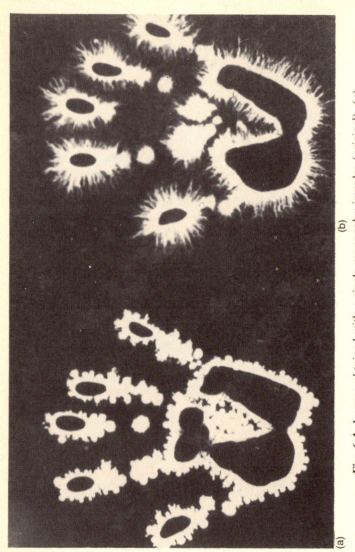

Fig. 6.4. Images obtained with a single monopolar impulse (original). (*a*) negative; (*b*) positive.

electrons will 'slide' on the external cover of the organism, generating the so-called pellicular effect. These surface electrons, by their primary and secondary collisions, with molecules and gas atoms will generate heavy positive ions which move across the electromagnetic field like luminous tracers. This is how the pellicular effect appears which is a fundamental feature of the Kirlian aura.

When the body is introduced into the electromagnetic field between two metallic armatures, it is polarised differently by each of the two armatures, creating electronic emissions which will act differently, due to polarity, and which will be recorded on the two photographic films placed in the dielectric space which separates the organism from each of the two electrodes (fig. 6a and 6b).

This device acts like a double electronographic device, the image being complementary for the two exposed surfaces. This complete condenser-type device was used on an experimental basis by us. When exploring the body the incomplete condenser device offers advantages as compared to the complete condenser device, because it makes it possible to place the body on the armature connected to the high tension source, and allows protection of vital organs from the effects of high-tension impulses. As far as the complete condenser conditions are concerned, beside the effect obtained by the exploration of the interposed organism, according to the values of the applied tension, the electrical permittivity and the thickness of the dielectric, channels of ionisation of the interposed gas molecules appear.

6.3 Control of the electron emission

Electron emission is obtained through a single impulse applied to the recording device, generated by a high tension source with amplitude values from between 1 kV to 60 kV. The growth slope, the descending slope, the duration, and polarity of the impulse are all controlled.

All these parameters affect the electronographic image. The image is formed by a single high tension impulse, which requires the use of a slope (front) with sufficiently rapid growth able to create the phenomenon of electroluminescence, and of a slow descending slope which must not produce the same phenomenon.

According to their characteristics impulses used in electronography are of many kinds:

1. The unipolar impulse, 'function-step' represents a gradient for the rapid transition from a level of initial potential to a background potential. This type of impulse with an extremely rapid variation, generates images with clearly defined marginal discharges (fig. 6.5a).
2. The triangular, unipolar, impulse, with an abrupt ascending slope, and slow return, is the impulse most used, which gives the electrons a fairly fast acceleration on the ascending slope, in order to obtain the phenomenon of luminescence, with a slow return which does not modify the initial luminescent effect (fig. 6.5b).

Fig. 6.5. Types of impulses used in electronography: (*a*) impulse step; (*b*) triangular impulse with ascending active slope; (*c*) triangular impulse with descending active slope; (*d*) biphasic impulse; (*e*) trains of impulses.

3. The triangular unipolar impulse, with a slow ascending (in amplitude) slope and abrupt return, is created at the power source with sparking at a level determined by the tension, the fall of tension being in this case extremely rapid and this alone producing the image (fig. 6.5c). This sort of impulse makes it possible to control the value of the tension by regulating the sparking conditions.
4. The bipolar symmetrical impulse ('impulse in scissors'), is used in the study of behaviour of the living organism in respect to its relative polarity (fig. 6.5d).
5. Trains of monopolar impulses are used in order to obtain some summation effect, as seen in the Kirlian effect, usually with different frequencies. These trains of impulses are used in the spectral analysis of an electroluminescent emission (fig. 6.5e).

The amplitude of the impulses varies according to the tissue surface being investigated, the depth of any phenomenon being studied and as to the external conditions in which the exploration takes place.

The rates of rise of tension is determined for the electronographic image, and the duration of the slope of rapid rise in tension varies between the limits 0.85 to 1.25 μs. A longer slope of more than 50 μs is required if this slope is not to affect the electronographic image.

6.4 Control of the electromagnetic field

Electronographic images are affected to a great extent by the characteristics of the electromagnetic field in the space between the electrodes. By modifying the dielectric interposed or interacting with the aid of other magnetic, electrostatic or electromagnetic fields, effects can be obtained which modify the electronographic image.

1. The interposition of dielectric layers with different thicknesses and electric permittivities modifies the electronographic image.
2. The interposition of vacuum chambers and the interaction with external fields change both the trajectory and the speed of movement of the electrons, making it possible to process the electronographic image by enlarging it or increasing the contrast.
3. The interposition of stratified light sensors inside the dielectric can obtain different images, of a complementary character. All these possibilities can be used in the analysis of the anatomico-functional significance of the fundamental electronographic image, making it also possible to reproduce the recorded phenomena.

6.5 Electrono-optic Conversion

Beside the effects of electroluminescent ionisation obtained by classical electroluminescence techniques, electronography can create images which are converted into luminous images from the energy of particles mobilised by the structures under investigation. This phenomenon is possible by using electrono-optical devices with different scintillation thresholds, or electrono-optical conversion. The conversion devices are composed mainly of substances which luminesce, or which, on being excited, emit luminous radiation at a certain energy level, specific for each excited state, the quantity of

light emitted being dependent on the energy of the electromagnetic field. Semi-conductor devices or electrets with particular thresholds make it possible to differentiate the energy of the incident electromagnetic field, the luminophore getting excited at particular thresholds of this energy. Liquid crystals can be used in this sense with an opening threshold at different tensions separately or in combination with phosphorescent substances.

Electronography frequently uses screens on whose metallic electrode phosphors are applied with predetermined thresholds having a remanence of the order of fractions of a second and sparking values of the order of kilovolts.

6.6 Analysis of the electronographic image

The electronographic image is composed of three distinct luminous effects. We shall summarise their characteristics which will be later interpreted from the biophysical point of view, and from their functional significance:

(*a*) the pellicular or marginal effect;
(*b*) the electromorphous effect;
(*c*) secondary luminous effects from the proximal electrical medium.

The pellicular or marginal effect represents a radiation zone on the surface of the living organism, with different details, shapes and dimensions. These characteristics differ on repeated exposures, showing their chance nature.

The spectral analysis of the radiation emitted in these peripheral discharges shows different energy values ranging from red to ultraviolet. The pellicular effect is manifest at the level of covering structures, and is determined by the superficial distribution of electrons which are present over the surface of the volume conductor, by the object being studied (fig. 6.6). The polarity of the source determines, to a large extent, the characteristics of the pellicular effect. Thus, electropositive impulses with an abruptly descending slope produce arborisations excentric in character, while impulses of the same type but of negative polarity produce arborisations which converge towards the interior of the image. Impulses with an abruptly ascending slope produce images with inverted polarity.

The pellicular effect appears at tension values above the critical

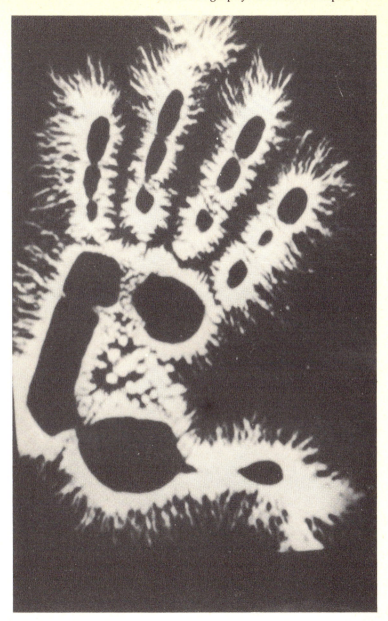

Fig. 6.6. Electronographic image (original) of the hand: with positive impulse showing the pellicular effect.

ionisation tension, and represents the graphic image of the ionisation effect by streamers over the surface of the skin.

The electromorphous effect is generated by differential electrono-optical conversion, given by attenuation of the applied field. This effect is in the interior of the images and shows the volumetric distribution of the electromagnetic field and its interaction with biological electromagnetic fields. Thus, according to these phenomena, it is possible to distinguish inside the images, light and dark zones which represent the electrical anisotropy of the structures under investigation. This electromorphous effect is characteristic of the electronographic image, and it can be reproduced on repeated investigation (fig. 6.7).

Besides looking at living organisms, a series of luminous effects which prove the existence of a structured electrical medium can be demonstrated, using electronography, functionally bound to the organism, and it also establishes a connection between it and the electrical environment. Therefore, the luminous effects generated by a layer of water vapour and gas ions were discovered around the body (fig. 6.8). This electrical environment has been called the 'proximal electric medium'.

Electronography differs from the electroluminescent method with the aid of the radio frequency electric current (Kirlian photography), and if, as in the case of Kirlian photography, one uses a real space for the acceleration of electrons, in the electronographic recording device, the space for acceleration is virtual, there existing no gas zones capable of determining the appearance of ionisation channels between the body under investigation and the light sensor.

Kirlian photography uses repeated and bidirectional acceleration of electrons in the acceleration space. Electronography uses a single acceleration, in a single direction, limiting the effects according to the polarity of the applied impulse. With the aid of the bipolar technique, electronography seeks the superimposition on the same image of the effect from each polarity, noting the behaviour of the biological structure at the same functional moment.

The use of precisely determined values of amplitude, and abrupt variation of the tension, makes it possible to create an effect of electroluminescence which reproduces a fundamental image, and not a summated image due to the superimposition of a successive series of waves. The pellicular effect appears as a chance phenomenon, determined to a large extent by the electrical conductivity of the

Electronography. General Principles 89

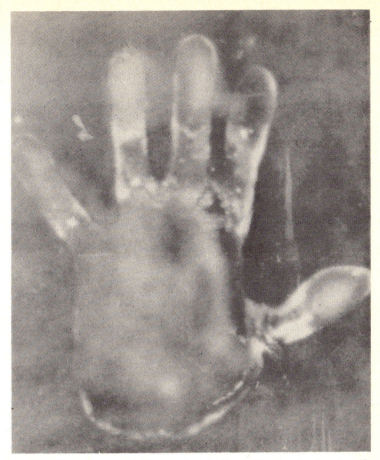

Fig. 6.7. Electronographic image (original) of the hand: showing the electromorphous effect.

structures under investigation, and of the effect of the surrounding medium, which, in an undefined superimposition as in Kirlian photography constitutes the fundamental characteristic of this technique.

In the electronographic image, the pellicular effect is less important, and it is sometimes completely eliminated by the introduction of corrections in the exposure, the electromorphous effect constituting a more important element in the analysis of such images.

Electronography is defined as a method of controlled electroluminescence. The data offered have a finite character, and are

90 *Electrographic Methods in Medicine and Biology*

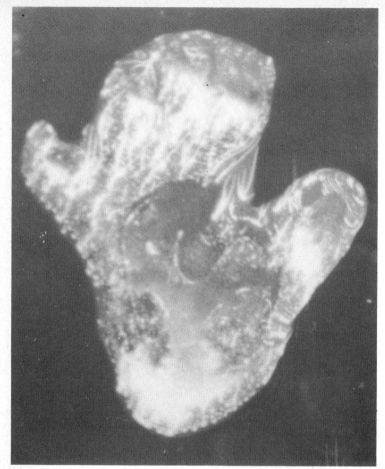

Fig. 6.8. Electronographic image (original) of the adherent aeroions layer.

repeatable according to the functional characteristics of the organism under investigation.

Electronography is a snapshot of bioelectric activity. Each image should be understood as an instantaneous record of continuous biological activity which does not illustrate the morphological structure, but represents a sequence in terms of the electrical activity of the organism.

Electronographic images differ fundamentally from Kirlian images, due to the presence of other defined and distinct elements in electronographic pictures.

Chapter 7

Biophysical Basis of Electronography

In the preceding chapter, we have stated the conditions in which electronography as a form of electrography uses the electroluminescent effect generated by a high tension electric impulse.

There can be described, beside the primary radiation generated by streamers, a luminous secondary radiation produced by the energy of the electromagnetic field propagated through the body under investigation.

7.1 Electromagnetic investigation of the living organism

The body can be regarded as a medium with distinct electrical properties which maintains and reflects biological phenomena occurring in the internal electrical medium.

The internal electrical medium contains the energetic and informational homeostasis of an electrical nature of the biological macro system made up of an immense number of cells and differentiated tissues.

At the limit of separation between the internal electric medium and the external electric medium (i.e. the skin) a series of electrical phenomena occur with an active role in the process of energy and informational exchange between the two media; we have designated these phenomena 'surface bioelectric phenomena'.* In close correlation with these phenomena which take place on the surface of the body, a neighbouring zone situated around the body can be identified in which are found, in a gaseous state, a series of components arising from the body's metabolism such as respiration and sweating, as well as substances present in the environment. All the structures in this zone are labile due to the permanent interaction of the biological electric medium with the external electric medium in the diversified conditions of the environment.

* See 'Man and the Electric Environment' – I. Fl. Dumitrescu.

We have called this transitional medium, in which are reflected the organic and functional characteristics, as well as the activity of factors found in the external electric medium, the 'proximal electric medium'.

In this overall view, the electrical exploration of the body implies the exploration of the biological electric medium, the surface electric activity and the proximal electric medium.

Understanding electronographic images requires, according to the technical conditions of the examination, the definition of three components which reproduce the body from an electrical point of view: the electrical activity of the organism; that of the skin, and the electrical characteristics of the environment, i.e. the proximal electric medium.

7.1.1 *The biological electric medium as an active volume-conductor*

The body represents a non-homogeneous, non-uniform, anisotropic volume-conductor, with variable space geometry, as well as important temporal variations of its parameters, due to the assumed functionality of the different organs and component structures.

The body is not just a volume-conductor with properties predetermined only by its own parameters and those of the exploring source; it is an active volume-conductor with its own sources of electrical tension which interact with the exploring source and, at the same time, continuously modifies the values of its own electrical parameters. All these data make precise knowledge of the distribution of the electromagnetic fields generated by the high tension impulse from the electronographic source difficult. The passage of an electric current through a volume-conductor produces a series of general effects, determined by its impedance, by the depth of penetration of the current, by its inductive effects in conductive media in the vicinity, and by the interaction with electromagnetic fields in its interior.

We shall summarise the main factors bound to the volumetric distribution of the electromagnetic field generated by high tension impulses.

The impedance measured inside the living organism differs from one tissue to another and is affected to an important degree by the frequency of the exploratory current. We give below, in Table 1 (reproduced after H. Schvan), the values of specific resistance

Table 1

The specific resistance of different tissues in ohm/cm

Frequency	Muscles	Liver	Lungs	Spleen	Kidneys	Brain	Vascular wall
11 KHz	170–250	220–800	165–200	250–500	150–270	460–850	147
1 MHz	160–250	210–550	150–180	230–380	140–250	430–700	140
10 MHz	150–170	180–260	110–150	150–170	120–170	300–450	90

measured at different frequencies, corresponding to the frequency values used in electronography.

The values of the dielectric constant for living tissues varies also according to the frequency. We present, from the same author, values of the dielectric constant for muscle and liver tissue, observing its reduction by a factor of ten when the frequency is increased by the same factor.

Table 2

The dielectric constant measured at high frequencies

Frequency	Muscles	Liver
100 KHz	3×10^3	$(7 - 12) \times 10^3$
1 MHz	2×10^3	$(1.2 - 2) \times 10^3$

The lines of electric current density inside the living organism are difficult to determine, because of the functional conditions. The non-homogeneous distribution of the electric current inside the body is produced both by the differing impedance of the tissues and organs, and through the skin, an effect which increases with frequency and with the total electrical resistance of the organism. It is due to the attenuated penetration of the electromagnetic field inside the organism. As the electromagnetic waves are propagated in the non-homogeneous medium, their amplitudes are differentially reduced. The attenuation constant is given by the relation:

$$\alpha = \sqrt{\frac{\omega \mu \gamma}{2}}, \tag{7.1}$$

where ω is the pulsation, μ – the magnetic permeability, and γ – the electric conductivity.

The attenuation of the electromagnetic field is more pronounced the higher the frequency and, at a given frequency μ and γ are also higher.

The main attenuation of the electromagnetic field generated by the electronographic impulse takes place at its point of entry into the organism, mainly by adduction currents at the areas of skin possessing the highest impedance values. Its depth penetration takes place preferentially through zones and points of minimum impedance, and its propagation is deeper, the smaller the impedance value.

Therefore, the electronographic effects belong to zones, the deeper they are, the smaller the impedance of contact between the recording device, and the skin, and the greater the duration of the impulse, but not exceeding the critical limit. The optimal duration of the impulse is of the order of microseconds. It is possible to explain the nature of the so-called electrodermal points with minimum impedance values as being places of preferential penetration of the electromagnetic field deep into the organism.

The driving effect has the following consequences: it determines an increase in heat loss (Joule effect), and it leads to an increase of resistance and inductance and to the dependence of these on frequency values.

The distribution of the electromagnetic field generated by high tension impulses is also affected by the proximal electric medium which can act both as an electric field, and a magnetic inductor, producing a 'proximity effect'. Thus, the influence that different organisms have over the geometry, intensity and chromatic spectrum of marginal discharges can be explained.

Some skin or body circuits which have low impedance in certain functional conditions (the biological impedance being recognised as being determined exclusively by the capacitive reactance), could become inductive, depending on the frequency of the applied impulse. Therefore, the appearance of electrodermal points can be explained.

7.1.2 *The part played by electrodermal activity*

The skin to a large extent determines the electronographic image, and in particular its pellicular aspect (fig. 7.1) as it is covered by a

superficial conductive layer consisting of sweat gland secretions which are under autonomic control for the peripheral control of energy exchange. The skin represents the conductor armature as far as the apparatus for electronography is concerned (the incomplete capacitor device), or the continuous conductor layer which becomes polarised inside the condenser (the complete capacitor device).

The electrical resistance of the skin mainly determines the impedance of the body.

Fig. 7.1. The anatomical structure of the skin.

At the level of the electronography screen the value of the electrical resistance varies within wide limits. Over the surface of the abdomen ($0.60 \, m^2$), it varies between 5 and 47 KΩ, and for the palm ($0.08 \, m^2$) from 2 to 83 KΩ. The electrical capacity measured at the level of the exposure screen varies from 1 nF to 0.1 nF.

Because of the presence of a conductive layer of sweat gland secretion on the skin, the driving effect of the electromagnetic field is important, determining the distribution of a large density of current on the surface of the body. The electron distribution determines in turn, primary collisions with surrounding gaseous molecules.

This superficial distribution of current generates the pellicular

effect. The dependence of the pellicular effect and by implication of the Kirlian corona, on skin electrical impedance and on the composition and conductivity of the proximal electric medium is obvious.

Skin electrical activity is subject to numerous functional changes. Electrodermal reflexes reduce surface electrical resistance (ΔR) to values from 1% to 20% of the value of the background resistance (R_0). These big variations in skin resistance affect the electronographic image considerably and especially the pellicular effect.

In pathological conditions, the change in cutaneous electrical parameters is determined by the irritation of efferent sympathetic pathways and this in turn causes a lowering of electrical resistance or in the case of pathology of the sympathetic nerves, the electrical resistance increases considerably. All these changes have their own electronographic correspondences.

The electrodermal points represent areas of minimum electrical resistance, which in pathological conditions lower their electrical resistance and become larger. Over these areas the electromagnetic field penetrates preferentially into the body with a spiral motion. Electronography is therefore a method for the investigation of surface electrical phenomena.

7.1.3 *The proximal electric medium in electronographic exploration*

The proximal electric medium has been so called because of its close relationship with the body. The living organism, through the skin, creates around itself a highly conductive electric medium which contains, in the ionised state, gases produced by transcutaneous exchange, organic electrolytes and ions, drawn by the layer of water vapour resulting from the evaporation of sweat. This polymorphous medium, in a partial state of ionisation, is bound in a labile fashion to the skin surface.

It ensures energy transfer via its high electric and thermal conductivity which is appreciably affected by the respective gradients between the body and the environment.

Under conditions of electronographic exposure, the gaseous cover (called by some authors 'biofield or bioplasma') has an important role to play because of the inductive magnetic effect produced in it by a high tension field. This effect is known as the proximity effect, and it also creates a redistribution of the lines of force of the acting field by the Lorentz effect on charged particles.

7.2 The origin of the pellicular effect

The pellicular effect is generated by the non-uniform distribution of the electromagnetic field on the surface of the body under investigation, a distribution which determines the predominant movement of elementary particles drawn into the field. This high density of electrons distributed over the surface of the body under investigation determines its contour via the streamers produced by the high tension current.

The process of streamer formation is complicated and cannot be understood unless all the interactions produced by electrons in a high tension field are understood.

Streamer formation is similar in electronography to that of Kirlian photography, the difference being that in the latter, a superimposition of a large number of streamers is formed on the image, and this produces a relatively homogeneous luminous effect.

Most authors when trying to explain the mechanism of Kirlian photography have applied the theory of photon emission in gaseous media, known as 'the streamer theory'. The first experimental research work on the luminous effects of high tension discharges was carried out by Loeb and Meek (1941) and later taken up again by Loeb (1965). The research of these authors has led to the first 'model' of the theory of streamers on the basis of which, the pellicular effect is explained. We shall use this experimental model to explain the pellicular effect.

The experimental model enabling a study of streamer formation consisted of a device for the discharge of a high tension impulse between two electrodes with flat, parallel surfaces of $1\,cm^2$, at a distance of 1 cm. The atmospheric pressure was 1 atmosphere, the discharge tension 31,600 V, and the induction was achieved by lighting the cathode with ultra-violet rays (the relation $E/p = 4.6$ V/cm/mmHg, the relation between the intensity of the field E and p – the atmospheric pressure). The ratio between E and p is determinant for the evolution of the phenomena.

In this model, a single electron from the cathode rapidly acquires a statistical quantum of energy equal to 3.6 eV and a speed in the direction of the field of $1.5 - 2 \times 10^7$ cm/s.

This electron, by its collision with atoms and molecules, determines the appearance of other electrons with a growth coefficient dependent on the relationship between the field power (E) and the

atmospheric pressure (*P*) (fig. 7.2). Therefore, in the space between the electrodes, an exponential growth of the number of electrons occurs, which in consequence leaves an equal number of positive ions. This growth (known as 'the avalanche') in the number of electrons determines the cumulative growth in the number of positive ions. The difference in speed between electrons and positive ions causes a slow migration of the latter initially by virtue of the collision inertia and later because of attraction in the electromagnetic field

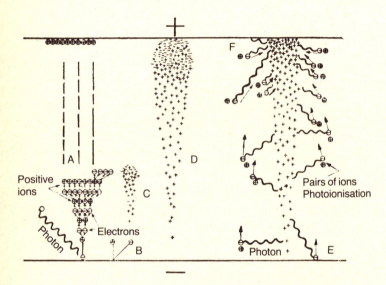

Fig. 7.2. Diagram showing the electron avalanche process.

between the electrodes (the speed of the positive ions is thirty times slower than the speed of the electrons). The electron avalanche is subjected to radial diffusion (*F*) according to the time of propagation of the electrons (*t*); this is dependent on the propagation space (*S*) and the speed (*v*): $t = s/v$ and on the coefficient of diffusion which can be calculated from the speed of the electrons (7.2).

$$F \times v = 2dt$$

The electrons on the polarised plates will reach the anode, with the exception of those additional ones in re-combination with positive ions.

The density of the positive ions depends on the growth coefficient of the number of collisions with atomic and molecular structures in the acceleration space.

Beside the primary electronic collision mechanism, with secondary release of photons as a factor for the generation of an electron avalanche, one can also presuppose the existence of certain secondary mechanisms like:

(a) the ionisation of gases through secondary collisions determined by the positive ions;
(b) the emission of secondary electrons by the cathode through the impact of positive ions resulting from the primary discharge;
(c) the impact on the cathode of photons resulting from the primary discharge which also generates electrons, a phenomenon dependent on the nature of the gas and of the cathode;
(d) secondary emission of electrons at the cathode through the impact of excited atoms in an unstable state (this phenomenon is very slow);
(e) the photoionisation of gases (this effect is thought, by Tiller, to be of primary importance in the formation of arborisations);
(f) the resonant transfer of charge.

This complex of phenomena which generate the secondary emission of electrons gives rise to processes following the primary electrode avalanche which can sustain it or can continue it at different periods of time. The photoionisation phenomena play an important role by forming channels for the propagation of charged microparticles in many directions by forming and directing new avalanches. Ionised molecules, atoms and electrons take part in the process of photoionisation (Dawson and Winn, 1955). The photoelectrons created around the positive ion channel in the vicinity of the anode exert a directional action on the positive ions and accelerate them. In conditions of slow propagation of positive ions which travel towards the cathode, these act as visible tracers, releasing photons by their slow re-combination with electrons. Positive space charges develop therefore from the anode towards the cathode as an autopropagation phenomenon fed continuously by secondary emissions and avalanches of electrons, delimiting luminous branches and secondary arborisations, which form the streamers.

The speed of propagation of the arborisations depends on the photoionisation of the gas and the propagation of photons at the

speed of light. This was determined experimentally as $1.3 - 10^8$ cm/s. In this way, arborisation appears directed toward the cathode in the region of space distortion directed along a line parallel to the field. On reaching the cathode, the 'plasmic' current driven along these branches produces intense local ionisation, causing strong light emission.

The evolution of this 'plasmic' current with positive charges towards the cathode is accompanied by a strong acceleration of

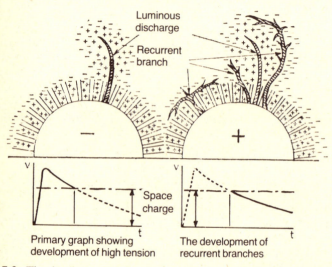

Fig. 7.3. The development of recurrent streamers according to the polarity of the source.

electrons towards the extremities of the arborisations and by the creation of a new emission of electrons in avalanches along the channels thus formed, which causes branching at the ends of the luminous arborisations. In this way, a 'pilot' branch detaches itself and directs the primary luminous discharge, completed at time intervals, according to the power of the field and the degree of ionisation in the acceleration space, by secondary discharges increasingly branched out. The plasma channels tend to standardise the potentials between the electrodes. The return speed of the secondary waves to the pilot channel is 10^9-10^{10} cm/s (fig. 7.3).

It is easy to understand why during the transitory regime of a high

tension impulse, by the photoionisation phenomena which appear within the exposure system electromagnetic waves with very different energetic spectra are generated, forming an oscillatory system between the electrodes, with different temporal polarisation.

In the same way, when applying an aperiodic impulse, the breaking-up into a chain of secondary oscillations generates phenomena which can be reproduced and modulated mathematically. When applying a high-frequency alternating current, the phenomena will be, to a large extent, dependent on the repetitive frequency of the impulses. By using an asynchronous impulse for electronography, it is possible to analyse the streamer phenomenon against the energy of the applied field, bearing in mind that the flux of electrons takes place only once, and in one direction. If the energy of the field is sufficient to produce in a predetermined fraction of time a critical multiplication of electrons able to create the avalanche phenomena, then streamers will appear. The length of the arborisations depends on the value of the applied tension, growing with it until reaching a maximum value that represents the break-down voltage.

The emission of electrons depends also on the material from which the cathode is made. Oxidised steel and nickel give the best emission of electrons, and living organisms the least emission.

7.3 Effects generated by polarising the dielectric inside the recording device

The classic model for producing streamers has been achieved in the acceleration space of the electrons between two metallic plates separated by a gaseous medium. In this situation, as we have already seen, one of the conditions for the formation of streamers is the establishment of a critical ratio between the intensity of the applied field and the pressure of the gas between the electrodes (E/p), in order to allow the creation of the critical potential for the electron avalanche.

In electronographic recording devices this potential is achieved via a dielectric medium, interposed between the electrodes which produces a discharge according to the characteristics of this dielectric medium, and which will affect the formation of streamers considerably. The acceleration space is virtual in the case of the electronographic device.

The dielectric of the electronographic device is polarised differently, during the transitory conditions, and at a given moment, superficial charge densities appearing on its surfaces equal and opposite to the positive and negative surface.

The polarisation is given by the relation $P = M/V$, where $M = Qpd$ represents the electrical moment of the dielectric with volume V.

Polarisation is expressed also in the superficial density of the charges which appear on the surfaces of the two armatures. They are numerically equal when the lines of force of the field which they are cutting are perpendicular.

Polarised charges create a polarisation field Ep whose direction is against the direction of the field applied by the high tension source, and which depends on the superficial density of charges and on the absolute permittivity of the medium.

The electric field inside the dielectric (E_d) is represented by the relation between the field applied on the armatures of the condenser E_o and the relative permittivity of the dielectric ϵ_r:

$$E_d = E_o/\epsilon_r \tag{7.3}$$

The introduction of the body into the dielectric space of the condenser changes its capacity according to its relative permittivity, thereby also modifying the value of field E_d. Therefore, the change in homogeneity of the dielectric or the achievement of a non-uniform distribution of field at the level of one of the armatures will produce a similar field distribution, generating the phenomenon of refraction of the electric and inductive force lines on their passage from one dielectric medium into another.

If we consider two dielectric media with their relative permittivities ϵ_{r1} and ϵ_{r2}, with a separation plane between, ϵ will be the electric field which intersects the separation plane at its entry into the electric medium. E_1 will make an angle α_1 with the normal at the point of penetration between the two media, the angle of deviation of the propagated field E_2 making, with the normal, an angle α_2 (fig. 7.4).

These relationships are expressed by the law of refraction of field lines, if, as in the case of the skin, there are superficial free charges present.

The refraction of the lines of force by the field between the armatures will therefore be different, according to the permittivity of the two media. In fig. 7.5, two types of refraction are represented, in

Biophysical Basis of Electronography 103

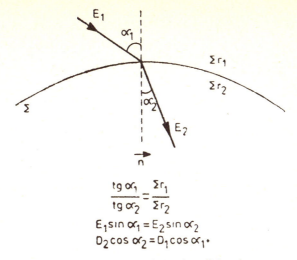

Fig. 7.4. Electric refraction in a dielectric.

conditions of different values of the two dielectric media. This non-homogeneity of the field inside the dielectric between the two electrodes will direct the charge-bearing particles which appear in the interior, affecting differently the orientation and size of the streamers forming in this non-homogeneous field.

As we have previously shown, in the polarisation of molecules interposed between the two armatures of the electronographic recording device, an active role is not only played by field E_d (resulting from the distribution of the initial field E_o of the source in the medium with a known electrical permittivity), but also by the electric field created by all the charges which act simultaneously on

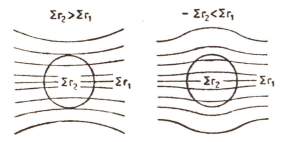

Fig. 7.5. The arrangement of equipotential lines according to the dielectric permittivity of the body under investigation.

the molecules in the dielectric as well as on the particles resulting from their excitation (fig. 7.6). Therefore this underlines the importance of the characteristics of the dielectric space in the formation of electronographic images.

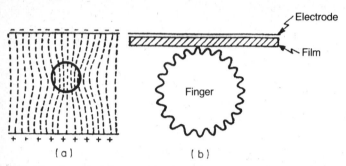

Fig. 7.6. The distortion due to a spherical dielectric; this shows the behaviour of a human finger.

The phenomenon of polarising the dielectric, which takes place during electronographic exposure, has three important consequences:

1. The effect of change in the field orientation produced by the high tension source.
2. An intermediary polarisation of all the dielectric materials with different electrical permittivities will occur, related to the polarity of the two electrodes on which the initial field (E_o) was applied. The values of the intensities of the intermediary fields (E_{d1}, E_{d2} ... E_{dn}) will be different, determined mainly by the value of their relative permittivities.
3. The non-homogeneous distribution of the superficial densities of charge determines the non-uniform distribution of the field of the two media, one of which (the body), has electrical characteristics distributed volumetrically, non-homogeneously and variable in time.

Knowledge of the dielectric medium makes it possible to influence the pellicular effect of the image in two main ways:

1. The control of the image by knowing the relative permittivity of the electrical medium which, related to electrical permittivity of the biological medium under investigation, enables a calculation

to be made on the distribution of the field between the two electrodes.
2. The possibility of interaction at this level with the help of external fields by influencing the phenomena connected with the appearance of streamers.

7.4 The role of electrode polarisation

The effect of polarising the electrodes has been studied by Nasser (1971) on an experimental model for discharge between a punctiform electrode and a flat one. The parameters of high tension current used by this author are very close to the parameters of the electronographic source. Nasser started from the same theoretical principle; he used an impulse with a very short active front, capable of precipitating the avalanche phenomenon, but with a return slope sufficiently long to eliminate the possibility of creating any electroluminescent effects generated during the period of return of the impulse (which would produce a superimposed image). In this way, the phenomenon is unique and its mechanism can be analysed.

In this model, the electrodes achieve an avalanche ionisation, and it is rapidly distributed towards the anode, whilst the positive ions move slowly towards the cathode. The electrostatic field between the two electrodes is modified as the process is taking place. When the punctiform electrode is positive, the electrons are accelerated inside the field of growth of intensity, leaving behind radial channels. With positive space charge the density of the charge towards the anode (fig. 7.7) increases abruptly. This phenomenon increases the tension at the anode end, giving it a branched distribution, and attracts new electron avalanches which enlarge the channels. We see, thus, the formation of a system of arborisations, determined by the positive space charges which start from the punctiform electrode, orientating themselves in space, until, at the extremity of the arborisations, the field decreases, unable to go on supplying the ionisation.

But, if the punctiform electrode becomes negative, the electrons move concentrically in a field whose intensity decreases. As a result of collisions, the electrons leave a positive space charge which reduces the conduction field of electrons and creates the components of a tangential field. The primary negative discharge thereby increases in certain sectors and forces the field in front of the cathode.

The image formed gives the impression of convergence towards its interior. The negative Lichtenberg scheme is therefore smaller than the positive one which has an expanding character extending outside the structure under investigation.

A branch of positive discharge becomes a plasma guide for a secondary emission of electrons, its electrical resistance growing progressively at the distal extremity. Therefore, secondary branches appear which complete the primary figure. Inside this arborising structure, during the discharge, various disturbances and reorientations take place to the values of the field in the transitory conditions determined by impulse restructuring, which remain impressed on to the recording film.

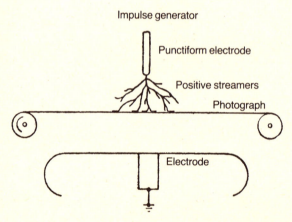

Fig. 7.7. Scheme used in the study of streamer polarisation.

The development of branches determines the reduction of overdevelopment and up to a certain value of local tension, and avoids penetration through the phenomena of field distribution.

The flux of electrons is a convergent flux which determines, through the effects of magnetic interaction (Lorentz forces), the transformation of the plasma resulting from ionisation into narrow channels.

The force which acts upon the charge bearers in the plasma is dependent on the vectorial product between the speed of the particles and the magnetic induction. In this way a magnetic conditioning of the distribution of arborisation takes place. By interactions with different electromotor forces from outside the field, the

shape of the discharge can be affected to a large extent. In the electromagnetic recording device we have achieved modification of the discharge lines by interaction with induced magnetic fields.

When interpreting the effect of polarity on electronographic images it is necessary to reconsider the principles generally used in the study of streamers, bearing in mind the series of particular factors represented by the characteristics of the recording device.

1. When exposing the body in the electromagnetic field, inner polarisation determined by the orientation of the inductive field occurs, so that the arrangement of charges on the surface of the organism under investigation has a dipole orientation in relation to the polarity of the electrodes which generate the field. The placing of a photosensor on one or other surface of the organism introduced into the field, will therefore record complementary images, the streamers being formed through a positive- or negative-type discharge determined by the consequent polarisation of the organism.
2. In conditions in which the surface of the living organism is considered as the armature of a separate condenser through a homogeneous dielectric of a metallic armature, there appears on the surface of the organism a variation of charge determined by the changes produced by the field.
3. The position of the photosensor in the recording system is decisive in obtaining the polarity of the image, the polarity characteristics of the phenomenon of electroluminescence depending on the direction of variation of the current against the recording plane. It must not be forgotten that the image sensor reproduces only the projection of luminous phenomena in the plane in which it is placed.
4. The polarity of the impulse is determined by the orientation of the active point of the source (that rapid variation of potential, capable of releasing avalanches). Thus, if positive impulses have an abrupt ascending front, they will behave positively, but if they have a slow ascending front, and an abrupt descending front, they will generate electro-negative-type images. Also, a bipolar impulse will be considered as of the type $-+$ or $+-$. In order to standardise the polarity of the impulse, it is related to the image obtained and not to the polarity of the impulse source.

It is interesting to show that in the process of orientating the

arborisations in the exposure space, at a given moment, polarity reversal can occur. Thus, when the tension is dropped, the accumulation of positive ions at the cathode end can cause a momentary polarisation of the image which manifests itself by the appearance of new branches of the opposite type. The presence of certain transitory re-polarisation disturbances at the level of the photosensor can help restructure the recurrent ramifications.

7.5 The part played by the composition of the gaseous medium within the dielectric space

The composition of the dielectric medium and the presence of gases inside the acceleration space between the electrodes can affect the formation of streamers.

Beside the value of the electrical permittivity of the dielectric medium, the degree of ionisation at a given moment in this medium, affects the image.

The introduction of a gas which, when disintegrating, releases electrons like carbon tetrachloride which disintegrates into carbon trichloride and chlorine ionising the medium negatively, can also modify the streamers by diminishing and thinning them.

The presence of abundant negative ionisation can act by reducing the threshold of the appearance of the electron avalanche and, as a secondary step, acts by retarding the evolution of positive ions, which, as we have already shown, produces luminous tracers in the formation of streamers. The presence of water vapour favours the formation of streamers and of discharge conditions in which the water vapour was not previously ionised, but at the same time it exerts an 'elastic brake' on streamer propagation.

The content of water vapour and gaseous ions resulting from tissue respiration (these are charge-bearing), affects the streamers in a different way after being charged. Biological ionisation, by producing heavy ions with positive charges in conditions of intense metabolic activity, increases the pellicular effect. The same effect is obtained by the presence of sweat gland secretion. This ionisation favours photon emission by producing large arborisations with many ramifications. On the other hand, negative ionisation reduces streamer formation. Variations in temperature and pressure of the gaseous medium play an important part by modifying the state of aggregation of the gas due to thermal agitation of the molecules.

7.6 Effects of polarisation of living tissue

As a result of applying an electrical tension on the surface of the body a redistribution of charge in the surface tissues takes place, similar changes take place, but to a lesser extent below the surface. This is the phenomenon of polarisation; with the electronographic technique the phenomenon of polarisation is negligible due to the extremely short exposure time and due to the transitory conditions in which the exposure is carried out.

When conditions of exposure using large numbers of radio frequency waves, as in the Kirlian technique or methods which require repeated impulses are used, then tissue polarisation can become a significant factor which, in turn, can modify the distribution of surface charge. This is one of the reasons for error in images obtained using the Kirlian technique.

The action of a field on an ionisable structure can generate two groups of effects:

1. The cathodic emission of electrons is accompanied by an accumulation of positive ions at the cathode, which therefore increases the tension value in that region, and diminishing its value at the back of the accumulation. This phenomenon is known as cathode drop.
2. The induction of a dipole moment in the vicinity of the electrodes determines the appearance of a back e.m.f., which therefore diminishes the value of the initial field, and which increases concomitantly with it.

When the cathode drop increases the emission of electrons, the back e.m.f. decreases.

Polarisation modifies ionic distribution in living tissue, this effect diminishing with increasing depth into the tissue from the surface. Polarisation in living tissue can take different forms:

(a) Ionic polarisation which takes place through the limited deployment, under the action of electric current, of ions which determine the induction of temporary electric moments;
(b) Dipole polarisation, as manifest by the orientation of the electrical axes of polar molecules in parallel with the direction of the electric field;
(c) Interface polarisation (between layers), which is due to the non-homogeneity of biological conductors.

Modifications can be caused by polarisation in the distribution of the electric field, and this can cause non-uniformities of distribution which must be distinguished from non-uniform distribution through the non-homogeneous body volume, and from the charge distribution resulting from interaction with biological electromagnetic fields.

As has been shown, the pellicular effect which consists of fundamental streamers due to exposure of the organism to a single high tension pulse is nevertheless a complex phenomenon which cannot be fully explained in conditions of everyday practice in the functional investigation of the living organism.

Because of these considerations, in the case of electronographic exploration, the pellicular effect has a directional character, and is often excluded by some recording methods, or by processing the image through television circuits.

Many authors, when analysing Kirlian photography, so far as the marginal discharges are concerned, criticise it for its inability to reproduce the same effect on more than one occasion; however, the chance nature of these phenomena is difficult to eliminate, and therefore reproducibility is often not possible.

When we carried out electronographic exploration, we developed a series of methods to improve the reproducibility of these phenomena, whilst retaining functional significance of the images obtained.

7.7 The electromorphous effect

In the image obtained through electroluminescence, a great deal of the impulse energy is lost without being able to change into an image.

The image produced by photon emission is recorded on film as the radiation produced in the visible light spectrum at the interface of two distinct electric media, or at the level of induction channels produced by the migration of positive ions between plates of the exposure condenser. Much ultra-violet radiation is recorded as well as a good deal of infra-red radiation.

The electromorphous effect is obtained through electrono-optical conversion with the help of a chemical transducer which has an excitation threshold, determined for the energy of the incident particles. (Colour plate No. 1.)

Kirlian techniques do not produce an electromorphous effect.

In order to be able to explain the appearance of the image which causes this effect in electronography, the phenomena which occur at

the level of the device for recording the electronographic image need to be re-examined.

Electrons are drawn into a resistance/capacitance circuit in which the impedance of the organism is in series with the condenser which is represented by the recording screen.

The screen is made from a metallic armature which receives high tension impulses and is covered by a uniform layer of electrono-optical converting substance and separated from the organism under investigation by a transparent homogeneous dielectric, with a relatively large permittivity. In this condenser, the surface of the organism under investigation becomes, through its surface hydro-lipidic film, a true biological armature situated opposite to the metallic armature. The photosensitive sensor is introduced between the dielectric layer and the body under investigation.

When a high tension impulse is applied to the metallic armature of the condenser, an electromagnetic field appears with non-homogeneous distribution over the biological armature of the condenser (i.e. the body being investigated) due to its attenuation by the live, non-homogeneous and anisotropic volume-conductor, constituted by the subject under study, as well as to its interaction with biological electro-magnetic fields from different organs and tissues of the subject. This disposition of the field will determine which way the dielectric is polarised, and on it will appear a non-uniform distribution of electric charge, of the opposite sign however to the surface of contact with the converter luminophore which reproduces, by scintillation, the electrical characteristics of the organism under investigation. The dielectric polarisation will determine the appearance of a local flux of electrons which excites the chemical layer by passing the electrons through a state of transitory excitation which releases, as a secondary action, photons which propagate through the transparent dielectric, thereby recording on the sensor placed between the organism and the dielectric.

Unlike mechanisms which generate the pellicular effect, the electromorphous effect represents a supplementary capture of light achieved by electrono-optical transduction, the transfer of information being achieved with the help of the electromagnetic field which traverses the organism under investigation. The electromorphous effect is obtained in two distinct phenomenological stages:

1. The projection of the electromagnetic field on the skin electro-

nographically exposed causes this field to be attenuated by the electrical characteristics of the live tissues, as well as by the interaction with electromagnetic fields of different organs and tissues.
2. The reproduction of this distribution of the exploratory electromagnetic field with a system of electrono-optical transduction. This is achieved via the exposure screen through gradations of light impinging on the photosensitive film, or onto other photosensors.

A luminescent layer produces light emission, due to the variations in the electromagnetic field into which this layer is introduced. According to the wavelength of light emission, the converters used by us are made of fluorescent and phosphorescent substances. The emission of fluorescent light is secondary to the excitation of the fluorescent substance through a source of primary radiation and is characterised by a short period of emission (of the order of 10^{-9}–10^{-6} s), after the initial primary excitation by the absorbent particle. The wavelength of the emitted radiation is determined by secondary collisions of the absorbent particles which can lose or gain energy (Stokes radiation or anti-Stokes radiation). Fluorescence is due to electron transitions from an initial energetic state to transitory states of excitation. The return from the excited state to the fundamental state for different levels of vibration of this state is accompanied by photon emission.

If the electron on its transition onto the initial energy state does not completely revert to this fundamental state, but stops in a metastable transition state (near to the excitation state, this state being characteristic of certain substances with complicated structures), then it can have a delayed return to the initial energetic state, and in this case photon emission takes place slowly. This secondary transition from a metastable energy level of the electron to the initial energy state produces the phenomenon of secondary phosphorescent emission. The passage of the electron directly from the first metastable level to the initial energetic level generates so-called betaphosphorescence, whilst the intermediary transition from the metastable level to the first excited level with subsequent return to the initial energy level produces so-called alpha-phosphorescence.

The phosphorescent emission in crystalline inorganic substances is a complex energetic process, and is due to the phenomenon of

trapping electrons in a 'trap' or luminescent centre found in the crystalline structure. The energy enabling the release of these electrons comes from the vibration of the crystalline network. In this way, the luminescent centres of the crystal capture electrons. The transitions are able to take place either towards a state of excitation, or towards the fundamental state.

The energy levels of excitation, as well as the fundamental ones, can be controlled by adding impurities to the crystals, thus obtaining light emission of different wavelengths.

In the electrono-optical conversion system used in electronography, fluorescent or phosphorescent substances are used, depending on the duration of photon emission required.

The passage of the electrons from an initial energy level to a level of excitation, or their temporary passage into a metastable energy level is achieved by excitation due to the exploratory electromagnetic field.

The excitation threshold of the substance, in the case of inorganic crystals, can be controlled by their degree of impurity, which determines the energy level of the excitation state.

The use of some substances which are excited at different tension values can produce, on the surface of a screen with a non-uniform energy distribution of the field, the emission of photons with different intensity and wavelengths.

The remanence after the excitation of the luminescent substance can be controlled, enabling luminescent effects with different persistencies and even with different colours, depending on the phenomenon being tested.

Electronography uses a luminescent substance with medium remanence (up to one second), and with a spectral conversion into visible light, or corresponding to the film exposed (orthochromatic, panchromatic, or colour).

7.8 The origin of colour in the electronographic image

Kirlian photography and, later, electronography, have shown the possibility of obtaining direct images in colour during electroluminescent discharges.

The appearance of photon emission with different wavelengths of the visible light spectrum, as well as of invisible radiation, like x-rays, high ultra-violet and, at the other end of the spectrum, near infra-red

radiation, has proved that it is possible to obtain a scale of emitted energy which allows the detailed analysis of luminescent phenomena.

The nature of these colours is not yet fully clarified. Recent research with the help of spectrography applied to electroluminescence has produced new findings. The main interpretations of the coloured light production in Kirlian photography have been as follows:

1. The process of streamer formation, studied with the aid of photomultipliers in colour, has made it possible to demonstrate that the positive ion bunches, in their path of migration, generate blue to ultra-violet light at their frontal extremity and red at their distal extremity (Tiller). It therefore seems easy to explain polarisation of the streamers according to the speed of propagation of positive ions which results, dependent on this, in a frequency modulation of the emitted photons similar to the Doppler effect.
2. The nature of the medium in which the discharge takes place affects photon emission in particular spectral zones, depending on the characteristics of the excited gas molecules. Thus, excited nitrogen molecules emit in blue, whilst sodium ions emit yellow and potassium ions emit red. In this way, excitation through electroluminescence reflects the constituent molecules of the gaseous medium in the vicinity of the discharge zone.
3. The colour would be determined by the electrical impedance at the discharge point. Very small electrical impedance zones emit predominantly in red, whilst the discharge through impedances with high values, emits in blue.
4. The nature of the cathode, as the main source of electrons, has been thought to give the energy value of the emitted spark. The density of the electrons emitted in unit time is very great, and the colour of the released light is predominantly blue.

Electronographic research carried out using coloured film, as well as using spectrography in electroluminescence, has provided us with the following data, which makes it possible to understand more fully the colours present in images produced by electronography.

(*a*) The emission of light depends on the energy and, especially, the tension of the impulse applied to the body under investigation. In the conditions when the impulse has a predetermined energy value, the chromatic variation of the emitted light depends on

the phenomena of attenuation of the field in the structure under investigation.
(b) Light recorded on photosensors depends on the particular energy of the electrons at the place where the streamers are being formed, thus imparting acceleration onto ionised particles according to the local character of the field unevenly distributed over the surface of the skin.
(c) The emitted light spectrum is subject to an energy polarisation due to interaction with living matter which determines energetic radiations through complex mechanisms.
(d) The emission of light in the same human subject is affected by the prevailing physiological state. States of nervous tension and physical tiredness are accompanied by an increase in red emission, whilst relaxation increases the blue radiation.
(e) The emission of light is affected by the polarity of the source; a negative polarity on a biological surface leads to an increase in red and infra-red emission, whilst a positive discharge results in the increase of blue and ultra-violet. This affirms the energy role of the process of streamer formation when obtaining the colour.
(f) The luminous discharges by direct sparking on the surface of a liquid produce the specific colour of the ion excited by the high tension source. In conditions of discharge onto biological surfaces, the value of the emission through the excitation of the constituent ions serves to identify the chemical composition of the surface covering.
(g) The electrical conductivity of the medium in which the discharge takes place has an effect through the diminution of energy values of the effective tension. Temperature also has an indirect effect through molecular thermal agitation, reducing or increasing the light emission, especially in the bands of red and infra-red radiation.

All these observations are fundamental to spectral analysis of electroluminescence which will be described in detail in this book.

It is necessary to add that obtaining the electronographic image in colour is important, especially as regards the electromorphous effect, the chromatic conversion being recorded on the luminescent layer. This can convert invisible radiation into the visible spectrum, according to the nature of the luminescent substance used.

Chapter 8

Electronographic Investigation of the Body

8.1 Technical principles in electronographic investigation

The technical requirements of electronography have shown, in early investigations of the body, false disadvantages compared to the Kirlian method, that is that the use of a single impulse with a higher energy value than the trains of radio frequency impulses used in Kirlian photography could constitute a risk which could damage vital organs. It is known that as the frequency of the exploratory current increases towards the microwave region, then it is less likely to penetrate tissues and does not present the biological excitation phenomenon.

The use of an electronographic impulse with high tissue penetration has therefore made it essential to adopt protective measures such as:

1. Limiting energy values of the high tension source and the control of the energy of the applied impulse.
2. Protecting the body by earthing.
3. Choosing areas of investigation which exclude vital organs.
4. Using an automatic control device for synchronising the high tension impulse with the electrocardiogram (fig. 8.1).

These considerations have led to the construction of an electronography apparatus for the investigation of the body.

Compliance with these principles has made it possible to obtain electronographic images on human subjects without risk.

Electronography has enabled us to obtain, for the first time, images differing from the structural images obtained by x-ray techniques and which reflect the electrical characteristics of the organs and tissues investigated.

Electronographic explorations carried out on a great number of people – healthy and ill – have shown that the electronographic

Electronographic Investigation of the Body

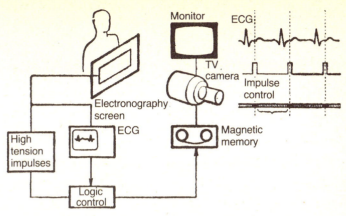

Fig. 8.1. Basic diagram of an electronography apparatus with synchronisation of the high tension impulse with the electrocardiogram (original).

images of the human subject express, in detail in terms of light intensity and colour, the electrical properties of each subject.

Electronographic images show the electrical characteristics of the proximal electric medium, the skin, and of the deep tissues and organs.

Fig. 8.2. Electronography unit (original).

These images which explore structurally different depths, can be obtained by modifying the parameters of the exploratory impulse by using screens with electrono-optical conversion, operating at different wavelengths, as well as by the spatial reconstruction of two images obtained at different angles of incidence.

Electronographic images of the human body reproduce the electrical characteristics by the spatial interaction of the electromagnetic field, generated by a high tension impulse, with a volume-conductor represented by the body. The images will depend, in this situation, on the following factors:

1. The characteristics of the high tension electromagnetic field, and its space time variations, as well as the distribution of the exploratory field inside the body, which will in turn depend on the body's electrical anisotropy and its physiological state.
2. The spatial distribution of the field between the two armatures of the condenser formed by the body and the recording electrode. The geometrical form of the electrode on which the high tension impulse is applied determines the space geometry of the resulting field in the acceleration device. The result is that equipotential lines of distribution of the field on the surface of the organism will be subject to changes which must be borne in mind when assessing electronographic images.
3. The scintillation characteristics of the luminescent substance used. The use of phosphors with predetermined conversion characteristics enables the differentiation of the field at particular tension values. According to the scintillation energy the electronographic image reproduces predetermined details of the field distribution.
4. Electronography of the human body presupposes the use of image processing systems able to show essential electrical characteristics. Depending on these factors, the electronographic images of the body are subject to many changes. When identifying the electronographic details of the human body and their functional interpretation, it is necessary to know these factors.

Although exploration of the body has been successfully achieved using direct observation via electrovision, the most useful images were obtained using photographic recording of the images.

We shall set out the observations made by this method. Electronographic examination can only be carried out in situations in which the

body maintains perfect contact with the recording device. Over the zone of contact with the screen the effect of atmospheric pressure and temperature variation can be reduced to a negligible level, making it possible to explore in conditions identical to the clinical situation.

The pellicular effect nevertheless remains dependent on the above listed factors, because it is produced in free space outside the organism under investigation.

8.2 Electronography of the limbs

The first electronographs (as in the Kirlian method), were obtained from the palms and soles. Examination of the hands and feet is easier because of their surfaces which can be applied directly onto the recording film. In order to obtain good images it is necessary to wipe the skin clean and to dry off excessive sweat.

Electronographic images of palms and soles are characterised by a pellicular effect determined by the exposure conditions and a more or less obvious electromorphous effect, dependent on the circulation of the limb under investigation and the electrical activity of the skin (palms and soles being the main areas of so-called psychogenic perspiration).

Electrodermal points are sometimes found on the palms. Local denervation of a limb produces a less luminous image with less systemised marginal discharges.

An important finding in the electronographic exploration of limbs has been that muscular zones with increased tonus produce darker images, whilst relaxed muscles produce lighter images (fig. 8.3).

Electronography of palms and soles has led to the discovery of certain peculiarities in the pellicular effect, caused by the reactivity of the subject under investigation. The palms of a normal subject produce images with regular fasciculated discharges which differ during repeated examinations. This fascicular aspect of the palm's streamers is due to the cyclic activity of the palmar sweat glands. As Kuno has shown, as early as 1939, sweat glands are not active in their totality, but only a third are generally active, the rest being in a resting state, and functioning only in conditions of intense autonomic activity. This explains the finding that during narcotic sleep (Mircea, Jianu, Dumitrescu, 1976), by blocking the sympathetic fibres, the transmembraneous transport of perspiration and its

Fig. 8.3. Electronographs of a limb (originals) of (1) contracted muscle; (2) relaxed muscle.

elimination, become slow and diffuse and the marginal streamers also become diffuse.

Electronographic exploration of palms and soles in conditions of hyperhidrosis show a disappearance of the fascicular character of the streamers, due to increased sweat gland activity (fig. 8.4).

The character of the streamers is also determined by the degree of keratinisation of the epidermis and by the number of sweat glands. These characteristics show individual variation and also age/sex variation (Guja, 1976).

Electronographic images of the hands therefore have anthropological significance (Sahleanu, Guja, 1976).

Excessive sweating due to endocrine or autonomic activity produces a less well-defined image. We discovered an important diminution in brightness of palmar electronographic images, as well as of the number of streamers, when studying changes during exercise (using a cycle ergometer).

The images 'in effort' are characterised by a reduction of the number of streamers which radiate visible light, as well as by the

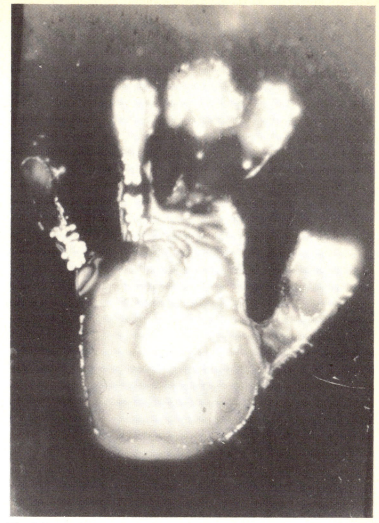

Fig. 8.4. Hand electronograph by electromorphous effect in conditions of hyperhidrosis (original).

reduction of radiation in red and violet, measured using spectrographic analysis of electroluminescence.

The electromorphous effect follows the modifications of the pellicular effect, being affected both by impedance of the skin and by the circulation of the limb segment under investigation.

Electronographic images taken during systole show a brighter image as compared with the image of the same palm during diastole.

8.3 Electronography of the abdomen

This shows the distribution of light and dark zones representing the electromorphous effect (fig. 8.5).

Fig. 8.5. Electronographic image of the abdomen (original).

The zones shown inside the body have no defined anatomical significance, but they represent the body's distribution of the electromagnetic field on the surface of the abdomen; this distribution is affected by the fields of various organs and, at the same time, by the geometry of the exploratory field imposed by the shape of the metal electrode.

The light zones are dependent also on the excitation threshold of the phosphors in the recording device.

When the metallic electrode is a perfectly flat, metallic surface of 40 sq. cm. and the phosphor is hermetically sealed onto a transparent, homogeneous dielectric, the images obtained are repeatable.

The kidneys show as areas of reduced brightness.
The umbilicus appears outlined by a pellicular effect (fig. 8.5).
Longitudinal dark zones are seen intercalated with other brighter zones. The liver area shows as a dark zone. (Colour plate No. 4.)

The image of the abdomen shows bright and dark zones with similar arrangements for all the subjects investigated by us. Electronographic exploration of the abdomen with reversible colour film has shown the predominance of red, with different shades and intensities on the skin (the pellicular effect), the predominance of blue and red mixing in different proportions. In the liver area, the pellicular effect contains a lot of blue, whilst over the spleen, blue radiation is much reduced. A number of electrodermal points have been found on the abdomen, appearing using very high frequency impulses, and are especially seen in pathological conditions.

Exploration carried out on the abdomen at different angles of incidence makes it possible to recognise the light zones with changes produced by varying the angle at which the pictures are taken against the ventral plane.

A variation of image according to the angle of incidence indicates their origin – a space with anisotropic electric properties. These recordings, taken with the abdomen placed in different positions, make it possible to obtain three-dimensional pictures of the images both optically and through the electronic analysis of images obtained from different angles.

8.4 Electronography of the thorax

This requires certain technical problems to be overcome in order to ensure protection of the heart by releasing the high tension impulse in the absolute refractory period of the myocardium. Electronography of the thoracic wall is of interest especially when used to examine the breasts. Electronographic images of the breast show a non-homogeneous distribution of dark and light zones. The glandular zones show on the electronographic screen as light zones. Electronography of the thorax shows a dark image of the heart in which the lighter cavities can be distinguished.

These findings have led us to conclude that structures with intense electrical activity show as dark zones, whilst light zones appear around the dark area. This phenomenon can be considered similar to a magnetic deflection of the electron beam created by the electro-

124 *Electrographic Methods in Medicine and Biology*

Fig. 8.6a. Electronographic image of the heart (original).

Fig. 8.6b. X-ray image of the same heart.

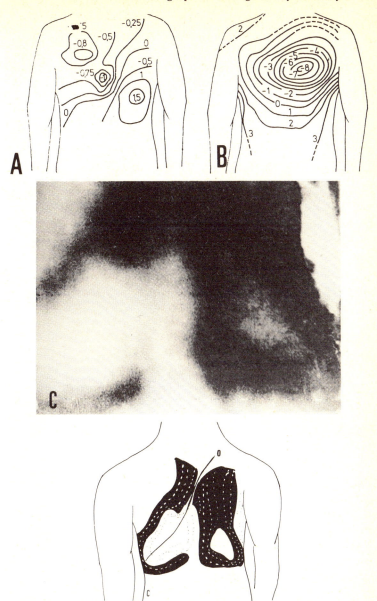

Fig. 8.7. Distribution of force lines of the electric field produced by heart muscle according to: (*a*) Franck (diagram by Franck); (*b*) Taccardi (diagram by Taccardi); (*c*) Interpretation of the electronographic image.

magnetic fields of electrically active organs at the moment when attenuation of the electromagnetic field is critical.

Inside the heart obvious light zones appear, which represent the auricular and ventricular chambers. Due to this contrast the valves can also be seen. Compared to x-ray images of the heart, electronography offers this additional information (figs. 8.6a and b).

On the right hemithorax, a light image is produced, due to the concentration of force lines caused by the electromagnetic field of the exploratory impulse (fig. 8.7).

8.5 Electronography of the head

This method does not involve risk, provided protective measures as outlined previously are taken. Images of the face, forehead, occipital region, and temporal regions have been obtained from many subjects.

A characteristic image is found around the nose and mouth due to the emission of expiratory air. These gaseous emissions, with a rich water vapour content and gas ions, create characteristic images (images like 'snowflakes' called free aeroions) (fig. 8.8).

On the forehead a light zone is found which can be attributed to copious psychogenic perspiration over the frontal region. The images obtained on transcerebral examination in the awake subject are lighter than those obtained in narcotic sleep, or in decerebrate coma. This differentiation cannot be attributed to an emission from within, when considering the cranium as a cover which disperses over its surface the lines of conduction of the electromagnetic fields, but it is due to modifications of impedance occurring on the skin. We believe that it is possible to explain cranial electronographic images as a psychophysiological change in the electrical activity of the cranial skin.

The electronographic images of the face and neck have shown a number of important electrodermal points.

Electronographic images have been obtained of teeth. The electronographic image of a tooth indicates a light area corresponding to the dentine. The tooth pulp and the surrounding space appear dark in the image, whilst the neurovascular bundle in the tooth root gives a well-defined bright image.

In order to obtain dental electronographs, a small-sized electronographic screen is used, made from acrylic polymers.

Fig. 8.8. Electronographic image of the face (original).

Another method tried for imaging the teeth was that of using acrylic polymer casts, sufficiently thick so as to ensure electrical insulation inside the casts, and the surface lying against the tooth was covered with a layer of photosensitive emulsion. After electronographic exposure, the emulsion was developed and fixed.

The general and introductory nature of this work does not allow us to develop the purely medical aspects of a semiology specific to electronography. In a future work we shall define more precisely the possibilities of diagnosis using electronography.

Chapter 9

Surface Electrical Measurement and Electronographic Images

9.1 Introduction

The electroluminescent image reproduces the electrical characteristics of the body, both passive (electrical properties investigated with the aid of a source outside the body), and active (the body being considered as a source of electromagnetic fields).

The living body, especially the human organism, has been investigated using electrical parameters for a very long time.

The electrophysiological measurements tend to be concerned with the study of the skin through which the biological electric medium can be investigated.

From an electrical point of view, the greatest resistance to the passage of electric currents from outside is due to the skin. The impedance of the inside of the body is a fraction of that of the skin due to ionic conduction occurring within the body.

When analysing the phenomenon of propagation of the electric current inside the body, it is found that the internal resistance is represented by the sum of the forward resistances of conductive ions through cell membranes in the body circuit. On the other hand, the resistance of the skin reaches values of the order of tens or even hundreds of thousands of ohms.

This value consists of the outermost layer whose role is to insulate the body, and membranes lying deeper with variable electrical conductance acting as electrical barriers of skin (dermo-epidermal membrane and basal membrane of sweat glands).

Skin impedance is not constant, but varies from one anatomical region to another, as well as varying in a temporal fashion (fig. 9.1).

Variations of electrical impedance are partly due to sweat gland secretion which is under autonomic control, and this in turn modifies the water and electrolyte content of secretions lying on the skin surface.

Surface Electrical Measurement and Electronographic Images 129

On the other hand, the electrical resistance of the skin even in the absence of sweat gland secretion is modified due to a slow depolarisation determined by the efferent sympathetic nerve fibres acting on the dermo-epidermal membrane.

On the skin, these changes produce a dynamic mosaic of zones with differing electrical impedance, which are constantly changing due to neurovegetative activity.

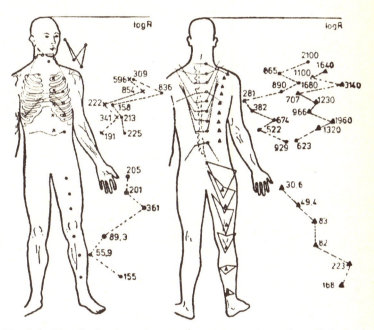

Fig. 9.1. The distribution of resistance values on the surface of the body (according to Eory).

A major influence on the autonomic system is psychic activity, and electrodermal reflexes can be triggered by many different psychogenic factors which produce a sudden drop in skin resistance (fig. 9.2). Edelberg represents, in an equivalent electrical skin model, the dermo-epidermal electric resistance as being coupled with an electromotor source, and in parallel with the transverse resistance of the sweat glands fed in its turn by a higher-value tension source.

We have defined the functional unity between the sweat glands and the electrical membranes of the skin in the concept of the electro-

dermal unit, consisting of nerve endings, sweat glands, and the portion of dermo-epidermic membrane supplied by a single sympathetic efferent fibre. The electrodermal unit acts synergistically and synchronously, producing an anatomically localised change, according to the size of the innervated zone (fig. 9.3).

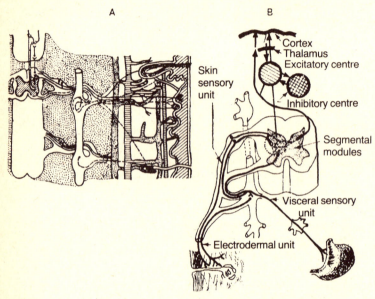

Fig. 9.2. Neurovegetative Pathways and Centres of Electrodermal Control.

The source electromotor tension in these conditions is due to the disposition, in parallel and in series, of several tension sources:

1. The dermo-epidermic source, due to the potential gradient between the biological electric medium and the electric medium on the surface of the skin.
2. Sweat gland secretion acting as a source due to slow basal secretion or excessive secretion stimulated by electrodermal reflexes. Just like the dermo-epidermic source, it is negatively polarised inside the body and positively polarised externally.
3. The secreto-motor source generated by the periglandular cells which take part in the expulsion of sweat gland secretion. This acts as a temporary and low frequency (2–6 Hz) source.

Surface Electrical Measurement and Electronographic Images

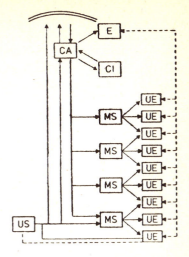

CA = Electrodermal activating centre
CI = Electrodermal inhibitory centres
MS = Segmental modules
UE = Electrodermal unit
US = Sensory unit

Fig. 9.3. A diagram showing the mechanisms for the neurohumoral control of electrodermal activity.

4. The source of tension resulting from the gradient of electrolyte concentration between the sweat and the fluid lying on the surface which is richer in cations than sweat. This source is directed between the sweat gland orifice and the skin surface.
5. The electromotor force due to resorption of sweat gland secretion is orientated in the opposite direction to the other sources listed above. It provides a continuous source of small value. The negative deflection of the potential curve from the electrodermal reflex of the palm has been attributed to this source (Lloyd).
6. Surface electric sources which appear to be due to electric surface dipoles, generated through transitory connections between zones with different electrical potential. These are difficult to systematise, being subject to many changes. They are either direct current sources, when they are generated through slow electrodermal activity, or are alternating current sources of low frequency (10 Hz) appearing as a consequence of changes due to electromagnetic fields generated by internal organs.

Sources which appear in zones of pathological electrical activity (zones of electrodermal activation) can also be included amongst these surface sources.

9.2 Electrodermal activity

A series of phenomena determined by the function of internal organs (fig. 9.4) are manifest on the skin surface.

In physiological conditions these changes express the activity of groups of electrodermal units.

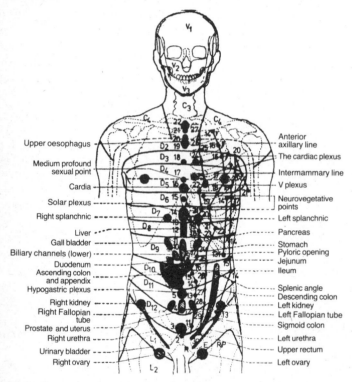

Fig. 9.4. Cutaneous projections of visceral reflex zones (according to Jaricot).

There appears to be a characteristic distribution of areas of psychogenic electrical activity sensitive to rapid variations in sympathetic tonus, which activates the electrodermal reflexes. They are present on the palms, soles and forehead, and are sometimes known as psychogenic sweat gland zones.

The mechanism of the electrodermal reflex has been studied by many electrophysiological research projects, and these have shown

the involvement of mid-brain structures and also parts of the reticular formation as well as vegetative cortical areas in these reflexes. These areas appear to activate the mechanisms for the activation and maintenance of electrodermal reflexes.

The involvement of descending pathways in the central nervous system as well as peripheral pathways belonging to the sympathetic nervous system (postganglionic cholinergic fibres) has also been established as important in electrodermal activity.

The role of efferent sympathetic nerve fibres in controlling electrodermal activity is more complex, because it also acts simultaneously on other mechanisms of energy control (i.e. temperature regulation, vasoconstriction, cellular energetic consumption, etc.).

Electrophysiological research has attempted to interpret the significance of electrodermal reflexes. They are determined, as we know, either by states of excitement which produce a complex vegetative alert reaction (increase of arterial pressure, vasoconstriction, increase in heart rate, etc.), or by stimuli which arise due to psychic processes such as stress, all states which are accompanied, more or less markedly, by responses of a neurovegetative nature.

In these conditions, the body begins to sweat mainly over the areas where electrical change in the body is noted, such as on palms, soles and the head. The psychogenic sweat gland zones have been inherited from quadrupeds, these areas being the only ones where sweat glands are found in several species. Having become bipedal, the hands maintain and develop the physiological ability of electrical communication with the environment, being amongst the body's most sensitive transducers.

The soles maintain their function of electrical contact with earth, and the head develops phylogenetically new electrical properties concerned with the development of the higher activities of present-day man. Thus, electrical impedance measured on the cranial skin shows the lowest values, as compared to impedance values measured elsewhere on the body's surface.

9.3 Electrodermal activity in pathological conditions

The electrical properties of the skin show a series of changes in pathological conditions. The first observation of these changes was obtained by C. Richter at the Baltimore School of Psychophysiology

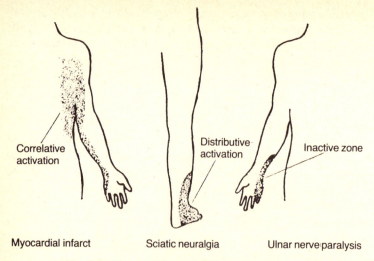

Fig. 9.5. Types of change in skin electrical activity.

with the help of a dermometric technique (by measurement of skin resistance). These changes were attributed to central or peripheral lesions of nerve fibres, subserving electrodermal control, and have been studied in comparison with surgical lesions of these pathways (fig. 9.5).

In 1969 a complex method was developed for electrodermal examination of the body by the simultaneous measurement of several electrical and physiological parameters (resistance, capacitance, potential, temperature, vasoconstriction, etc., Dumitrescu and Golovanov). These recordings made it possible to systematise the main changes which appear from an electrical standpoint, on the skin surface.

The cutaneous electrical changes have been systematised into the following groups, according to the electrical parameters:

9.3.1 Local electrical changes

These can occur in different ways: through skin lesions, due to sweating or by local nerve damage.

In this group, changes occur limited to precisely localised zones in which one of the mentioned causes acts either through a skin lesion, in which the surface electric potential is virtually obliterated by the

Surface Electrical Measurement and Electronographic Images

electrical potential of the internal electric medium (wound potential, or so-called current of injury), or changes take place of an irritative or denervation character which show up initially either as an increase or decrease in skin conductivity.

9.3.2 Electrodermal changes of a general character

These are characterised by an increase in conductivity, accompanied or not by an increase in skin potential, or by a diminution in conductivity accompanied by a reduction in surface potential. These changes of stimulation or inhibition of electrodermal activity are due to changes of ionic permeability of the previously listed 'cutaneous electrical barriers', due to the action of the autonomic nervous system.

9.3.3 Reflex electrodermal zone changes

These appear on the skin as a result of irritative processes due to nerve damage which cause a change in the spontaneous activity of

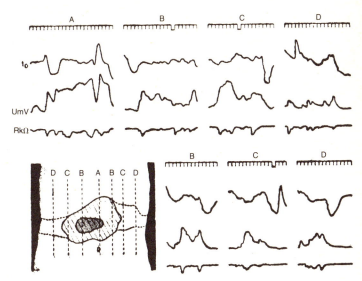

Fig. 9.6. Cancer of the head of the pancreas. Electric potential resistance and temperature measurements and the mapping of the active electrical zones (original).

relevant electrodermal units, neurofunctionally correlated with the site of the prevailing pathology.

As well as these changes, several other types of electrodermal activity can be distinguished by an increase in skin conductivity and potential (punctiform activation, activation of correlative and distributive zones) as well as electrodermal inactivation due to nerve damage.

This is characterised by a reduction in skin conductivity and potential and is accompanied by the disappearance of the electrodermal reflexes (fig. 9.6). A modality for analysing the electrodermal activity is represented by the comparative measurements and recordings against the metameric symmetry of the body's axis.

We thought it necessary to present this résumé of the main electrodermal changes in functional and pathological conditions because they have correspondences in electronographic images which will be interpreted according to data given by surface electrical measurements.

9.4 Surface electrical modifications and their correspondence with electronographic images

Electronography shows surface electrical phenomena via the skin acting as the reference electrode in the recording device.

It is obvious that any modification of skin impedance will cause a modification in distribution of the electromagnetic field; this will therefore cause a different brightness which will, in its turn, modify the recorded image.

But, as we have shown, the electronographic image does not only represent surface electrical phenomena, but it also shows the interaction of the exploratory electromagnetic field with the electromagnetic fields of different organs and tissues. In this way, the electronographic image represents a super-imposition of surface electric phenomena and the restructuring phenomena of the electromagnetic field inside the body. Skin electrical changes in pathological conditions find their correspondence in electronographic images.

One can show all the electrical modifications indicated by the electronographic method by taking multiple exposures in different recording conditions (different amplitudes of the impulse, dielectrics with different permittivities, layers of scintillation with different

sparking energy levels). We shall try to present a few correlations between electrometric and electronographic exploration.

9.4.1 *Activation of electrodermal points*

Electronography has made it possible to obtain, for the first time, direct pictures of activated electrodermal points. They are shown in the electronographic image as a luminous zone consisting of concentric circles with a spectral emission of intense red and infra-red.

Electrodermal points correspond generally to the known points of traditional acupuncture, but they are also found outside the points known in classical acupuncture atlases.

The connection between these points and pathological changes of internal organs has been statistically demonstrated. They correspond to the correlations neurofunctionally attributed to them.

Electrical measurements on the points electronographically found have proved convincingly that they correspond to points of minimum electrical resistance, and it was found that their value was lower than $80\,\text{K}\Omega$.

Recording of potential at the centre of these points, as compared to the surrounding skin, showed values of around $42\,\text{mV}$, with a range of between 8 and $65\,\text{mV}$ as compared with much smaller values for the surrounding skin (around $6\,\text{mV}$).

These observations show that the appearance of the electrodermal point in the electronographic image, is due to the penetration of the exploratory electromagnetic field at a point of low resistance. This penetration focuses water vapour and ionised gases, which produce a luminous vortex-like distribution of force lines under the influence of the prevailing biological electromagnetic fields.

In pathological conditions a number of points are found distributed over a wide area of skin. Thus, in syndromes producing electrical activation due to irritation of nerve trunks, as in the case of peritoneal irritation, numerous electrodermal points appear on the surface of the abdomen.

In dysfunctional syndromes, points with more or less large areas appear depending on the extent and severity of the pathology, and this proves the existence of the electrodermal point, as described by Podsibiakin.

Electrodermal points shown with the help of electronography are of different sizes. In certain pathological conditions they can be large,

nearly reaching the size of an activation zone. In these conditions the central zone of the point extends, or there appear around this central zone several other dark zones. These concentric luminous circles extend for a considerable distance around the point, the total area occupied reaching the size of a localised zone. This surface widening phenomenon of an electrodermal point has also been observed using electrical surface measurement.

Another characteristic of points shown electronographically is the variability of their presence, according to the different functional states of the body at the time of recording. Thus, they can be found on several electronographic films taken successively or only on some of them. This phenomenon is explained by the fluctuation of electrical resistance values due to variations in autonomic control.

The electrodermal points indicated by electronographic examination can diminish or expand superficially, the electronographic image confirming the phenomenon of points opening and closing as previously shown by us.* ('Occlusion and fenestration phenomenon.')

The finding of electrodermal points by numerous recordings with different electrical parameters will make possible not only their functional classification, but may well also provide an important pointer to diagnosis.

9.4.2 *Electrodermal activation*

The reduction of the cutaneous electrical impedance in a delimited zone is manifest electrographically by an increase in brightness of the respective zone, accompanied by a modification of the spectral composition of the light emission.

Zones of cutaneous electrical activation are shown electronographically by bright images. The distributive or correlative inflammatory activation zones correspond to an increase in light emission, both in ultra-violet and blue radiations, visible light, and in infra-red.

Light emission from tumours increase the emission of blue and red light. Soft tumours emit in red, as distinct from solid tumours which emit predominantly in blue and red, with an intensity which greatly

* Dumitrescu, Tintoiu: The Bulletin of Kyoto Pain Control Institute, Japan, 1970.

exceeds that of inflammatory phenomena, which emit in the red and infra-red band.

The distributive activations are better represented electronographically than the correlative activations which often are limited to the appearance of a number of electrodermal points.

9.4.3 *Electrodermal inactivation*

The loss of peripheral sympathetic control results in increase of electrical impedance, and collapse of the surface electric potential. These phenomena appear electronographically as a modification of marginal discharges as well as a diminution of the electromorphous effect in the denervated zones. Together with these changes there is a reduction in infra-red emission, whilst the ultra-violet radiation increases.

9.5 Correlations between thermographic recordings and electronographic images

Thermal phenomena on the surface of the body are reflected both directly, by an increase in light emission in the infra-red region, and indirectly by processes of skin electrical activation which are caused by hyperthermia by activation of the sweat glands and by a modification of autonomic tonus which increases skin blood flow.

The conjugation of these thermal phenomena with the electrical ones has made us adopt the 'energetic homoeostasis concept' (Dumitrescu, 1977). Comparative research by using thermographic and electronographic methods has revealed that the thermographic and electronographic changes have a definite correlation.

Much more significant is the correlation between spectrometry by electroluminescence, and thermography. Thus, increase in local temperature is associated with an increase in infra-red and red emission.

We believe that combined electronographic and thermographic examination, accompanied by the spectral analysis of the radiation, will be of real use in the diagnosis of malignancy.

Chapter 10

Electronographic Imaging of the Proximal Electric Medium

10.1 Introduction

Electrographs obtained using the Kirlian technique have provided, for the first time, proof of the existence of a gaseous covering around the body, differing from person to person, and which is constantly changing. This gaseous envelope is affected by the biological activity of the organism, mainly by its energy exchanges with the external electric medium. The energetic 'envelope' makes itself apparent both through wavelike phenomena and through corpuscular phenomena. Kirlian photographs have persuaded biophysicists to accept these two categories of phenomena. These phenomena are represented by a complex phenomenology which has been defined using concepts of 'biofield', and 'bioplasma', in the sense of the existence of a polymorphous substance in a gaseous state, composed of electrons, ions and neutral atoms permanently interacting with biological electromagnetic fields, and with those of the external electric medium. This arrangement (for which we consider that the descriptions: 'biofield' or 'bioplasma' are inaccurate because they define only the wavelike, or corpuscular nature of the phenomena) is in an unstable thermodynamic equilibrium (mainly because the space electrical charge is characterised by a series of local oscillations).

Experimental data obtained by using electronographic methods have led us to give the name 'proximal electric medium', an idea which designates that zone in the environment through which the body interacts with the energetic and corpuscular external electric medium.

The proximal electric medium is the site of a number of physical phenomena, which reflect both the biological characteristics of the living organism and its response to the conditions of the medium in which it is placed.

If surface bioelectric phenomena (with which we have dealt

previously)* represent the first interface between the organism and the external electric medium, the second interface lies on the surface structures and lies between the body and the phenomenological sphere of the external electric field.

As distinct from surface bioelectric phenomena, the phenomena which take place in the proximal electric medium are dependent, to a greater extent, on factors found in the environment than on biological phenomena arising within the body which affect these only to a very small extent.

It is interesting to note that biology and medicine has dealt before with electrophysical exploration of the body, exploring the characteristics of the internal electric medium as providing reliable data easily submissible to direct interpretation. Thus, the electrocardiogram can show an electrical change indicating a myocardial infarction.

In time electrophysiological examination extended to looking at the limit of separation between the biological electric medium and the external electric medium, by looking at skin bioelectric phenomena as being of functional significance in regard to both electric media.

Interpretation of this category of phenomena is more difficult, as it presupposes a knowledge of the type of the energetic and informational connection between the body and the diversified medium which surrounds it.

But beyond the phenomenological sphere, investigation by electroluminescence enables the proximal electric medium to be investigated directly, at the same time as looking at the body. The limits of scientific knowledge in this field of overwhelming importance are obvious.

We believe that the use of electrographic techniques will make it possible to establish pathogenesis, from an electrical point of view, and thus contribute to a broader understanding of disease.

10.2 Electronographic exploration of the proximal electric medium

As we have previously shown, examination of the pellicular effect through electronographic techniques or of its multiplication as a corona, as seen in the Kirlian effect, does not indicate, except

* Man and the Electric Environment – I. Fl. Dumitrescu. Ed. Stiintifica si Enciclopedica, Bucharest, 1976 – in Rumanian.

indirectly, the phenomena of electrical exchange through the investigation of the characteristics of electrical conductivity, and magnetic permeability of the proximal electric medium. Any change in its quality will be shown by the shape and brightness of the

Fig. 10.1. Electronographic image (original) of two test tubes. 1. Containing clotted blood. 2. Containing agar gel. In test tube 1 the luminosity generated by the gaseous medium released by the blood can be seen.

discharges. The phenomena are only reproducible when there is strict maintenance of working conditions. Temperature variation, variation in humidity, chemical composition of the atmosphere, its electrical state (i.e. degree of previous ionisation), are important when exploring these phenomena (fig. 10.1).

Electronographic investigation of the proximal electric medium,

shows that local discharges occur via channels with a chance orientation (depending on the environmental factors enumerated previously), but the global structuring of the electronographic image of the proximal electric medium is reproducible for similar morphofunctional states of the organism under investigation (figs. 10.2 and 10.3).

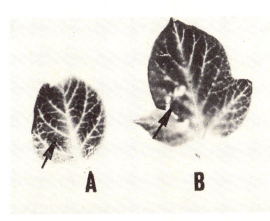

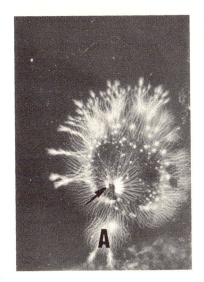
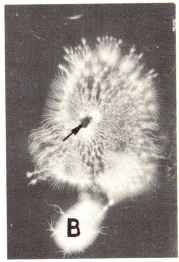

Fig. 10.2. Structuring of streamers around a biological lesion (leaf): (*a*) not apparent; (*b*) visible.

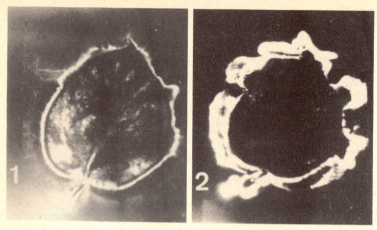

Fig. 10.3. 1. Electroluminescent image of a leaf. 2. Its 'luminous imprint' on a glass plate six hours after the leaf was removed (original).

10.3 Demonstration of the layer of adherent aeroions

By using the electronographic technique, we have succeeded – by attenuating the electromagnetic field (generated by the high tension impulse), up to a critical value determined by the characteristics of the proximal electric medium – in obtaining the first photographs which show a structured zone of the proximal medium which can be reproduced in repeated exposures (fig. 10.4).

The zones thus orientated consist of successive strata which surround the body, imitating details of the skin. Thus, the images of the hands show concentric lines which reproduce the configuration of the papillary grooves. From place to place, we have noticed the presence of fascicular discharges caused by water vapour. We have called this gaseous layer, fixed to the skin, the layer of adherent aeroions. It represents a transitional medium between the biological medium and the external electric medium and is generated by the evaporation of sweat gland secretion, containing as well as water vapour, electrolytes in ionic or bound states, organic ions, as well as mixtures of gases resulting from respiration. The adherence of this layer is due to electrostatic and tribo-electric* attraction (fig. 10.5).

* Tribo-electric = electric charging produced by rubbing.

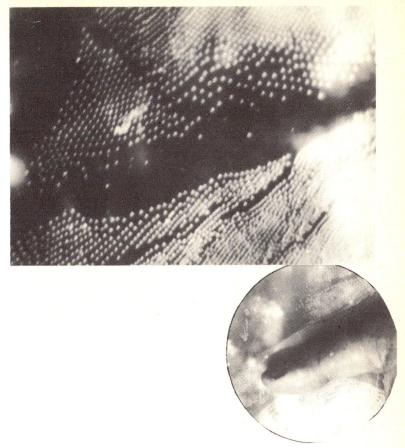

Fig. 10.4. Layer of adherent aeroions. Detail of distribution of streamers around the fingertip.

The layer of adherent aeroions is continuously renewed by the metabolic activity of the skin, and is moved rhythmically through perspiration and cellular respiration or through abrupt discharges caused by neural reflex mechanisms, as in the case of the electro-dermal reflexes. A part of this layer is retained in the form of adherent aeroions and structured in the shape of 'force lines' by the attraction of the body, and another part is released into the environment in the form of free ions.

The layer of adherent aeroions plays an important part in the phenomena of exteroception.

146 *Electrographic Methods in Medicine and Biology*

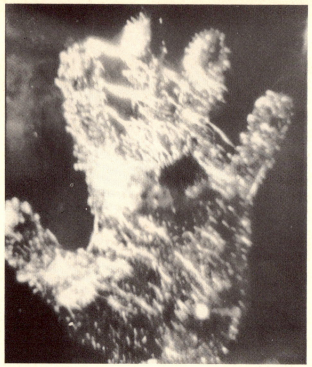

Fig. 10.5. The structure of the layer of adherent aeroions around a hand (original).

Also, various functions in the reception and transmission of electromagnetic information can be attributed to this layer. Further information regarding the layer of the proximal electric medium can be obtained by spectral analysis.

10.4 Free aeroions

Electronographic recordings of images obtained from samples of expired air shows the presence of luminous zones (10.7). The images have a corpuscular structure with filiform extensions (so-called 'snow-flake images') which are orientated in the direction of the air current. Expired air breathed into plastic bags gradually loses these electroluminescent properties. Similar images were obtained

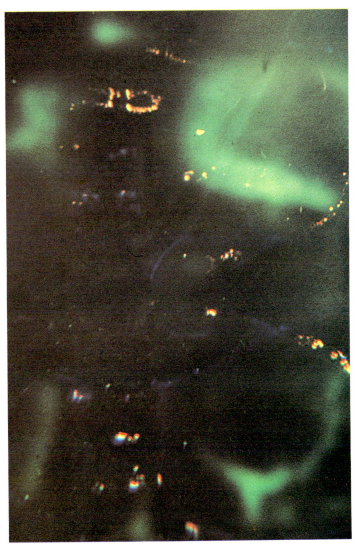

1. Electronograph of two hands. The pellicular effect appears in blue and red, while the electromorphous effect is seen in green

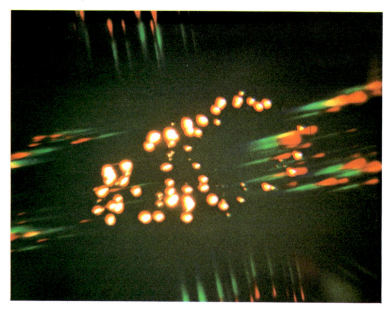

2. Spectral analysis by Electroluminescence through diffraction grating of a finger print.

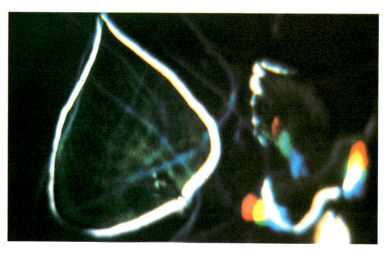

3. Spectral analysis by Electroluminescence through diffraction grating of a living leaf and of a dead leaf.

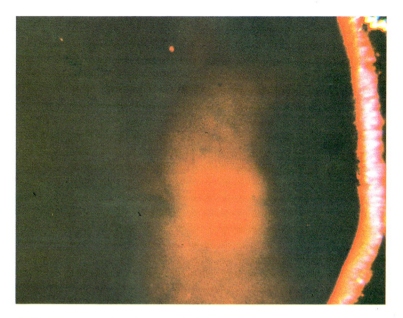

4. Electronography of a normal abdomen.

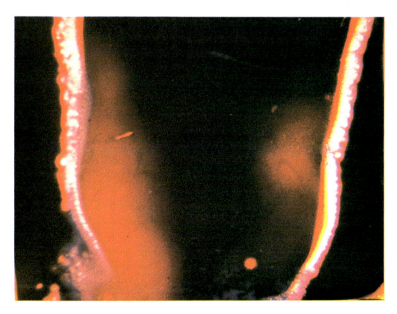

5. Electronography of an abdomen showing an electrodermic point in the left Iliac Fossa.

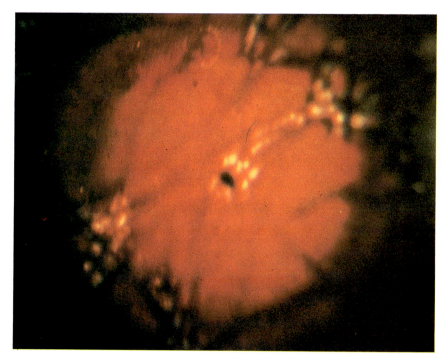

6. Enlarged image of an electrodermal point.

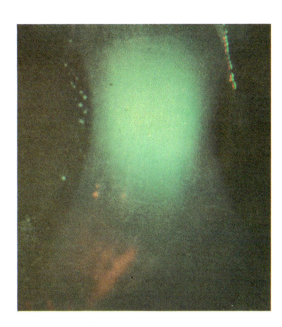

8. Electronography of two fingers in conditions of reciprocal interaction without sweating (the phenomenon of biological interference radiation can be seen).

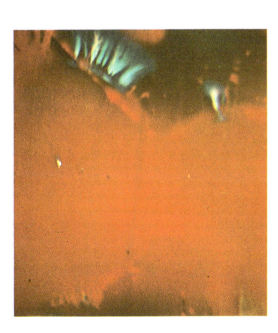

7. Electronography of two fingers belonging to two different subjects in conditions of sweating (Electrodermal reflexes are simultaneously occurring for both subjects).

9. Microelectronographic images obtained by chromatic conversion of some cells of the Algae Cladophora.

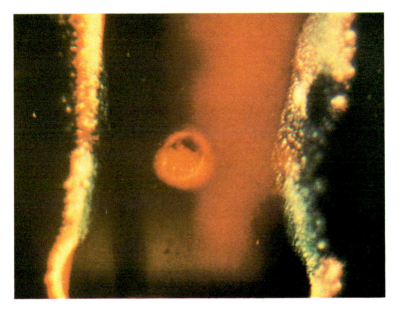

10. Colour electronograph of an abdomen of a patient suffering from portal hypertension.

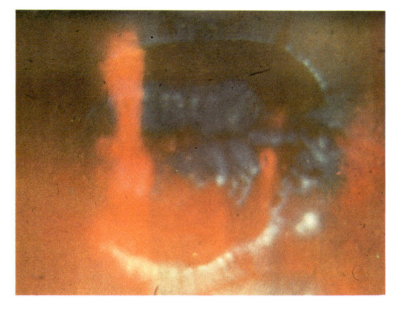

11. Colour electronograph of epithelioma of the lip.

Electronographic Imaging of the Proximal Electric Medium 147

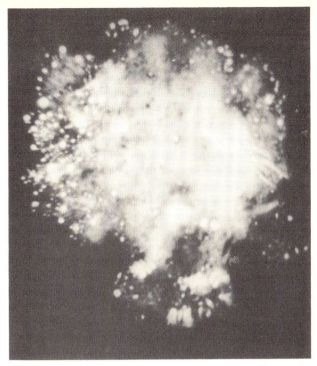

Fig. 10.6. Electroluminescent image of excessive sweating (original) – taken of the forehead of the subject at some distance from the electronographic screen.

on the surface of the body, in conditions of excessive sweating or through rapid evaporation of sweat gland secretion to a warm, dry current of air (fig. 10.6).

We have also noted the abundant presence of free aeroions in regions affected by peripheral ischaemic processes. In these cases, we have interpreted the appearance of the phenomenon as the intensification of the respiratory exchanges of a compensatory nature for the deficit in blood flow (figs. 10.8, 1 and 2).

Electrical exchange via free aeroions is a recognised mechanism in modern electrophysiology. The pulmonary alveoli, like the surface of the skin, offer a very large active surface for exchange with the air of free aeroions, discharging an excess of energy which the body accumulates during functional processes.

10.5 'Biological Interference' radiation

Methods of exploring the body using electroluminescence have demonstrated an interesting phenomenon of electrical origin, whose significance must be sought in the energy exchange processes of the body. At the limit of separation of the pellicular zones between the two fingers of two different subjects there appears, sometimes, a radiation in the ultra-violet spectrum, definitely different from each individual pellicular effect. Thus, when recording two subjects whose hands are close together, there appears in the interval between the two pellicular effects, an unstructured radiation with a colour

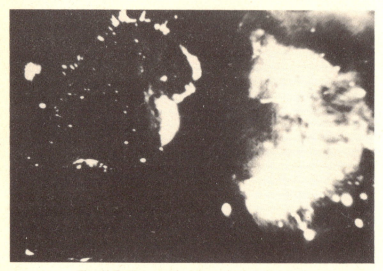

Fig. 10.7. Free aeroions in expired air (original).

spectrum different from that of each individual subject. (Colour plates No. 7 and 8.) The appearance of this radiation can be attributed to the interaction between the two proximal electric media under the exciting action of the high tension impulse. Within this interface of the two electric media, and when the predetermined conditions have been satisfied, a radiation in the ultra-violet spectrum occurs (fig. 10.9).

Electronographic Imaging of the Proximal Electric Medium 149

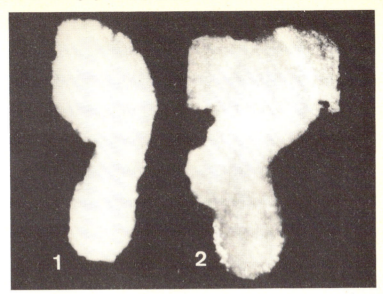

Fig. 10.8. 1. Electronograph of a healthy foot (original).
Fig. 10.8. 2. Electronograph of an ischaemic foot (original).

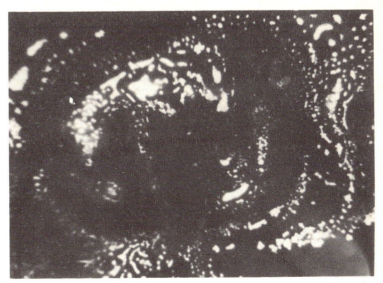

Fig. 10.9. Electronographic image of a plate made of glass four hours after the imprint of a hand has been made on it (original).

These phenomena have been observed also in isolated cells and in cell cultures. If we separately introduce blood samples taken from different subjects into two plastic tubes with high porosity, a strong zone of radiation in ultra-violet can be seen at a certain critical distance between the two tubes.

Chapter 11

Electronographic Imaging of Acupuncture Points

The electrical properties of acupuncture points have been studied by Dumitrescu since 1962; research which has led to the functional characterisation of these points through three electrical properties which differentiate them from the surrounding skin:

1. Increased electrical conductivity (values in the order of tens of kΩ).
2. Electrical potential with higher values than the surrounding skin (values in the order of millivolts).
3. Increased electrical capacitance (values in the order of $0.1\,\mu F$).

These points have also been called electrodermal points by us. The study of these points has enabled us to devise exact methods for their detection and exploration (as for example the multimetric correlation method).

The electrodermal points which were found, appeared to be connected functionally to particular organs or tissues and, furthermore, were subject to electrical activation in pathological conditions.

The mechanism of these electrodermal activations has been explained by us following many neuro-physiological studies, being attributed to convergence phenomena – projection from brain centres of the pathological stimulus with a consequent secondary cutaneous manifestation. Thus, for instance, visceral pathology manifests itself through the appearance of a point or a constellation of points with high conductivity and increased values of potential, sometimes with reversed polarity.

In 1957, with remarkable foresight, Podsibiakin called this phenomenon 'the dominance of the active points'.

The electronographic method has enabled us to explore the body in its totality, making it possible to record not only surface electric

152 *Electrographic Methods in Medicine and Biology*

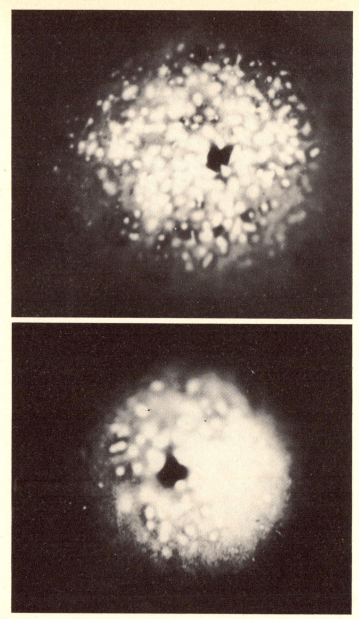

Fig. 11.1. a and b. Electronographic images of an acupuncture point (original). (*a*) with negative impulse; (*b*) with positive impulse.

phenomena, but also the electromagnetic phenomena occurring inside the body.

One of the most interesting findings obtained using electronography of the body has been the discovery of electrodermal points corresponding to certain acupuncture points; points which appear only in functional, or pathological conditions, and can in turn be used as diagnostic indicators. (Colour plate No. 5.)

The first electronograph of an acupuncture point was obtained in 1975 and was shown at the International Acupuncture Congress in Montreal (fig. 11.1).

With the aid of the electronographic method we succeeded in obtaining the first detailed photographs of electrodermal points, leading us to the following conclusions. During electronographic investigation carried out on more than 3,000 human subjects, in various states of health and disease, we have found in a large number of subjects luminous points which correspond to acupuncture points.

As we have shown in a previous paper,* systematic research carried out on a large number of human subjects has made it possible to demonstrate the electronographic characteristics of acupuncture points:

1. The electronographic appearance of the electrodermal point is dependent on the high tension field, showing a critical energetic value.

 The appearance of points which indicate local electrical activation manifests itself by a reduction in electrical impedance and surface extension.

 The optimal parameters of the exploratory impulse used to visualise electrodermal points of pathological significance are: 29–33 kV, active slope of $1\,\mu s$ and an impulse duration of $50\,\mu s$.

 An increase in impulse energy caused the appearance of false electrodermal points due to the penetration of the skin electrical barrier by the exploratory impulse.

2. Electrodermal points within normal limits of activity, explored electronographically, did not appear. Their appearance indicates the presence of a dysfunctional or pathological situation. Observations on 886 patients suffering from different diseases have

* Modern Scientific Acupuncture – I. Fl. Dumitrescu, 1977. Ed. Junimea, Jossy, Rumania.

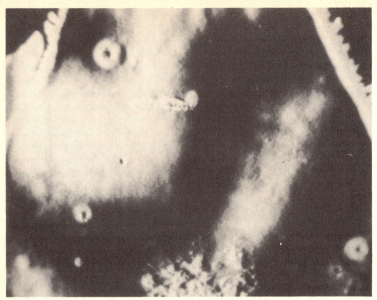

Fig. 11.2. The distribution of electrodermal points in lines suggestive of meridians, taken over the abdomen (original).

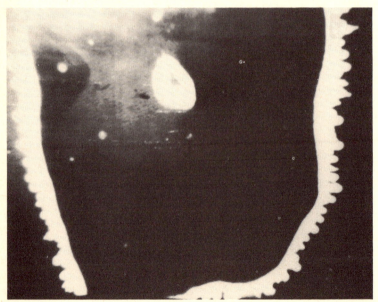

Fig. 11.3. Configuration of points characteristic of duodenal ulcer (original).

enabled us to decide on the diagnosis based on the distribution of the electrodermal points shown by electronography (fig. 11.3).

Their localisation by superimposing the image onto the skin, has demonstrated that they are distributed in localisations found in visceral pathology. In most of the cases investigated by us, we have confirmed the neurophysiological correlation diagram found by Jaricot with regard to the abdominal points.

The appearance of electrodermal points depending on the pathological state is explained by an increase in the electrical difference between the surrounding skin and that of the above point, due in our opinion to a viscero-cutaneous reflex mechanism.

The appearance of points has a pathognemonic character and can be used in diagnosis. It is believed that electrodermal points appear only after a long process of previous electrical activation.

Electronographs carried out in patients with malignant tumours have shown, in the vicinity of the tumour, the presence of points similar to electrodermal points, which do not correspond to traditional acupuncture points. Their significance was attributed to local electrical changes, followed by penetration of the cutaneous electrical barrier. False electrodermal points have been detected in different vegetative disturbances, and especially in syndromes involving irritation of the paravertebral sympathetic ganglia.

3. The electrodermal point consists of a dark central zone, of irregular shape, and with a 1–2 cm. diameter, surrounded by a luminous circular area (the areola) formed of concentric interrupted lines with diameters of 3–40 mm. (fig. 11.2).

 When the point appears in the marginal pellicular effect (i.e. when seen in profile), it appears as a luminous 'eruption' with a luminous central zone (luminous nucleus), and with interrupted radiations into this surrounding space, delimited by the more luminous external corona (fig. 11.4).

4. The different sizes of electrodermal points are determined by their degree of electrical activity. In acute diseases, electrodermal points are bigger and more numerous.

 Electrodermal points can be transformed into zones of activation which can be more or less extensive (fig. 11.5).

5. The meridians have not been shown directly on electronographic images, but the electrodermal points are often placed on paths which can be considered as corresponding to meridians (fig. 11.2).

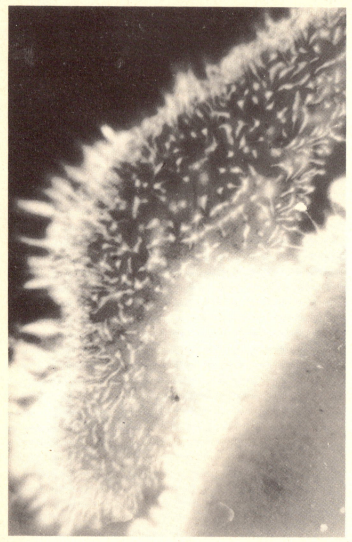
Fig. 11.4. Electronographic image of an electrodermal point taken in profile (original).

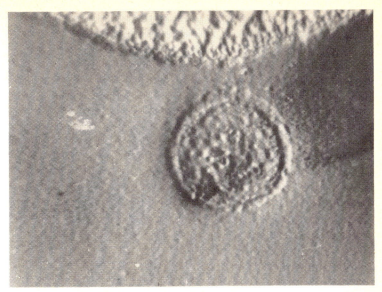

Fig. 11.5. Electronographic image of an activated electrodermal point (original). (Note expansion in area of point.)

6. The image of active points obtained with the aid of electronography on coloured emulsions, shows fairly constantly the colour red, which is characteristic of the zone around the dark central point, with a surrounding blue area. (Colour plate No. 6.)
7. The analysis of points on the electronographs of different subjects enabled us to measure the dimensions of the central zone, and this has a mean diameter of 1.87 mm, varying from 0.93 mm to 21.6 mm.

The interrupted peripheral zones vary within much greater limits. We note that the zones within the areola are not continuous, but have a spiral orientation around the central point. The mean size of the areola is 16.28 mm (varying from 8.18–26.20 mm).

The central zone of the active point has an intense electromagnetic force, able to eliminate electrons which will otherwise generate microstreamers.

The structure of the active point when viewed in the frontal plane, as well as in profile, shows that the eruptions of marginal discharges are due to a current of ionised air, polarised around the central point.

The demonstration of electrodermal points with the aid of electronography has made it possible to obtain real images of these points, reproducible when the examination was repeated and superimposed on luminous zones generated by the electromorphous effect. Their electro-physiological significance is determined by their electrical characterisation, which distinguishes them from the rest of the skin

Fig. 11.6. Distribution of some electrodermal points in a case of splenectomy in thrombocytopenic purpura (original).

and which allows penetration by the exploratory field, with a surrounding concentric pellicular effect. The electrodermal point appears to be an 'electrical pore' concerned with energy exchange between the body and the surrounding electric medium (fig. 11.6).

The reproduction of this phenomenon on dielectric membranes with similar resistance points, suggests this interpretation.

All the findings point to the electrodermal point as being a pore through which active electrical exchange takes place.

Fig. 11.7. Electronographic detection of abdominal active points with images recorded on a closed-circuit TV (original).

The electrodermal point found on the electronographic images shows as a virtual or real transcutaneous channel, pre-existent or caused by the high tension impulse, which activates a flux of ions, similar to an inverted cone of air, and having a circular motion (fig. 11.7).

Whatever its origin, the electrodermal point can only represent electrical communication between the sick organism and the surrounding electric medium.

Micro-electronographic research has demonstrated the existence of intercellular electroluminescence, which takes place at certain points, analogous to the electrodermal points. Similarly, we have shown the existence of similar points in plants. These findings demonstrate a functional analogy in living organisms for which the electrodermal points constitute methods of energy exchange with the external electric medium.

Chapter 12

Experimental Modelling of Electronographic Effects

12.1 Physical conditioning of the pellicular effect

The pellicular effect results from the interaction between electrons generated on the skin and the surrounding gaseous covering which is in a partially ionised state. The electrons torn away by the high tension impulse are driven back by the conductive surface provided by the cutaneous hydrolipidic film representing the interface between the biological volume conductor with a relatively high impedance, and the proximal electric medium with a resistance varying within wide limits. This 'driving back' action is more powerful in the case of the electrons driven by low energies, but is sufficient by itself to produce, in the gaseous media in the vicinity, a luminous avalanche sufficient to generate streamers. In the area around the body discharge channels are therefore created which will produce a pellicular effect. As the phenomenon starts within a very short time, this leads to an exponential growth in the number of electrons and ions which will polarise the surrounding space. According to their charge the primary and secondary particles resulting from the ionisation of the surrounding medium will move differentially towards either of the two poles of the system. The positive ions will travel towards the cathode, whilst the electrons will be attracted towards the anode.

The molecular composition and aggregation of the proximal electric medium impart characteristic colours to the discharge. The presence of nitrogen produces a violet colour, whilst sodium gives a characteristic yellow colour. Spectrographic analysis of the pellicular effect can lead to the characterisation of the proximal electric medium. Its composition has an individual character, differing from subject to subject. The diagnostic possibilities of spectrography by electroluminescence, in which the elimination of different components of perspiration in physiological or pathological proportions

can produce important spectral modifications, raise a fruitful new area of research.

Spectrographic analysis of the pellicular effect also enables the determination of sex, individual characteristics, as well as the presence or absence of specific substances metabolised by the body, and eliminated secondarily through the skin. This method enables the dynamics of transcutaneous elimination of water vapour, electrolytes, and of metabolites from sweat gland secretion to be studied.

The pellicular effect should be considered as being strictly dependent on the parameters of the impulse generated by the high tension source, as well as by the physical characteristics of the medium in which the investigation takes place (atmospheric pressure, temperature, humidity, chemical composition). Thus, the direction of photon emission resulting from multiple collisions with dissociation and re-combinations of particles which generate photon emission, is dependent on the orientation of the particles in the acceleration space and polarisation of the source, on the acceleration of electrons given by the growth slope of the impulse, on their critical energy which generates the 'avalanche' phenomenon (in which the number of accelerated particles grows exponentially), and therefore on the parameters of the impulse. These elements will generate different effects with different impulses which will in turn affect the electronographic image, and will often confuse the untrained observer.

The pellicular effect should also be interpreted in conjunction with the composition of the medium in which the examination takes place, as this has an important role to play in the systemisation of the phenomena taking place.

The wide interest aroused in the scientific world by the Kirlian 'aura', especially through the luminous marginal discharges which represent a time/space summation of the pellicular effect obtained by the electronographic technique, has given rise to a number of interpretations concerning its supposed functional significance. One of the most controversial explanations was that the marginal discharges were manifestations of psycho-energetic phenomena.

12.1.1 *Electronographic images performed on experimental models*

We have tried to reproduce, with the aid of some simple models, the electrical behaviour of the human body in the electronographic device.

With this in mind, we have placed, on a round glass plate 6 mm thick and with a 20 cm diameter, four flat electrodes, 2 cm in diameter, which were connected via four different resistances, of 10 kΩ, 100 kΩ, 1 MΩ, 10 MΩ respectively, connected in parallel to the high tension source. The resistances were encased, for the sake of insulation, in epoxide resin. The choice of resistances was because of their comparable values with physiological values encountered on the skin (figs. 12.1 and 12.2 a and b).

The model was placed on the screen of the electronography apparatus and gave reproducible images. By analysing them we noted that the extension, arborisation, and luminous intensity of the streamers depended on the value of the resistance applied on the screen.

Fig. 12.1. Drawing of the device for modelling the effect of the impedance distribution of electronographic effects (original).

The biggest and most intense pellicular effects were generated by the lowest resistance, their size decreasing as the resistance increased.

The most intense electromorphous effects were also obtained with electrodes of low resistance.

By using an identical arrangement, four different capacitances of the order of 1 nF, 10 nF, 0.1 μF, 1 μF were placed on the same model.

The image reproduces the electronograph obtained using the previous model. It was also obvious that the pellicular and electromorphous effect depend on the capacitance, the biggest capacitances generating the smallest pellicular effects (fig. 12.3 a and b).

These two models demonstrate the dependence of both the pellicular effect and the electromorphous effect on the value of the electrical impedance of the skin.

With the aid of another series of models we have tried to investigate the dependence of the pellicular and electromorphous effects on the

Experimental Modelling of Electronographic Effects 163

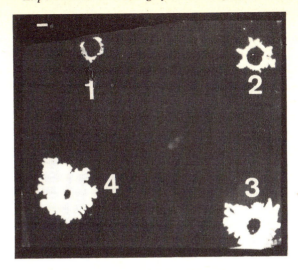

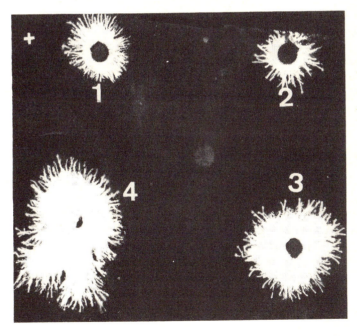

Fig. 12.2. Electronographic images (original) obtained on the model with different resistances: (*a*) negative impulse; (*b*) positive impulse.

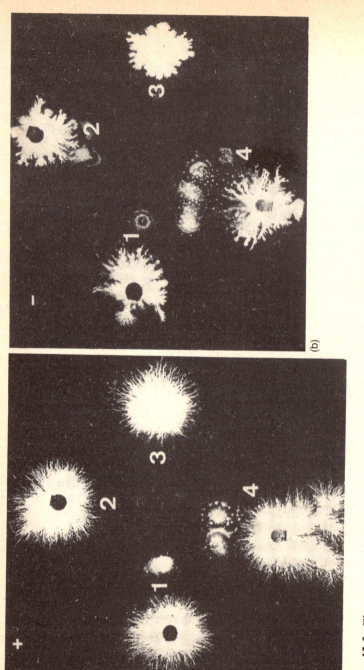

Fig. 12.3. Electronographic images (original) obtained on the model with different electrical capacities: (*a*) negative impulse; (*b*) positive impulse.

water content of the volume conductor (the body) and on the volume itself, and the area of contact surface. To this end different-sized cylinders were made of synthetic rubber by water polymerisation.

At the beginning, and during the drying process, the images showed important changes both in the pellicular effect and electromorphous effect.

It was seen that the pellicular effect, in conditions of high humidity, has a reduced number of streamers and produces a diffuse brightness around the body. When the humidity around the body decreases, the

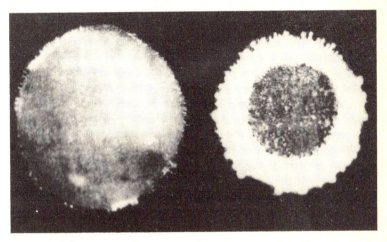

Fig. 12.4. Electronographic images (original), obtained on the model referred to in the text, in order to demonstrate the role of humidity (*a*) moist; (*b*) dry.

streamers assume a regular character, and the electromorphous effect decreases (fig. 12.4 a and b).

This phenomenon can be explained by the diffusion of electrons in the water vapour generated through the evaporation of water around the rubber model, with the consecutive formation and generation of streamers with reduced energy. The formation of arborisations of streamers indicates an increase in energy in the formation of avalanches and the maintenance of a high tension gradient, with their progress in time.

By using spheres of the same material, but of different volumes, we have found that the electromorphous effect depends both on the

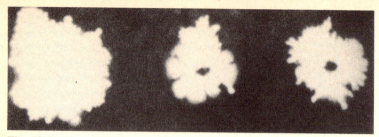

Fig. 12.5. Electronographic image (original) obtained on rubber models demonstrating the effect of volume and contact surface on the electromorphous effect.

explored volume and on the contact surface, increasing with the volume and contact surface. In the case of equal volumes the electromorphous effect increases with increase in contact surface (fig. 12.5).

12.2 Physiological conditioning of the pellicular effect

We have tried to establish, by carrying out a series of experimental research projects, possible correlations between the pellicular effect of the electronographic images and different functions of the organism under investigation.

We have thus found correlations between the electrical activity of the skin, and the pellicular effect manifested through the shape and intensity of the emitted light, and the geometry of the marginal discharges.

Electronography offers a real advantage over other electrographic techniques by electroluminescence, because it requires a very short exposure (an instantaneous image) which can characterise the electrical conditions of different physiological states. In order to measure the emitted light, we have made use of spectral analysis of the films and an electrono-optical system for direct recording with the help of photosensors. In this way, we have obtained electronographic images of hands and soles on radiological films. The exposures were carried out in different functional conditions, choosing an impulse of positive polarity which gives the streamers fine detail.

12.2.1 *Dependence of the pellicular effect on electrodermal activity*

Electrodermal activity is created by the skin, through complex functions, maintained by energy consumption and being characteristic of living organisms.

Experimental Modelling of Electronographic Effects 167

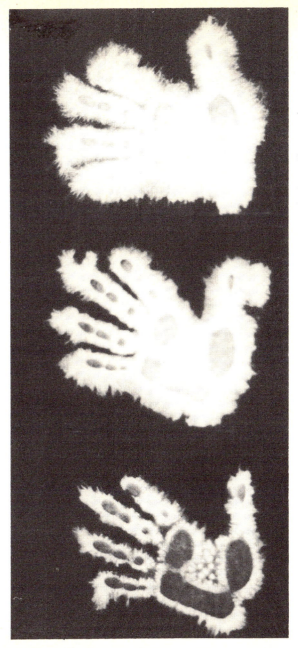

Fig. 12.6. Electronographic images (original) of the pellicular effect obtained in conditions of varying contact impedance with the electrode. (*a*) 160 KΩ; (*b*) 28 KΩ; (*c*) 12 KΩ.

Just like the cell membrane, the skin, in higher organisms, plays an active part in the maintenance of an energetic homoeostasis. Both thermal and electrical exchanges between living organisms and the environment take place with the aid of a control acting on the skin (fig. 12.6 a, b and c).

In the structure of the skin there are layers whose role is to insulate electrically, limiting it to electrical exchanges which at the same time are controlled by the central nervous system and can open up, allowing active electrical exchange between the organism and the environment (the 'occlusion-fenestration' phenomenon, Dumitrescu and collaborator, 1970). Sweat gland secretion, whether passive or active, is under the control of the autonomic nervous system. We know that sweating occurs due to a variety of sensory and psychic stimuli. The distribution of perspiration on the skin, as well as its electrolyte composition and organic ion contents, ensures a good electrical communication with the external electric medium, the dielectric structures in the skin being electrically shunted by sweat gland secretion, providing a much lower resistance as compared to the resistance of the sweat glands at rest. The dependence of these phenomena on psychic stimuli is a proven fact, and it is used in psychophysiological investigation. It has been possible to demonstrate that the electrodermal reflexes show not only the emotions and reactions to sensory stimuli, but also that the reflex responses are differentiated according to the emotional reaction type, distinguishing reflexes arising from particular emotions (of surprise, fear, etc.).

The dependence of electrodermal activity on psychic stimuli in man has led to the development of particular zones which have a predominantly psychogenic response, the so-called 'psychogenic sudoral areas' (palms, soles, forehead).

The philogenetic development of man from a quadruped organism where the neurogenic sudoral zones are on the plantar area zones of the limbs, suggests that these zones served, in the philogenetic past, for the discharge of energy surplus resulting from the electrostatic and tribo-electric charging of the body and its subsequent transmission to earth.

Thus, the sweat gland zones under autonomic control serve the adult individual in the same way for contact with the external electrical medium. Respiration causes discharges permanently into the environmental air, the expiratory air is ionised 'biological' air,

Experimental Modelling of Electronographic Effects

resulting from a mixture of water vapour and substances resulting from the metabolic processes inside the organism. The electrical elements introduced by the skin into an electric circuit of a high tension rating – corresponding to the front of the impulses used in electronography – behave like an RC circuit, with an impedance composed of the skin in series coupled with the internal resistance (capacitance) of the inside of the body, acting in parallel with the skin (fig. 12.7).

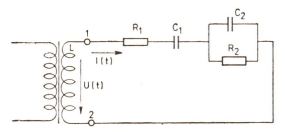

Fig. 12.7. Circuit of the exposure device (original).

The total impedance of this circuit is given by the following equations:

$$\text{in which} \quad Z_{(1-2)} = \frac{1 + (\tau_1 + \tau_2 + \tau_3)\omega + \tau_1\tau_2\omega^2}{\omega C_1 (1 + \tau_2\omega)}$$

$$\omega = \text{pulsation}$$

$$R_1 C_1 = \tau_1$$

$$R_2 C_2 = \tau_2$$

$$R_3 C_3 = \tau_3$$

The impedance of the skin is a variable determined by the value of internal capacitance and by the value of the surface resistance; the variation being accomplished by sweat gland shunting and by the depolarisation of the dermo-epidermal membrane, which represents the main cutaneous electrical barrier. Measurements carried out on this circuit have always been difficult because of artefact introduced by the measuring electrode's pressure, and of its polarisation in A/C or D/C current ratings, as well as by the numerous fluctuations due to the functionality of the cutaneous covering (in the main, by electrodermal reflexes).

Starting from these general principles we have carried out a series of studies into the value of certain electrodermal parameters and their correlation with electronographic images.

12.2.2 *Dependence of the pellicular effect on the frame resistance and electrical tension (EDr and EDu)*

We have followed up measurements on 25 human subjects, with the resistance value and of the electrical tension measured between the palm of the right hand applied on the electronographic screen, and the reference electrode placed at the high tension source, and connected at a distance of about 20 cm to the wrist joint. The measurements were carried out with the aid of a high impedance electronic millivolt meter, and a Wheatstone bridge to measure the resistance in A/C, interchangeable via an electronic switching circuit. The measurements were therefore carried out simultaneously, after which the electrodes were placed at the high tension source, and the surface of the palm was applied onto the recording screen.

By correlating the data with the electronographic images thus obtained we could deduce the dependence, of a constant character, of the amplitude and luminous intensity of the discharge on the value of the electrical resistance, and of the measured potential. We found the biggest discharges on subjects in whom we measured the smallest resistance values and small, negative values of electrical tension. Also on the subjects with low palmar electrical resistance, we noticed that the discharges were diffuse and in those with high electrical resistance, branches appeared with intense arborisations with precisely outlined streamers.

12.2.3 *Dependence of the pellicular effect on variation of resistance and skin electrical tension (ΔR and ΔU) of a reflex character (electrodermal reflexes)*

In experiments with twenty normal subjects we recorded, using radio-telemetry, the values of electrical resistance and tension from the palmar and dorsal surface of the hand, for particular time periods, whilst on the opposite hand we recorded the electronographic images of the palm. The recordings were made at different tension and resistance values, measured during sweat gland inactivity and during electrodermal reflex activity.

The electronographs obtained in these conditions have demonstrated that the image created by the pellicular effect can be different for the same subject, depending on fluctuations of resistance and tension values generated by electrodermal reflex activity.

In the case of electronographic recordings made on workers who work in high intensity electromagnetic fields of 60–80 kilogauss, the images were much brighter and with more diffuse discharges than in other types of workers. We explained these findings as being due to increased autonomic outflow to the sweat glands, which secrete with a richer hydroelectrolytic content.

Research carried out in these subjects has shown a statistically significant increase in electrical conductivity, and of potentials recorded on the palms. These observations were not found in control groups of industrial workers working in environments free from electromagnetic pollution, but with other pollution, physical or chemical, and neither were these observations made in normal subjects.

All these findings confirm the existence of a correlation between the sympathetic nervous control of electrodermal activity and the characteristics of the pellicular effect recorded electronographically.

In another series of experiments, we tried to obtain different recordings of the pellicular effect both during and outside electrodermal reflex activity and determining the correlation with the timing of sweating. We recorded, simultaneously, skin resistance (the Fere effect) and potential (Tarchanoff), using radio-telemetry with apparatus of the Hellige type which was modified (one of the channels records electrical potential reflexes, the second electrical resistance reflexes and the third skin temperature using a thermistor probe held in the hand) (fig. 12.8 a, b and c).

In this way we examined 35 normal subjects. In all cases investigated by us we noted marginal discharges with numerous ramifications, which attain a maximum value once the maximum amplitude of the reflex is attained. This was maintained on the descending slope of the reflex and continued immediately after the reflex ceased, the pellicular effect ending up being smaller than it was prior to the activation of the electrodermal reflex.

This chronology of different pellicular images, dependent on electrodermal reflexes, can be attributed to variation of electrical conductivity of skin due to sweat gland activation.

Therefore, at the time of appearance of the electrodermal reflex,

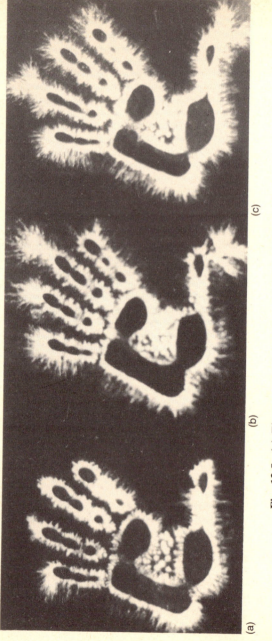

Fig. 12.8. (a) Electronographic image (original) obtained in conditions of basal electrodermal activity; (b) image made at maximum electrodermal reflex activity; (c) after the electrodermal reflex.

a series of functional changes (increase in permeability of basal membranes, cellular migration of hydroelectrolytic components of perspiration and contraction of the myoepithelial apparatus, connected to the sweat glands) occurs synergistically, and these changes produce and expel perspiration for approximately one second.

With the aid of a hygroscopic and thermal gradient, perspiration is expelled in a vapour-like form. During the process of violent tearing of electrons out of tissues, the vaporisation increases and at the same time an intense ionisation of the layer of pre-existent gaseous ions takes place. At the time of reaching the maximum value of the electrodermal reflex electrical conductivity is at its maximum, and abundant active ionisation occurs.

On all of the descending slope of the electrodermal reflex, as well as immediately after it stops, aeroions adhering to the skin can be seen; a few of these detach themselves and pass into the environment. Active retro-absorption mechanisms come into play on the skin, causing a drop in electrical conductivity of the proximal medium. At this moment, there is a corresponding reduction in brightness, and of size, of the proximal effect.

This research has enabled us to assign variations of luminosity of the homogeneous discharge of Kirlian type, not directly to a psychic action, but to the consequence of an autonomic mechanism for the control of surface energetic phenomena which can be identified as the mechanism of electrodermal control.

We believe, however, that it is useful to explore with the aid of the Kirlian technique, as well as the electronographic exploration of the pellicular effect, because in this way unknown aspects of the energetic interrelation between body and the electrical medium in its immediate vicinity can be shown. The pellicular effect shows the ways in which these changes take place and also enables the study of their dynamics, that must not be confused with phenomena occurring in physiological conditions.

12.3 Dependence of the pellicular effect on the peripheral circulation

Peripheral circulation accounts for the main energy source of the tissues by metabolic and gaseous transport to and from the tissues. We have followed up, in a series of experiments, the correlation between the pellicular effect of the electronographic image and the

arterial, capillary and venous circulation of the area under investigation.

The use of high frequencies, of the order of those derived from the high tension impulse used in electronography, reduces surface resistive and capacitive effects.

Due to this fact, high frequencies are currently used in the rheoplethismography method, in which volume variation of a body segment due to the filling and emptying action of the circulatory tree is converted into an impedance variation. The relationship between the amplitude of the rheographic wave and tissue volume under investigation is called a relative pulse and is expressed in promiles per second being calculated on the basis of the formula:

$$\Pr\%_{00} S = \frac{\Delta R(m\Omega)}{R(\Omega)\, T(s)}$$

in which ΔR is the difference of resistance, represented by the rheoplethismographic wave, R – the resistance of the tissue, and T – the duration of the cardiac cycle. Normal values are higher than $1\%_{00}/s$.

Whilst monitoring the capillary pulse by rheoplethismography and photoplethismography, we have obtained simultaneously electronographic images of the opposite hand, at two specific moments, related to the peripheral circulation, at the moment of systole and during diastole.

We made 218 recordings by taking electronographic images at these two moments of peripheral circulation. The pulse curves have been recorded and superimposed on the signal generated by the electronographic impulse, therefore linking the recording with the timing of the pulse.

We have noticed in all recordings that images obtained during systole are bigger and have more luminous pellicular effects than those obtained during diastole. Also, during thermal or reflex vasoconstriction, the images obtained during the same moments (systole and diastole) show smaller and weaker pellicular effects than those given by normal peripheral circulation. Vasodilatation produces opposite effects. Circulatory stasis affects the discharges in the first four minutes, and then they lose their fascicular characteristic and become diffuse. In the first few minutes of venous stasis the image is modified less and has a more extended and diffuse pellicular effect after the first minute of such stasis. The recordings show an important

circulatory conditioning of the electronographic image, made manifest by the pellicular aspect.

In chronic ischaemia we have often encountered extension of luminous zones, looking like 'snowflakes', around an ischaemic hand or foot. We attributed these differences from the normal to peripheral sympathetic paresis which produces dysfunction in sweat glands causing continuous perspiration, especially on the soles.

12.4 Dependence of the pellicular effect upon central nervous control of electrodermal activity

Palmar recordings made during profound narcotic sleep, when compared with recordings made during the waking state, have shown that the discharges in wakeful states have a well-defined character with emission pores generating streamers, whilst the pellicular effect during sleep shows a diffuse luminous aspect in which discharges no longer appear grouped together, but branch out all over the skin.

The same finding is met with over denervated areas, or areas infiltrated by local anaesthetic. In studying the role of the neural control of electrodermal activity we have recorded electronographic images on normal frogs and compared these with frogs with the sciatic nerve severed, and with frogs whose spinal cord had been cut. We found that in the absence of nervous control the skin and the denervated tissue generates totally different images, with the disappearance of streamers, and with the appearance of diffuse luminous zones indicating increasing transcutaneous water loss. This shows convincingly the role of sympathetic innervation when obtaining electronographic images (fig. 12.9 a, b and c).

The changes can only be due to a diminution of peripheral sympathetic tonus which controls the dynamics of the skin. In these conditions the cutaneous electrical barriers become permeable to cations and water. For the human body in states of denervation the sweat glands secrete continuously and slowly. They express partial or total, reversible or permanent loss of central nervous control over electrodermal activity and, in a wider sense, over the energetic exchanges of the body.

The electronographic images during natural sleep show a diminution of the intensity and extent of the pellicular effect, compared to the effect seen during narcotic sleep. The images of cerebral recordings on subjects in narcotic sleep and in decerebrate patients

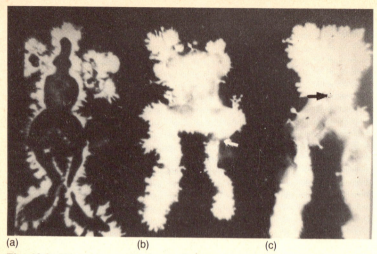

Fig. 12.9. Electronographic image (original) of frogs: (*a*) normal; (*b*) with the right sciatic nerve severed; (*c*) frog with the spinal cord severed.

show changes of a diminution in luminous intensity of the images obtained. This finding can be interpreted as due to the electrodermal effects on the cranial skin of decerebration and of narcosis. Starting from these findings, we tried to verify the dependence of the pellicular aspect of the electronographic image on the neurovegetative reactivity of the subject under investigation. With this in mind we have recorded electronographs in different states of reactivity, correlating the image thus obtained with the following tests: the electro-encephalogram according to its amplitude and frequency; during the latency period of electrodermal reflexes; and the speed of nerve impulse propagation in peripheral sympathetic fibres.

In all cases under investigation, we have observed that states of normal neurovegetative reactivity are characterised by images with a relatively regular distribution of arborisations, whilst states of stress, as well as those of autonomic exhaustion, are characterised by a diminution in the pellicular effect shown in the electronographic image.

Toxic damage to peripheral fibres which produces a slowing down in the speed of impulse propagation in peripheral sympathetic fibres manifests electronographically as flat unclear images (and produces diffuse pellicular effects).

Chapter 13

Exploration Using Transparent Electrodes and Dynamic Electronography

13.1 Introduction

The study of electroluminescent phenomena inside the body has been of special scientific interest.

The dynamics of the luminous phenomena, as well as the interrelations between various organs and even between different people, has led to the need for equipment whereby electroluminescent images could be visualised and examined directly.

Direct examination of high tension discharges through ionisation channels and obtaining successive images in series on cine film with the aid of high speed cameras, constitutes one possible way of examining dynamic energetic events in the body. This method is used in high voltage examination techniques for use in industry.

Exploration with the aid of high frequency current made it possible to visualise electronographic images of the surface of the body directly.

S. D. Kirlian and Valentina Kirlian have put forward, and used, various techniques for direct visualisation with the help of optical and electrono-optical devices.

One such device is made of a transparent roll made from an insulating material inside which are transparent conductive wires to which the high tension current is applied. Rolling such a transparent electrode over the skin enables zones of luminescence to be found.

Direct examination of various body regions in these conditions has shown different-coloured images.

Thus, examination of the heart zone shows a deep blue colour, the forearms a blue-greenish colour, and the thigh an olive colour.

Another method for direct exploration via an electrono-optical device has been used for the examination of smaller structures. Such

a device enables the behaviour of small-size structures to be followed, and thanks to the use of an image amplifier enables enlargements to be made (fig. 13.1).

Another device for direct visualisation which has been used is an optical condenser system called 'electron-proton'. In this device with the aid of high-frequency current, transmission of an image onto a fluorescent screen in the presence of gas at low pressure can be

Fig. 13.1. Optical device for visualising discharges.

achieved not by the discharge in an auto-electron acceleration space, but via a selective capacitive conductance. The image is transmitted through a medium at atmospheric pressure into an air-free receptacle, with strict super-imposition of the object onto the dielectric of the device (fig. 13.2).

This system differs from the classical principle of the Kirlian effect, being similar to the principle of electronography in which there are no gaseous spaces between the organism under investigation, the light sensor, the dielectric and the electrode, or for the auto-electronic emission, the image being formed by the action of electron fluxes similar to propagation in a vacuum. This system, called by

Kirlian an 'electron-proton system', reproduces optical densities of the image and their dynamics for small-size organisms and structures. The visualisation of electronographic images presupposes the application of essential principles of electronography, as distinct from high tension sources at high-frequency ratings.

Electronographic sources with controlled impulses have the disadvantage of poor light emission, and an extremely short exposure.

Fig. 13.2. Proton-electron devices.

Dynamic observation of electronographic images requires the following technical conditions:

1. Securing a series of fundamental images, within the limits of physiological optical fusion, and an ability to resynthesize the dynamic changes of the phenomena;
2. Visualising or recording the phenomena through transparent electrodes, with minimum luminous retention;
3. Using amplifying layers of light, interposed within the optical system, able to amplify the photon emission with a remanence not exceeding the time required by the system for processing the image.
4. Using photomultipliers interposed between the exposure system and that of image reproduction.

13.2 Obtaining fundamental images in series

Electronography obtains a fundamental image achieved using a single impulse, and in well-defined conditions.

In following up the dynamics of electronographic phenomena, reproduction in series of the fundamental images in time sequence is necessary. The duration of the fundamental image is that of the impulse, being between 1.5 and 50 μs. But the effective duration is prolonged by the persistence of ionisation phenomena, as well as by the remanence of the light amplifier, phenomena which, altogether, must not exceed 0.06 s (1/50–1/16 s).

At the same time the image obtained on the collecting screen must be perfectly synchronised with the recording device (TV or cine camera), so that each frame corresponds to a fundamental image. In this way, the succession of images will reproduce the differentiated electrical characteristics of the electronographic image in functional (temporal) succession.

The synchronisation of the high voltage impulse with the imaging camera (TV or cine) is carried out by means of electronic control circuits.

When using direct observation, frequency within the physiological limits of the fusion frequency of the frames is used.

13.3 Use of transparent electrodes

The use of transparent electrodes, made from conductive material, has preoccupied many researchers.

One of the most widely used solutions has been the manufacture of transparent screen made of acetate or other plastics, with fine metallic deposits applied.

The metals can be deposited chemically, electrolytically, or by injection at high pressure, and temperature on crystals of different composition (e.g. by plasma jet).

White metals, Ag, Al, In, St, An, etc., have been frequently used for deposits onto glass, under metallic or oxidised composition.

For deposits in layers of the order of microns, special methods have been evolved for obtaining particular fineness, for instance, the 'transparent electrode' under delivery number 60 945, manufactured by the firm Eddison, or the French technique called 'Pyrosol'.

For the exploration of the electroluminescence effect Ross

proposes an electrolyte solution placed between two transparent sheets of glass.

Beck uses a saline solution in a glass tube.

In order to create transparent screens, we have used similar techniques in several variants.

(*a*) A large transparent screen was made up of two transparent glass plates with an inner space of 40 sq. cm., the distance between the plates being 2 mm. The screen was filled with an electrolyte solution of sodium chloride and hydrochloric acid at a pH of 4. The glass plates were glued together at their edges, over a 5 cm distance, with epoxy resin.

(*b*) Transparent screens were also made by placing a fine layer of agar–agar 2% with sodium merthiolate 1/1000, which is a gel at normal temperature, between the two glass plates. The tightness and insulation were again ensured using epoxy resin.

(*c*) Particularly interesting results were obtained when using transparent screens made from pressure-resistant plastics, with an inner space into which were introduced rarefied gases at pressures of the order of 10^{-2}–10^{-4} atm. Under the high tension impulse, the low-pressure gas becomes conductive and ensures simultaneously the transparency and luminosity of the image.

(*d*) Devices with transparent electrodes, containing electrolyte solutions or low-pressure gases, which were adaptable to TV or cine cameras, have also been timed, by means of which images were obtained in daylight, the objective having been shielded by protective and absorptive layers of external light.

13.4 Chemical photomultipliers

The use of layers of chemical photomultipliers fulfils two main aims in dynamic electronography.

(*a*) The amplification of light by the conversion of variations in particular spectral zones, ordinarily invisible in visible light, and:
(*b*) The energetic differentiation of the electromagnetic field by the different reactivity of the electrono-optical converters.

Fluorescent substances used to show the electromorphous effect require a remanence not exceeding 0.06 s.

When the sequencing does not require exact chronological reproduction, screens with long remanence can be used.

13.5 Image photomultipliers

The filming of electronographic images with reduced luminosity even using highly sensitive films requires a longer exposure time.

In order to obtain a high-quality image, ultra-sensitive cameras need to be used, or when the image is particularly dim or the intercalation of a photomultiplier is essential. The use of colour image amplifiers opens up many possibilities in dynamic electronography.

13.6 Methods of dynamic electronography

1. Direct continuous observation can be achieved by observing the electroluminescent phenomena with the aid of a transparent electrode, or by projecting the image onto a fluorescent screen. Direct observation can be achieved at normal size, or after the image has been enlarged by electronic magnification.
2. The filming of electronographic images is obtained by synchronising the filmed frames with each image obtained by the single exploratory high tension impulse.

Black-and-white or sensitive colour films are commonly used. Also a screen with a long remanence can be used, and this effect can be enhanced by extending the exposure time for each frame. As a result, a time-lagged sequence is obtained which enables the observed phenomena to be followed in slow motion. Colour image amplifiers can amplify the image up to 50,000 times.

13.7 Electronovision

This is a useful method for dynamic exploration of the body using electronographic images (fig. 13.3).

The use of video-cameras with selective sensitivity to certain bands of the visible light spectrum, enables the images to be differentiated according to the wave-length of the emitted light on magnetic tape, and then processed electronically allowing further analysis of the images (relief effect, the delimitation of equidensity contours, extractions and super-impositions by correlating images, etc.).

Electronovision also facilitates computer-aided image processing.

Transparent Electrodes and Dynamic Electronography 183

Fig. 13.3. a and b. Equipment for obtaining images of the body in TV circuit (original). (*a*) with flat electrode; (*b*) with electrode using vacuum transmission of images (videotube transducer).

184 *Electrographic Methods in Medicine and Biology*

13.8 Results of investigations carried out using dynamic electronography

By following electronographic phenomena directly we have collected some interesting data concerning the distribution and composition of the proximal electric medium. It has been possible to study the adherent ion layer which lies over the skin.

It can be shown that this layer has a rich water vapour content which affects, to a large extent, its size and adhesion to objects in the environment. This layer of aeroions is constantly freshened up via the transcutaneous passage of water, organic substances and electrolytes. By comparing two different people it can be shown that their adherent aeroion layers show different phenomena of attraction and confluence, of precise delimitation or of diffuse radiation.

By using a direct observation method (electronovision) the phenomena of image remanence have been noticed after contact with the screen has been cut off. This has been erroneously interpreted by

Fig. 13.4. Equipment for processing the electronographic image in TV circuit. 1. TV camera. 2. Electronographic image. 3. Computer. 4. Feeding source. 5. Monitor. 6. Video-tape recorder (original).

some as a phantom image, having in turn produced many erroneous interpretations.

If traces of aeroions are left on the glass screen, or on the fluorescent material, then these can, by exploring them in an electromagnetic field, reproduce the initial image even after a considerable time lapse. This phenomenon is due to the adherence of aeroions resulting from transcutaneous water, organic substances and electrolytes onto the investigation screen.

A similar phenomenon is sometimes encountered when part of a leaf is cut off and photographed. An apparent recreation of the part removed sometimes shows on the resultant image.

This phenomenon can be explained by the organisation of the proximal electric medium composed of water vapour and organic substances arising from the leaf.

PART III

OTHER ORIGINAL ELECTROGRAPHIC METHODS IN BIOLOGY

Chapter 14

Principal Electrographic Techniques Used in Study via the Electronographic Method

14.1 Electrography by high tension sparking gap

Electrographic methods used in the exploration of biological and non-biological structures differ in the characteristics of the exploring electromagnetic field, because of the phenomenology of the physical processes which characterise the interaction of this field, and the explored object, and because of the methods used for the graphic recording of these processes.

Among the interactions which take place between the exploring electromagnetic field and the object under investigation is the effect of electroluminescence, an effect frequently used in electrography.

These effects are generated either by luminescent electrical discharges in gases, or by the excitation, in an electromagnetic field, of luminescent substances such as phosphors, etc.

The electrographic methods based on electroluminescence due to electrical discharges in gases are Kirlian photography, spectrography by electroluminescence and electronography, the last one using also as an essential element the luminescence generated by electrono-optical convertors. All these methods are discussed in detail in other chapters of this book.

Another electrographic method, using the electroluminescent effect generated by an electrical discharge, is electrography by high tension sparking gap. With the help of this technique, zones and points of minimal impedance can be demonstrated, and in these areas electroluminescent discharges occur, generated in the electric field from the high tension source. This technique is used in fault-finding (defectoscopy) for insulators.

The luminescent discharges generated by ionisation channels are determined, on the one hand, by the impedance distribution on the

surface of the object under investigation and, on the other hand, by the volume distribution of the impedance in the dielectric medium (gaseous, liquid or solid) interposed between the object being investigated, and the electrode on which the sparking potential is applied. When the interposed dielectric medium is homogeneous and isotropic, from an electrical point of view, and when the exploratory electrode has a geometry which gives a uniform field distribution, photographic recording of electroluminescent discharges enables the distribution of impedance on the exposed surface of the studied object to be seen. In this way, electrography using a high tension sparking gap is useful in detecting the electrodermal points, points which are characterised by low electrical resistance compared with the surrounding skin. Photographing the discharge channels by ultra-fast processes makes it possible to follow, sequentially, the formation of sparking channels, thereby demonstrating the dynamics of the processes occurring in electroluminescent discharges.

14.2 Electrography by weight-motor effect

Electrography by weight-motor effect is included in the category of electrographic methods, and is based on the non-luminescent effects of the electromagnetic field applied to the structure under observation.

Weight-motor effects are due to the orientation and migration within an electric field, of neutral, or electrically charged dielectric particles. In order to describe quantitatively the weight-motor effect on neutral particles let us examine the case of a dielectric under the action of an external electrical field.

A fundamental property of dielectrics consists in the impossibility of an electric current flow across them. Because of this the intensity of a constant electric field applied across dielectrics is not necessarily null, the equations which describe this field being given by electromagnetic theory.

$$rot \, \vec{E} = 0 \qquad (14.1)$$

$$div \, \vec{E} = 4\pi \bar{\rho}, \qquad (14.2)$$

where E is the intensity of the external electric field, and ρ – the mean charge density per unit volume of the dielectric.

In the case where no 'free' charges are introduced inside the substance of the dielectric, the total resultant charge for the whole

volume of the dielectric remains zero, and after its introduction into an electric field:

$$\int \rho \, dV = 0. \qquad (14.3)$$

This integral relation (which corresponds for any body of any shape) signifies the fact that the mean density of charge can be written in the form of a vector which is shown as \vec{P}:

$$\rho = -\operatorname{div} \vec{P}. \qquad (14.4)$$

The value \vec{P} is called the vector of dielectric polarisation of the respective body; a dielectric for which \vec{P} is above zero is polarised. The physical sense of vector P is that it represents the dipole moment per unit volume of the dielectric.

By dividing (14.4) into (14.2), we obtain

$$\operatorname{div} \vec{D} = 0, \qquad (14.5)$$

where \vec{D} is a new value, defined as:

$$\vec{D} = \vec{E} + 4\pi \vec{P} \qquad (14.6)$$

So that the equations (14.1) and (14.5) should constitute a complete system of equations one must add to them the relation between induction \vec{D}, and intensity \vec{E} of the field. In most cases this relation can be considered as linear, being bound by the fact that by comparison with internal molecular fields, external electric fields are small. The linear dependence between \vec{D} and \vec{E} is described in most cases by the following simple formula:

$$\vec{D} = \epsilon \vec{E}, \qquad (14.7)$$

where coefficient ϵ is the dielectric permittivity of the substance, and is a function of the thermodynamic state of it. It is proportional to the field, and polarisation \vec{P}:

$$\vec{P} = \chi \vec{E} = \frac{\epsilon - 1}{4\pi} \vec{E}, \qquad (14.8)$$

where χ is the dielectric susceptibility.

For thermodynamic considerations, when looking at the dielectrics' behaviour in an electric field, we see that total free energy is given, in the conditions specified above, by the relation:

$$F - F_0 = \int \frac{D^2}{4\pi\epsilon} \, dV \qquad (14.9)$$

where F_0 refers to the dielectric in the absence of the field.

By varying ϵ the field induction varies also. When calculating the resultant variation of energy in this case, we obtain:

$$\delta F = \int \frac{\vec{E}\,\delta\vec{D}}{4\pi}\,dV - \int \frac{E^2}{8\pi}\delta\epsilon\,dV \qquad (14.10)$$

If we consider the variation of the field with constant sources, the first term in the right side of equation (14.10) cancels out, and therefore:

$$\delta F = -\int \delta\epsilon\,\frac{E^2}{8\pi}\,\delta V \qquad (14.11)$$

From equation (14.10) conclusions regarding the direction of movement of the dielectric body in a quasihomogeneous field can be determined; in other words, in a field which can be considered to be constant at equal distances from the body under examination (the practical case for proving the weight-motor effect). In this case E^2 leaves the sign of the integral and the difference $F - F_0$ is a negative value proportional to E^2. On the other hand thermodynamics tells us that the different thermodynamic potentials (amongst them, free energy also) have the ability to reach, in a state of equilibrium, a minimum compared with the arbitrary variations in the state of the body. By trying to occupy a position in which its free energy should be minimal the body will therefore move in the direction of increase in E. This is how we can explain the orientation and migration of dielectric particles occurring in the weight-motor effect.

The weight-motor effect also shows itself where the particles which migrate have electric charges either above or below zero.

In an external electric field E, they orientate themselves in the directions of the force lines, the interaction with the field being given by the relation:

$$\vec{F} = Q\vec{E}, \qquad (14.12)$$

where F is the interaction force and Q – the electric charge of the particle.

By using the weight-motor effect a method was devised for directly obtaining electrographic images of the body in daylight.

In this method, PVC microspheres are used, electrostatically charged and covered with fine graphite and colophonium. The powder thus obtained is spread in a uniform layer between two sheets of porous paper which are applied on to a recording screen. The

screen is connected to one of the terminals of the field source, and the body being investigated is connected to the other terminal, and is applied on to the screen through the paper sheets between which lies the layer of powder. After exposure in this field the two paper sheets are removed, and the images thus obtained are fixed, by heating on a

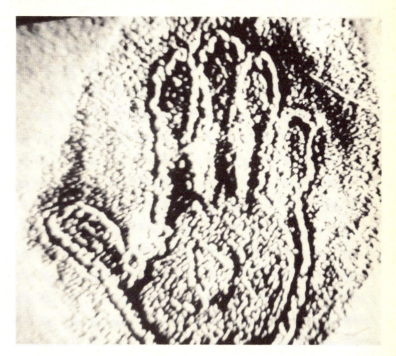

Fig. 14.1. Electrography of a hand by weight-motor effect with microparticles without charge (original).

metal plate. The fine common resin powder acts as a fixative on the graphite granules.

The electrographic images obtained by this technique show the interaction between the electromagnetic field of the exploratory source and the biological system under investigation. One case demonstrated both the space structuring of the electric field around the object being studied and the attenuation of this field as it was propagated differentially through the body (figs. 14.1 and 14.2).

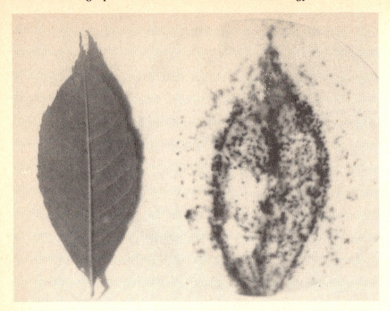

Fig. 14.2. Electrography of a leaf on ozonometric paper containing starch and potassium iodide. This method is an example of the weight-motor effect associated with the electro-chemical effect (original).

By this method, the electrodermal points can be shown around which force lines tend to come together, and often combine. Also, at the marginal zones, a lack of continuity of the maximum density of the field is seen. When the intensity of the electric field is small, precise images of the fingerprints can be obtained (fig. 14.3).

Electrographic images by weight-motor effect depend on the physical conditions in which they are done; the intensity of the applied electric field, the dielectric properties of the particles which migrate, the characteristics of the migration medium (electric, rheologic, surface properties, temperature and humidity).

In order to obtain reproducible images, the recordings must be done in standardised conditions (fig. 14.4).

The weight-motor effect associated with electrostatic charging has been used in electrography, utilising electrostatic polarisation. This method is based on the phenomenon of migration in an electric field by weight-motor effect of certain dielectric or semi-conductor

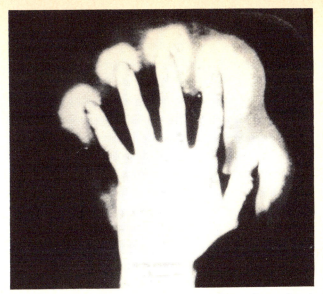

Fig. 14.3. Dynamic exploration of the force lines of an electric field propagated through the hand and utilising very fine powder as tracers (original).

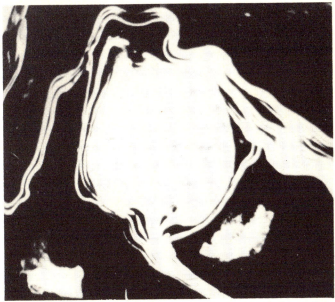

Fig. 14.4. Electrographic image of weight-motor effect around a leaf (original).

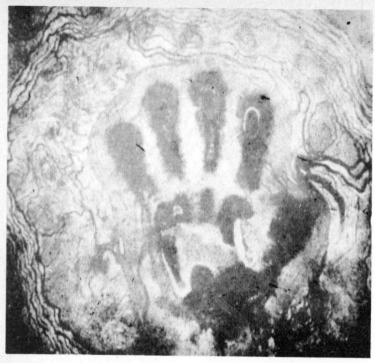

Fig. 14.5. Distortion of force lines produced by the different impedances of a hand (original).

materials which gather by electrostatic charging (as a result of the phenomena of polarisation) microgranular pigments through which the image is transduced. The electric field is generated by a high tension source, which gives rise to a single, monopolar impulse identical with that used in electronography (figs. 14.5 and 14.6).

By this technique, a clear reproduction of electronographic images can be obtained.

14.3 Electrography by blocking the secondary light emission (the first variant of convertography)

Electrography by blocking the secondary light emission is based on the use of a luminescent screen with secondary light emission of the

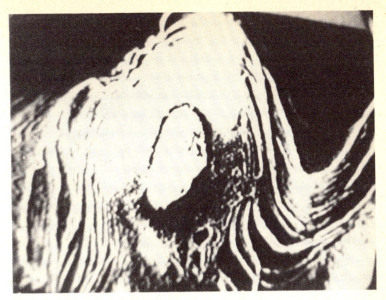

Fig. 14.6. Detail of distribution of the force lines around a finger (original).

phosphorescent type on which one places the organism under investigation in an electric circuit at different tension values (high or very high).

Following the action of visible light on a substance with phosphorescent properties, the excitation of the free and molecular electrons takes place, which on returning to the rest state emit secondary radiation (or phosphorescence). If the excited phosphorescent layer is bombarded with electronic fluxes produced by a high tension electromagnetic field, an effect of blocking this secondary light emission occurs. The images obtained by this effect reproduce, by outline and shading, the characteristics of the electronic emission (fig. 14.7).

In order to obtain electrographs by this effect a screen whose active substance was a mixture of metallic sulphides, with a phosphorescent remanence of ≈ 2s, was used, this substance being deposited onto a dielectric backing. The organism being investigated was placed on the dielectric backing, being connected to the table of the impulse source (a source with variable characteristics). The circuit was closed through a transparent electrode insulated from the

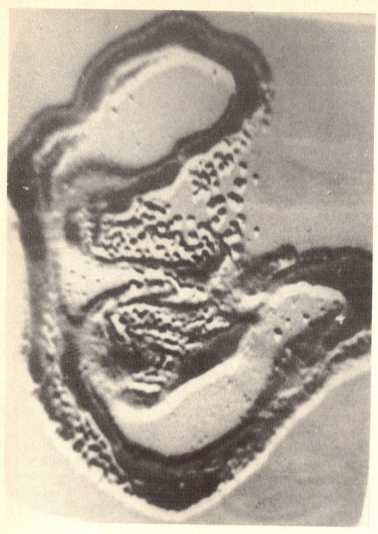

Fig. 14.7. Hand electrography by blocking the secondary light emission (original).

phosphorescent screen by a dielectric, also transparent. The phosphorescent excitation is obtained from an intermittent source of external light whose control is coupled to the tension source.

The images are collected by closed TV circuit or are photographed through the transparency of the electrode and of the dielectric layer. Due to the blocking of phosphorescence (secondary light emission), these images show dark zones whose distribution depends on the characteristics of the object under investigation, as well as the amplitude and polarity of the impulses applied to the exploratory circuit.

This method demonstrates certain characteristics of the structures being investigated, which can be compared with details obtained by methods using electroluminescence phenomena. Thus we obtained images with a marginal zone corresponding to the pellicular effect, being more marked when positive impulses were used. The external contour of the images depended on the structure of adherent aeroions, whilst the inner images reproduced the electrical configuration of the organism under investigation.

The effect of blocking the secondary light emission can be explained by the interaction of the electronic emission generated by the electromagnetic field with excited molecular electrons of the phosphorescent underlayer. The electrons from the flux emitted in the field occupy the free fundamental energy states of molecules, so that the electronic transitions from the excited states do not occur any more, transitions which generated the photons (i.e. luminescence).

This phenomenon is affected by the intensity of the electromagnetic field propagated through the object under investigation, as well as by the temperature, the phosphorescent emission decreasing whilst the temperature increases due to amplification of electron mobility.

Electrography by blocking the secondary light emission represents, together with other electrographic methods, one way of exploring the body electrically, and its interactions with the external electromagnetic medium.

14.4 Convertography, a method for examining biological systems

The convertographic method is based on the principle of the energetic conversion of a transitory electromagnetic field into images by the electronic saturation or substitution phenomenon during

transitory and labile states, properties characteristic of phosphorus and phosphorus-like substances.

This method is based on the property of certain chemical substances to change the energetic states of their weakly bound electrons which are made to pass from a fundamental state to an excited state. Starting from the need to differentiate the electromagnetic fields used in electronography, we have studied the behaviour of certain luminophores which, in certain combinations, show the convertographic phenomenon. This phenomenon was described for the first time in 1976 (Dumitrescu).

The phosphors used are inorganic and of the metallic sulphide and complex halogens group, with controlled impurities added of rare elements. The substances used are magnesium, zinc, tin, cadmium sulphides, also complex hallogens of calcium, magnesium and barium with impurities of rare elements added from the lanthanide series: Ce, Eu, Gd, Tb.

Numerous experiments have led to perfecting a convertographic method for the investigation of the body.

14.4.1 *General principles of the method*

This method is based on the phenomenon of electronic saturation by the varying image energies of substances with marked electronic mobility which can be differentially excited, both by an electromagnetic field and by photon emission in the ultra-violet and x-ray regions. This phenomena is of a physical nature, and has been demonstrated during experiments carried out in our laboratory in 1976. These experiments had necessitated the setting up of special equipment in order that the phenomena could be reproduced without variation (figs. 14.8 a and b).

The general principle of a convertographic apparatus consists of transforming the effects of a transient electromagnetic field, followed by memorising this in a converting structure, and subsequently reproducing this with the aid of an irradiation device using ultra-violet or soft x-rays. This apparatus consists of a single impulse source of medium, high and very high tension which is applied through the body to be investigated directly onto the converter underlayer, or through dielectric separation layers which not only protect electrically, but ensure the control of the distribution of the electromagnetic field through the body under study.

Principal Electrographic Techniques Used in Study

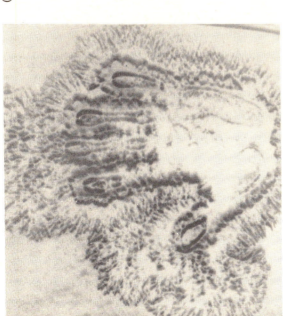
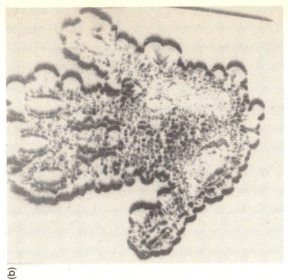

Fig. 14.8. Convertographic image of a human hand (original), showing the characteristics of electric discharges in a solid body through electronic transmutations: (*a*) with a positive impulse (10 kV); (*b*) with a negative impulse (10 kV).

The converter under-layer is made up of a mixture of converting substances, deposited in a uniform layer and with a homogeneous composition onto cardboard, plastic or glass backing. The mixture of converting substances is chosen on the basis of their ability to memorise the electromagnetic phenomenon.

The exposure time in the electromagnetic field represents the first stage required for obtaining a convertographic image. This time depends on the characteristics of the source and on the electrical characteristics of the propagation medium (i.e. body to be investigated, and intermediary dielectric structures). The second time span required in the convertographic process is the time taken for memorising the image which can be of the order of tens of seconds up to minutes, and can be varied according to the qualities of the converting substance used.

The third essential time is that of exposure of the converter layer with its memory to high frequency photon radiation in the high ultra-violet or soft x-ray regions. This method is known as photonic post-excitation convertography. It is different from blocking of the secondary light emission, which is sometimes known as photonic pre-excitation convertography.

In principle, the method consists in the partial or total placing of a living organism in an exposure system of the electronographic type, the difference being that no photosensor such as ordinary film is placed on the exposure screen. In the device the converting screen is exposed in an x-ray device, showing the distribution of the electromagnetic field in extremely fine detail. By superimposing the convertographic foil onto a photosensitive film the image can be copied photographically.

14.4.2 *Recording of convertographic image*

To start with, the physical body to be explored is introduced into the electromagnetic field generated by the high tension source, which discharges the impulse inside a device of the complete or incomplete condenser type.

The exposure is made in conditions of reduced light, or in low intensity red or green dark room lighting.

After an interval of time, depending on the memory capacity of the converting layer used, the converting foil is put into the irradiation device and there exposed to soft x-rays.

This produces an image which can be picked up both directly radioscopically and also indirectly, by copying it with the aid of photosensitive film (i.e. a radiograph) and transferring the non-visible image memorised by the convertographic foil into photosensitive film. More recently other variants of convertography have been developed by the author (Dumitrescu) – synchroconvertography – in which exposure in an electromagnetic field and photonic exposure are carried out simultaneously.

14.4.3 *Significance of the convertographic image*

The convertographic method offers a possibility of transducing into images, the effects of a low tension exploratory electromagnetic field.

Fig. 14.9. Convertography with the interaction of the lesional fields from two amputated leaves (original).

Fig. 14.10. Convertographic image of two human heads placed in the same electromagnetic field. The field gradient can be seen determined by reciprocal interaction (original).

In this sense, this method may be considered as the most sensitive amongst all the electrographic techniques.

Convertographic images were taken of various parts of the body and when these were correlated with electronographic images, the convertographic images show many fine details better than the electrographic images, and brings out the particularities of distribution of the electromagnetic field according to the electrical impedances distributed in the structure being investigated.

The pellicular effect as seen in convertography depends on the polarity of the applied impulse as well as on the composition of the converting mixture which shows clearly how sensitive the convertographic method is when showing streamers.

The internal images of the organism under study demonstrate, via dark zones, the distribution of the electromagnetic field through zones of minimal impedance. In this way convertography can be used as a diagnostic method for electrical skin studies.

The functional and diagnostic significance of this method, as well as its numerous possible applications, are in the course of being systematised. This will be described in detail in a forthcoming book: 'Convertographic and electrono-optical phenomena and their Biological Applications' (I. Fl. Dumitrescu, in preparation).

Chapter 15

Microelectronography

15.1 Introduction

Microelectronography is a means of investigation by electroluminescence at tissue, cellular and sub-cellular level, based on taking a photographic record of an electronographic exposure of living tissue. A recent variant of this method, termed microelectronovision, is an electrono-optical method which allows direct visualisation of electroluminescent phenomena at cellular level.

The exploration of the living cell from the point of view of its electrical behaviour is of special interest. The exchange of bioelectric information between the cell and its electrical environment is a complex biological process, subject to the laws of electro-chemistry and electromagnetism applied in biology.

Cellular electrophysiological research has been carried out for the most part using methods of electrical measurement with the aid of microelectrodes, cell membranes being the structures most accessible to this measurement method.

The use of electroluminescent phenomena in the exploration of living cells opens up a new perspective in research regarding cellular components in conditions of their exposure to high voltage fields.

The microelectronographic method developed by us in 1975, makes use of the exposure of the living cell inside a device made up of a condenser on which is applied a voltage in the order of tens of thousands of volts, produced by an electronographic source (Dumitrescu and Herivan).

Recently, we have developed a series of original techniques which facilitate microelectronographic exploration.

15.2 Microphotography by electroluminescence

The microphotographic electroluminescent method consists in taking micro photographs of tissues and cells, producing electroluminescent discharges due to the applied high potential and being placed under the lens of a specially adapted microscope.

The preparation to be studied is placed on a plate made of a transparent optical crystal, which is in turn placed between transparent electrodes or between glass electrodes with applied liquid or paste conductive layers. The preparation is separated from the conductive part of the electrodes by two 4–6 mm-thick glass dielectric layers. At the same time, the layers are separated from the metallic mass of the microscope, which will be connected to the high tension source.

The high tension source is applied across the conductive portion of the two electrodes, with an adjustable frequency of the power source from 10 to 50 Hz.

The clarity of the image is obtained with the help of transillumination (from a light source) of the preparation; this light is then switched off thereby obtaining the electroluminescent image on the dark background of the microscope field. A camera set up with a long exposure time in the order of minutes is attached to the microscope objective.

Simultaneously with release of the high tension source, the camera shutter is also released. The method has the disadvantage of long exposure, during which time the biological preparation may be damaged.

This technique has enabled us to photograph the propagation of the electroluminescence phenomenon at cellular level. The differing electroluminescence of different tissues is due to the propagation of exploring electromagnetic fields interacting with different biological media. Depending on their electrical conductivity and magnetic permeability a differential attenuation of the electromagnetic field occurs, enabling data to be obtained regarding cell function (fig. 15.1 a, b and c).

15.3 Microautography in electroluminescence

This is an indirect method of looking at the electroluminescent effect at cellular and subcellular level. The images are obtained by covering the biological preparation with layers of a photosensitive emulsion, or by direct observation through optical or electrono-optical devices.

In the method used by us, a photosensitive emulsion was applied to the living preparation (the kind of emulsion used in autoradiography with radioisotopes); this was then exposed electronographically, and then developed, fixed and examined under the optical microscope,

Fig. 15.1a. Microscopic image (original) of the paper-thin leaf of an onion bulb.

Fig. 15.1b. Microelectronography using ordinary photographic film (original).

Fig. 15.1c. Microelectronography using a photosensitive emulsion (original).

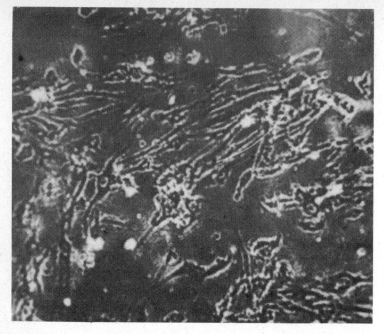

Fig. 15.2. Microelectronography of a fibroblast culture (original).

thereby obtaining negative microelectronographic images which can be made into positive prints if required (fig. 15.2).

The exposure of the preparation can be done using a single impulse, so obtaining the fundamental image of the electroluminescent discharge.

Colour photographs show the chromatic structuring of the luminescent zones.

As far as black-and-white images are concerned, excellent results are obtained when using the emulsion as for nuclear autographs which are developed in a developer with weak contrast.

The disadvantage of microautography in electroluminescence is that it limits the size of object which can be studied, because of the granulation of the film emulsion.

In order to be able to exceed these limits, we have a method of taking the signal and subjecting it to electronic processing using TV circuits.

15.4 Microautography by chromatic turning

This consists in obtaining coloured images by using a selective chromatic turning of the cellular zones in which the electroluminescent phenomenon is present. (Colour plate No. 9.)

We illustrate this method for cellular examination with images representing the propagation of the phenomenon of electroluminescence inside the cell of an algae Cladophora.

The explored tissue is put onto a glass plate as a monocellular layer. The living preparation is covered with a layer of photosensitive emulsion, diluted in physiological saline in a proportion of 1/4 or 1/5. The preparation prepared like this is exposed using electronographic equipment.

After a single pulse exposure the preparation is fixed, in the dark, in a weak 10% formalin solution. This preserves the cellular structure so that it will not be deformed during subsequent processing and it also fixes the photosensitive layer onto the morphological backing provided by the cell. The preparation is then developed using an energetic contrast developer, after which the preparation is fixed in ordinary photographic fixing solution.

The principle of the method consists in transforming the zones affected by electroluminescence into zones coloured in a conventional colour by treating silver halide with heavy metal salts, like copper sulphate, gold chloride, vanadium, etc. In this way the image, enlarged with the aid of the microscope and photographed, is the negative of the electronographic image in which the zones of electroluminescence are specifically coloured and/or shaded according to the tonalities used.

Colours with maximum contrast compared with the colour of the preparation are chosen in order to bring out the image details which, in the black-and-white microelectronographic process, can be confused with cell structure. This confusion is even more pronounced in the study of cell membranes because the electrono-optical image is superimposed onto the cell structure. By using this process, the zones affected by electroluminescence are selectively coloured, the remainder of the cell remaining normally coloured.

Here are the stages of processing microelectronographs by chromatic turning:

1. Obtaining the preparation
2. Covering it with photosensitive emulsion

3. Electronographic (single pulse) exposure
4. Fixing in formalin 10% (5 minutes)
5. Drying the preparations (approx. 10 minutes)
6. Developing (3 minutes) in a contrast developer
7. Washing (5 minutes)
8. Fixing in thiosulphate (5 minutes)
9. Washing (10 minutes)
10. Chromatic turning (according to the formula used)
11. Washing (20 minutes)

As far as the turning is concerned, the following formulae are used:

1. Turning in red-brown with copper (3).

87.5 g potassium citrate is dissolved in 800 ml water to form solution 1; 6.7 g crystallised copper sulphate is then dissolved in 60 ml water to form solution 2, and 5.9 g potassium ferricyamide is dissolved in 60 ml water to form solution 3. Solution 2 is mixed with solution 1, then solution 3 is added, mixing all the time, and to whole water is added up to 1000 ml. Mixing time 10 minutes.

2. Turning towards red (4).

1.19 g gold chloride is dissolved in 55 ml water; 2.8 g thiourea is then dissolved in 55 ml water; the solutions are added together and made up to 1000 ml with water. Mixing time 7–8 minutes.

Chromatic turning processes as used in photography, as well as colouring with various colouring agents for the cells, using histochemical processes, can both be used.

15.5 Microelectronovision

This is a method of exploration derived from the technique of direct microscopic observation of the tissue and cellular electroluminescent phenomena. An optical microscope, adapted according as previously described, is connected to an ultra-sensitive television camera. The image obtained by this method can be memorised magnetically and optically, also images can be taken in series by synchronising the impulse generator with the image camera.

15.6 Electrono-optical systems for enlarging an electroluminescent image

The microelectronographic image can be transduced into an electronic flux that makes it possible by focalisation and successive deflection to obtain an electronic magnifying glass effect, and even an electron-microscope effect.

The simplest electronic deflection of the electroluminescent image can be achieved in a specially made vacuum tube.

The deflection can be magnetic or electrostatic. This elementary principle can be used in an electrono-optical system with powerful enlarging and definition capabilities.

15.7 Microelectronographic examination

This shows the main electronographic aspects of living cells. The study of information and energy exchange between living cells, as well as between cells and the electric medium, has enabled us to reach certain conclusions which we will summarise as follows:

We have studied plant cells, specifically cells of the paper-thin leaves of the Allium bulb, also cells of the Cladophore Algae, as well as human and bovine spermatozoa, liver cells, mesothelial cells, blood cells, and cell cultures of fibroblasts and epithelial cells.

This research was carried out by comparing the microscopic image with the electronographic image, differentiating and, at the same time, localising the electroluminescent images with tissue and cellular structure.

All this research led us to a number of observations which we shall summarise in order to define cellular electronographic characteristics.

1. The electroluminescent phenomenon does not remain localised in the cell, but it propagates from cell to cell across the cell membrane (fig. 15.2).
2. The protoplasmic space is relatively dark, with the exception of a luminous network made up of the endoplasmic reticulum, the centrosome apparatus and other cell organelles, all of which play an active role in cell metabolism.
 It is interesting to note that propagation of the electroluminescence inside the cell starts from the inner face of the cell membrane, from one or more points of contact with part of the

inner luminous network (i.e. endoplasmic reticulum, centrosome).
3. The electroluminescence propagates from cell to cell via points of 'transmembrane passage' or it respects the membrane structure and appears on the opposite side of the membrane similar to a capacitive electrical transfer.
4. Cells of the cladophore alga show an interesting manner of propagation of electroluminescence both by way of the cell membrane and also inside the cell, through luminous filaments which have no known structural correspondence. These luminous filaments traverse the zones of contact between cells, and inside the cell they propagate between nuclei and cell organelles. Old cells lose both the luminescence of their membrane, and that of the inner filaments, whilst young cells show a 'dense spindle' of luminous filaments.
Electronography by chromatic turning made it possible for us to show the presence of an 'electrical pore' which is more clearly visible in the fully active cell.
5. The cell nucleus shows an intense luminosity which outlines the nuclear membrane. The luminosity of the nuclear membrane is directly connected to that of the cell membrane via an internal luminous network which we have described previously. In this way, cell electroluminescence is characteristic of membraneous structures, and propagation takes place continuously in all types of cells under study. These findings indicate the possibility of the existence of a conductive electrical network through and around cells determined by the electrical activity of certain conductive structures.
6. Research carried out on fibroblasts in culture when compared in three different states – killed by chemical fixing, live in a state of metabolic activity, and changed by contamination with measles virus and adenovirus – has shown a series of interesting findings. The dead fibroblast behaves like an inanimate conductive structure, radiating a diffuse luminosity in the intercellular spaces. No intracellular details are noted. Live cells are evidently different because the illumination of the membranous zone forms a luminous network in the tissue. As distinct from the dead cell, the live one shows intercellular luminescence as indicated by the luminous outline of the nucleus and other organelles (figs. 15.3, 1 and 2).

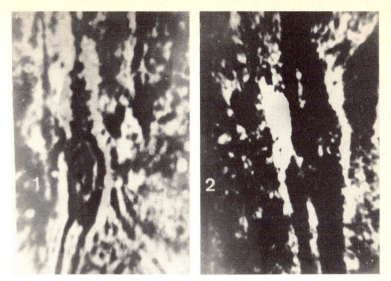

Fig. 15.3. Microelectronography: 1. live fibroblast; 2. dead fibroblast (original).

Electroluminescence in the live cell is specific and reproducible, defining its electrophysiological characteristics. Cells affected by viruses show a series of changes in the luminous emission, around cell membranes. Thus, the cells infected with adenoviruses exhibit histologically, a syncytial aspect which, electronographically explored, reveals the presence of luminous membranous structures, not seen during ordinary optical examination.
7. The study of the electrical behaviour of cells during mitosis shows luminosity changes in the organelles as well as in the nuclear membrane.
8. The cinematic exploration of electroluminescence, inside the cell, shows a series of rhythmical pulsations, determined by intra- and intercellular ionisation processes.
9. Zones of contiguity between two different cells show in the electronographic exposure a high luminosity when compared to the rest of the cell membranes.
10. Microelectronographic study of tumour cells taken from experimental mice with Erlich ascites, has enabled us to show that malignant cells have increased brightness when compared to

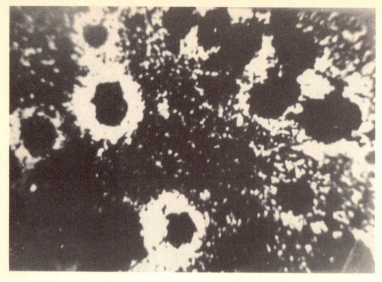

Fig. 15.4. Microelectronography of Erlich ascites cells; their differing degree of luminosity can be seen (original).

normal cells, at the same time a visible differentiation between malignant tumours appears manifest, some of them losing their luminescence entirely.

Microelectronography opens up interesting perspectives in the study of malignant neoplasia (fig. 15.4).

The nature of electroluminescence at a microscopic level can be attributed to intense ionisation processes with secondary luminous emission which takes place in cellular microstructures, differentiated by different ionic conductivity. The luminescence appears as a result of ionisation produced by the high tension impulses, through the naturally occurring biological conductors existing in the cell. Thus, electroluminescence appears as a tracer of those paths, faithfully demonstrating their presence.

In a wider sense, membrane structures generate, store and transfer matter, energy and biological information. Microelectronography shows these processes at the cellular level.

Hopefully it will contribute to a greater extent than classical methods, using microelectrodes for the electrophysiological

exploration of the cell, not only from the point of view of internal functions, but also from that of its electrical behaviour in different environmental conditions.

We can draw a number of conclusions; that cells communicate amongst themselves electrically, and also with the surrounding electric medium by transmembranous dynamic bonds.

Chapter 16

Electroluminescent Spectrography

16.1 Introduction

Electroluminescent spectrography is an original method of biological investigation and is the subject of a Rumanian patent (1976). This method consists of the analysis of the chromatic spectrum of the electroluminescent emission by breaking the radiation into two bands. The study comprises of the extremes of the visible spectrum, i.e. the blue and red bands. The considerations which led to this decision were based on the ideas at the basis of the streamer theory. Whilst taking shape, the streamer has, in the acceleration space, a red or blue dominance, according to the specific energy of the processes of attraction towards the cathode. Thus, Tiller maintains that at the proximal extremity of the streamer the colour is predominantly blue, whilst at the distal extremity the colour is predominantly red.

In this way, exploration by electroluminescence makes it possible to analyse the phenomenon from an energetic point of view. The energy of the streamer depends to a great extent on the electrical resistance of the skin exposed in the electronographic device. The electrical surface impedance is, as shown by cutaneous electrophysiological studies, dependent on autonomic control.

Besides the direct dependence of the streamer's energy on the electrical surface impedance, it is also dependent on the physical and chemical factors of the surrounding medium. The reproducibility of the phenomenon depends on the constancy of these parameters of the surrounding medium. In constant humidity, ionisation, temperature and atmospheric pressure, and composition of the gaseous medium, the phenomenon is then only dependent on the physiological factors of the body under investigation.

It is also found that the phenomenon is dependent on biological electromagnetic fields which can interact with the streamers produced in the vicinity of the live organism. (Colour plate No. 2.)

Beside the energetic dependence of the luminous emission of the energy forming the streamer and on the secondary interactions to

which they are subjected, it also shows a chromatic dependence according to the chemical composition of the proximal medium. (Colour plate No. 3.)

The existence of anions and cations resulting from metabolism, found in the surrounding gaseous medium, initially biologically ionised and secondly, strongly accelerated by the high tension impulse, can also affect the spectrum of the electroluminescent emission. Electroluminescent spectrography is a method which explores a complex of physical and biophysical phenomena; on the one hand, the energetics of the biological phenomenon, and, on the other, the functional condition of the organism investigated in the medium in which the examination is taking place. In other words, electroluminescent spectrography examines both the energetic phenomena and the electrical relationships between the live organism and the surrounding electrical medium. One of the first developed, electroluminescent spectrographic methods consist in the simultaneous recording (with the aid of two photo-electric cells, one of which is sensitive to red, the other being sensitive to blue) of luminous emission produced by the sample being investigated under the action of a high tension source (fig. 16.1).

The interpretation of the spectral emission of the two different domains was carried out through an intercorrelation value, by using an x, y type of recorder where the x axis represents the blue emission and the y axis the red emission.

The recordings on human subjects were carried out on the hypothenar eminence of the right hand applied onto the spectrograph screen. By using this first method of spectrography by electroluminescence we have carried out a series of preliminary research in different biological fields, which are at present being studied in greater depth, both theoretically and experimentally.

16.2 Spectral analysis by electroluminescence on normal subjects in physiological conditions

Explorations carried out by means of the above described method enabled us to show a series of characteristics of the spectral emission in functional conditions for normal subjects.

Our observations may be summed up as follows:

1. Spectral curves are dependent on the value of the palmar electric

218 *Electrographic Methods in Medicine and Biology*

Fig. 16.1. Set-up for spectrography by electroluminescence with an analogue display (original).

resistance. Consequently, increased values of the palmar electric resistance can be correlated with increased values of blue radiation while reduced (decreased) values of palmar resistance give predominantly red emission.
2. Circadian modifications in relation to the two radiations can be observed: blue radiation is predominant in the morning, while red radiation appears predominant on recordings performed in the evening and at night.
3. Characteristic variations imposed by age and sex can be observed as well: blue radiation has a statistically increased predominance for adults and for males, while females and children show an increased red emission.

With constant reproducible characteristics there was established a correlation between the daily variations of red and blue radiations for normal subjects recorded simultaneously with the values of dowsing signals.* All experiments were performed using a double-blind technique.

Spectrography has been applied to normal subjects and correlated with the dowsing signal on a seismic fracture zone from Vrancea to Covasna in Rumania (experiment carried out in co-operation with A. Apostol).

The dowsing signal was recorded independently of the spectrographic curves by a trained operator. The recording of the dowsing phenomenon was carried out every half hour for a period of three consecutive days, during which the dowsing signal showed a series of characteristic fluctuations modifying its amplitudes (fig. 16.2).

Spectrographic recordings, made with the help of a mobile laboratory over the seismic fracture zone, were carried out on six subjects, one of whom had dowsing ability. The two sets of information obtained separately were subsequently correlated through the diagram of the spectrographic curve amplitude in which were discovered proportional variations of blue and red, and also

* The dowsing phenomenon known also as radioaesthetic sense; with the help of a rotating movement of a rod held in the hands of the operator, states of abnormal tension in the earth's crust can be detected. This phenomenon has attracted, in the last few years, the attention of workers in the field of biophysics. With the aid of radio telemetry, A. Apostol and I. Fl. Dumitrescu have demonstrated a mechanism for producing rotation of the rod being due to an asymmetry in electrical tension, recorded on the palmar hypothenar zones of the hands of the operator (1975).

220 *Electrographic Methods in Medicine and Biology*

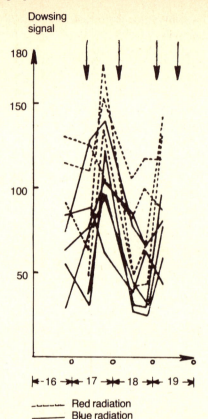

Fig. 16.2. Superimposition of the spectral curves of electroluminescence in the presence of the dowsing signal (original recordings).

variations of the amplitude curve for the dowsing phenomenon. This correlation showed a particularly interesting phenomenon requiring further explanation and investigation.

During appearance and maintenance of the dowsing signal, the spectrographic curves showed a marked decrease in red and blue in all subjects taking part in the experiment. Once the dowsing signal disappeared red and blue radiation in the spectral curves increased. This inverse relationship of electroluminescent emission and the dowsing signal indicates that dowsing is a measurable biophysical phenomenon.

16.3 Spectral analysis by electroluminescence during measured physical effort in man

Recordings were made on human subjects before and during measured effort on a cycle ergometer, the recordings being made after every five minutes. Spectrographic recordings were also made every five minutes during the period following the exercise bout.

Analysis of the recorded curves showed an exponential decrease in emission for both spectral regions (red and blue), more pronounced for blue emission in the period when muscular pain occurred, as well

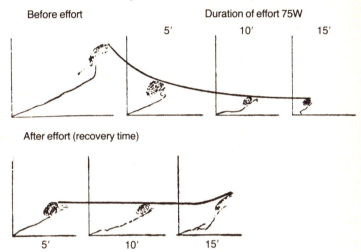

Fig. 16.3. Spectrographic curves obtained during measured physical effort in man (original recordings).

as a slow return to the amplitudes of the curves, during the recovery period after effort (fig. 16.3).

A slower return of the spectral curves after exercise was always noticed when compared to that seen of recuperation after oxygen deficiency. These observations show the dependence of the electroluminescent emission on the intensity of measured physical effort.

16.4 Causes of electroluminescent spectral differentiation in exploration of the hand

We consider that the spectral differences in electroluminescent radiation can be due to the following factors:

222 *Electrographic Methods in Medicine and Biology*

1. The composition of the perspiration found on the surface of the skin.
2. The superficial electrical impedance at the limit of contact with the exploratory screen, this impedance being determined in the main by electrical activity controlled by the autonomic nervous system.
3. The interaction of biological electro-magnetic fields with the streamers which are formed at the point of contact of the skin with the exploratory screen.
4. The characteristics of the electrical medium in which the exploration takes place, i.e. atmospheric pressure, temperature and humidity. These factors are eliminated when investigations are carried out in air-conditioned surroundings where humidity and temperature can be controlled.
5. Interaction with external electromagnetic, magnetic and electrostatic fields from inanimate bodies or from other live organisms. In such cases, the spectral analysis successfully visualises all these complex phenomena, of which the composition of the surface film of fluid on the body's surface, electrical impedance and the interaction with the electromagnetic fields of the organism under exploration, remain the three essential factors influencing the streamers.

16.5 Spectral modifications in electroluminescence in some pathological conditions

As yet a rather limited experience in this domain does not allow us to systematise the main aspects that can be used in diagnosis. Nevertheless, we shall limit ourselves to the presentation of certain aspects that suggest some implications for diagnosis as a result of this method.

Investigations carried out in some febrile illnesses showed changes characterised by high curves with increased radiation both in the blue and red; these curves followed in parallel the clinical evolution of the illness.

Within an experimental framework, we investigated patients with different types of acute or chronic leukaemia, at different stages of evolution. The recordings were taken from the hypothenar eminence on the right hand. The curve obtained spectrographically was

Electroluminescent Spectrography 223

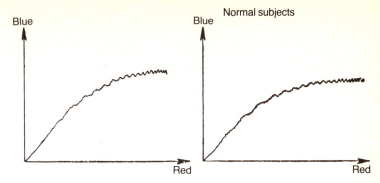

Fig. 16.4. Palmar spectrographic curves from normal subjects (original recordings).

confirmed by comparison with haematological and clinical data (figs. 16.4 and 16.5).

The investigation showed differences between spectral curves obtained on normal subjects and curves obtained from leukaemic patients. We have been able to obtain two distinct types of curve which correlate with the white cell count.

(*a*) In the blood picture showing an increased number of leucocytes, there is an increase in radiation, predominantly in the red band (fig. 16.5a).
(*b*) In the forms where there is bone marrow depression, characteristic of the final stages of leukaemia, there is a diminution both of radiation in the blue and of the red band, much under the limits characteristic of normal subjects (fig. 16.5b).

Recordings performed on different cancers showed changes that can be correlated with the activity of tumour growth. Thus, in the incipient stages of some breast cancers, some lung cancers and viscero-abdominal cancers, curves were recorded with increased emission values which in the final stages changed to flat curves with diminution in the red emission. It is difficult to state at this time whether these changes are characteristic of neoplastic disease or produced by metabolic and neurovegetative disturbances associated with malignant disease.

In an experimental study performed on blood samples of a large number of cattle with leukaemia, the index of correlation between the blue emission and the number of leucocytes was found to be

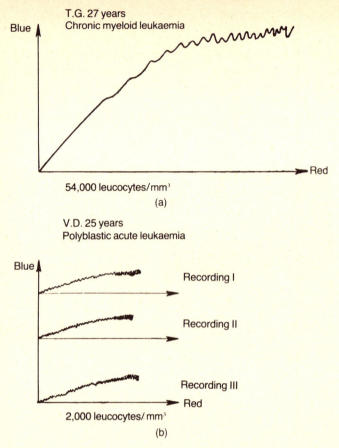

Fig. 16.5. Spectrographic curves in different leukaemias (original recordings): (*a*) acute leukaemia; (*b*) in final stage of leukaemia.

above zero, which means that there is a positive correlation between these two variables. Also, the index of correlation for leukaemic blood and that for normal blood are significantly different, showing a positive correlation between the leukaemic state and blue emission.

Statistical analyses on populations of animals can give information regarding their leukaemic potential. For this purpose electroluminescent spectrography becomes more efficient by memorising and processing the data obtained by the spectrograph in a computer, with a special program attached to the recording device.

16.6 New methods of complex spectral analysis by electroluminescence

The first spectrography-by-electroluminescence method has been fully justified by its utility, simplicity and reproducibility in supplying a dynamic characterisation of the streamer energetics.

It is obvious, however, that its exploratory possibilities of some spectral zones within which various biological phenomena take place are rather limited.

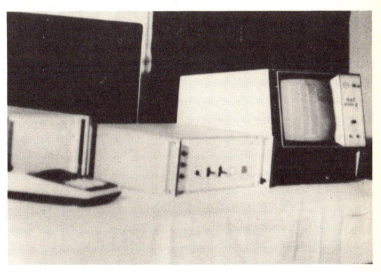

Fig. 16.6. Spectrography-by-electroluminescence unit with digital display, statistical calculation and analysis of the data carried out by computer.

These considerations lead us to develop new methods of spectrography by electroluminescence based on the simultaneous spectral analysis both in the visible spectrum and in the neighbouring invisible areas (such as ultra-violet radiation and infra-red radiation).

This new generation of spectrographs makes use of up-to-date computer techniques.

In fig. 16.6 one of these pieces of equipment is shown.

Spectrography by electroluminescence is a biological investigatory technique with many possibilities.

As development possibilities we have considered several methods relating to both the analysis of the radiation in electroluminescence in rigorously controlled conditions and the analysis of the spatial distribution in the living organism.

A monograph will be published in the near future outlining all these methods and their results in different biological fields.

PART IV

ELECTRONOGRAPHIC INVESTIGATION OF ELECTRICAL BEHAVIOUR OF MALIGNANT TUMOURS

Chapter 17

Electromagnetic Behaviour of Malignant Tumours*

Man lives in an environment containing a multitude of electromagnetic fields generated by different terrestrial and cosmic sources. Also, the body is itself a source of its own electromagnetic fields which interact specifically with environmental fields. This interaction is very important as regards the morphofunctional aspects of different biological structural entities. Different functional states, including pathological ones, in which the body finds itself are characterised by specific electromagnetic interactions of the organism with the surrounding medium, which can be demonstrated by study in controlled electric and magnetic fields. Research carried out with methods to study this interaction has shown structural and functional changes in the cells and tissues due to these fields. In this way investigations looking at the electromagnetic interaction of the body and the environment may lead to the establishment of new diagnostic and therapeutic methods.

The main differences in electrical behaviour of malignant cells with normal analogous cells can be seen as due to specific interactions with electric and magnetic fields applied from outside the body.

The human body is diamagnetic, and through it static magnetic fields penetrate with relative ease. These magnetic fields deform atomic and molecular structures and exert forces on microscopic components of the body. These physical effects cause modification of various biochemical processes, thereby affecting cellular control mechanisms. The intensity of the biological effects of magnetic fields upon the body is different, ranging from magnetotropism up to complete destruction of living beings. Morphological changes can be observed in laboratory animals in fields of 200–300 ϕe. Fields of

* A large part of the data presented in this chapter has been supplied by Dr Kim S. Yang's monograph, Department of Physics, Ohio State University, USA.

300–700 ϕe reduce the rate of DNA and RNA synthesis in different tumour cells. R. L. Liboff has shown (1965) that intensities of magnetic field greater than 100,000 ϕe can affect transmembraneous ionic diffusion, thus influencing the development of the cells. L. Gross (1964) has shown that a small difference in magnetic field can produce physical effects, as in the case of paramagnetic electronic resonance, and it can be assumed that small energetic perturbations caused by very weak magnetic fields can and do produce significant physical effects. The biomagnetic effect of low intensity fields can be explained by deformation of atomic valency angles, the reaction speed of many biochemical processes being thereby reduced. Magnetic fields modify the wave function of electrons in macromolecules, producing a greater paramagnetic susceptibility, which leads to a change in reaction speed. This is explained by modification of molecular diffusion, and the number of molecules taking part in a given reaction can be modified by the Zeeman effect.

In a field of 5,000 ϕe, it is estimated that a reaction can be reduced by 0.2%, and if a given chain of biochemical reactions is made up of 15 separate reactions, then the total reduction of the final product will be approximately 20%.

Magnetic fields also affect cell division. This process is preceded by DNA replication which implies a multitude of chemical reactions involving complex structuring in molecules involved. If these components have anisotropic magnetic susceptibility, then not only the velocity of rotational diffusion but also the relative orientation of these vital components will be changed. Thus, it is possible to disturb the replication of DNA by the action of magnetic fields.

The major physical effects produced by magnetic fields are:

(a) Pressure.
(b) The appearance of moments of magnetic forces. The pressures deform cellular components and can affect transmembraneous permeability and also cell replication. Moments applied to molecules affect their speed of rotational diffusion, whilst moments applied to cell components (chromosomes, mitochondria, microsomes, etc.), can upset various functions of the cell.

It is a known fact that the cancer cell has the ability to multiply uncontrollably as well as a tendency to invade, replace and destroy neighbouring or distant normal tissue, causing lesions which cannot be cured spontaneously, and which can eventually lead to death.

Since the essential biological effect of magnetism acts mainly on cell division, it is evident that magnetism could markedly affect the development of malignant cells more than the development of normal cells.

A large number of research workers have studied signals of electronic spin resonance (ESR) in tumours. Mallard and Kent (1966) found that the ESR for liver cancer in rats is approximately 20 times smaller than that for normal tissue, at the Lande factor $g = 2.004$. A specific signal for malignant tumours has been observed at $g = 2.016$ for metastases in rats. It has been demonstrated that in the case of tumours certain specific paramagnetic molecules are present. Balitski (1973) has shown that in the case of the rabbit, the 'Brown Pearce' carcinoma can be detected at an early stage, via a specific anomaly in the electroencephalographic recording. Dumitrescu (1973) has shown clinically that human breast cancer is accompanied by an increase in skin electrical potential and a decrease in electrical impedance over the tumour zone.

An important biomagnetic effect in cancer therapy is the delay of any effect when applying static fields, this being noticed in many cells, tissues and organs.

An applied magnetic field, combined with microwaves at a particular frequency, causes tumour regression in rats (Riviere, 1965). Magnetic fields of 300–620 ϕe have been used together with microwaves with wavelengths of 3–80 cm on different types of tumours in rats (such as non-typical epitheliomas, adeno-carcinomas and lymphosarcoma). Exposures of 10–20 minutes were given at intervals over one month. Tumours and their metastases regressed and in some cases were eliminated. Malignancy may be caused by a disturbance in the self-regulating mechanisms of the body, these mechanisms being most probably electromagnetic in nature. It has been shown (Loewenstein 1974) that small molecules can pass through normal cells, and electric charges can pass directly through passage points in cell membranes, whilst similar events do not happen in tumour cells. The passage points in cell membranes play a vital role in intercellular communication, and in developmental control. Magnetic forces acting on membranes can affect this vital communications function of these membranes.

Measurements of magnetic sensitivity have shown differences between malignant and normal tissue. Generally speaking dead cells are more diamagnetic than living cells, most probably due to the

presence of free radicals in living cells. This implies that cells which develop faster than normal are less diamagnetic than those which develop more slowly (as shown by experiments carried out by Seuftle and Hembright (1969).

It is known that mammary cell membranes are negatively charged (mammary cells, suspended in a medium, orientate themselves according to the electric field lines). Sound waves, with a force of at least $2.5\ 10^{-2}$ dynes, reduce the electrophoretic mobility of these cells by 16%, which means that the binding force between the charges present is less than $2.5\ 10^{-2}$ dynes. The electrophoretic mobility of tumour cells is approximately 30% higher than that of normal cells.

Morphological research carried out using an electron microscope (Ambrose, 1970) on cancer cells has shown that the external surface of these cells is visibly modified, pointing towards changes in organisation and composition. Tumour cells show weak intercellular cohesion.

Microwaves were used with good results by Schmidt (1974) in the treatment of superficial tumours. Cancer cells are more sensitive to the heating effect of microwaves and they reach the lethal temperature of approximately 41–40c before normal cells. Normal cells are more efficiently cooled by blood circulation and are less affected by radiation. It is worth noting that the general effects of microwaves on malignant and normal tissues are similar to those of static magnetic fields (Presman, 1970). This similarity is due, most probably, to moments of rotation and pressure induced by microwaves as well as to the magnetic effect on electric dipoles. It is well known that electromagnetic radiation can cause chromosomal aberrations, leading to morphological and other anomalies (Presman, 1970). Data are now available showing the reversion of malignant cells to normal cells under the influence of radiation of various sorts. On the other hand it is possible to cause cancer by the radiation of various sorts of electromagnetic fields. Lowden (1963) shows that the process of proton tunnelling can be implicated in the process of gene replication.

After the replication of DNA, protons from hydrogen pairs pass into non-equilibrium states. There is a finite probability that protons could affect transitions to these states, thus modifying the genetic code. This process of tunnelling could be a major cause of spontaneous cancer. A fortuitous accumulation of abnormal states can disturb delicate developmental control mechanisms. Bernothy

(1964) has shown the possibility that magnetic fields can affect the tunnelling process by direct interaction with proton spin and by modifying wave functions and tunnelling probability.

Genetic replication can be altered if magnetic fields modify the biochemical processes involved in replication. Static magnetic fields affect the rotational diffusion of macromolecules and can affect certain types of spontaneous chemical reactions in protoplasm. Darfman (1962) has shown that DNA molecules have a high magnetic anisotropy and therefore are very sensitive to magnetic fields.

Meksheukoo (1965) has shown that DNA molecules align themselves perpendicularly to magnetic fields (6,500 ϕe) when they are submerged in a liquid medium. Pregnant female rats exposed to fields of 2,500–4,200 ϕe have been shown to gain 20% in weight and have a shorter life span than normal rats. Powerful fields can cause the resorption of the embryo (Barnothy, 1963). Similar effects were observed in rats exposed to magnetic fields before coupling. Morphological anomalies of growth have been observed in chicks, plants, etc. It is to be noted that these growth anomalies were transmitted over 30 generations, which shows that changes had taken place in the genetic code.

Magnetic fields can also affect cellular activity through effects on cell membranes. Due to their semi-rigid nature, cell membranes are particularly susceptible to magneto restriction (Witenberg, 1967). If these membranes are made of smectic phospholipids, magnetic fields can produce twisting waves which can cause membrane depolarisation and hence an increase in permeability (Ferguson and Brown, 1968). The Harmeman result (1962) regarding increase in sodium and potassium elimination in rats exposed to 7,200–14,000 ϕe can be tied to membrane depolarisation.

Increase in permeability can reduce the ability of cells to absorb specific molecules and to retain cytoplasmic materials. This could explain cell degeneration as seen in many experiments.

A possible therapeutic effect of magnetic fields is that the facility of communication between tumour cells can be facilitated by an increase in permeability, which then in turn can bring about a return to normality. The implosive nature of magneto restriction on cell membranes could delay the dissemination of malignant cells (Ambrose, 1970). It is possible that magnetic pressures can reduce the effective charging of cell surfaces by inducing a greater symmetry

in cell shape. Cancerous cells appear to have a greater negative charge than normal cells. Some malignant cells are more susceptible to magnetic fields than normal ones; they are less well organised and less cohesive than normal cells; their surface is more negatively charged than the surfaces of normal cells; they have high dielectric constants and they cannot form membrane junctions and thereby make intercellular communication.

These biophysical characteristics of cancer cells produce specific electromagnetic behaviour, clearly differentiated from the equivalent behaviour in homologous normal cells.

The specific electromagnetic behaviour of malignant tumours can be clearly demonstrated with the aid of electrographic investigation and especially by electronographic techniques. The results given by these methods will probably help in the early diagnosis of malignancy.

Chapter 18

Electronographic Examination of Experimentally Induced Malignant Tumours

18.1 General principles

The electronographic examination of malignant tumours starts from the following premises:

1. The malignant tumour, like any tissue proliferation, is accompanied by a change in the tissue impedance in relation to the tissue of the organ under investigation.
2. The change in the tissue magnetic properties results from the diminution of the magnetic dipole moment at the cellular level. A window or magnetic void with obvious magnetic anisotropy is found in the tumour region (Szent–Gyorgy, 1958).
3. Malignant tumours modify surface electrical activity through the phenomena of electrodermal activation, which can be studied with the aid of electrodermal investigation (Dumitrescu, Danila, Golovanov). These electrical modifications on the skin must not be confused with changes in the neoplastic tissue, and in order to be able to give a tumour diagnosis, it is necessary to know the pathophysiological mechanism.

Thus, the phenomena of electrodermal activation acting through the autonomic nervous system must be differentiated from nerve lesions which can produce electrodermal inactivity.

Malignant tumours can manifest themselves in a non-specific way, from an electrical point of view, through any one of the previously listed characteristics.

It is clear that when looking at these aspects of tumour electrical behaviour, possibilities arise for using electronography for diagnosis.

High tension discharges for examining and detecting malignant tumours have been used by several groups of workers.

Research carried out by S. D. Kirlian and Adamenco has shown

that in patients with malignant tumours there is a special form of marginal discharge, these discharges being noticed especially in gastric cancer. Recordings were made of the palms, but no papers with photographs have been published in support of these findings.

Using electronography the first images of the behaviour of malignant tumours were obtained by Dumitrescu, Golovanov and Celan in 1975.

In 1976 Majajakrom described certain forms of marginal palmar discharge in patients suffering from malignant tumours. Subsequently, in 1977 Shaphiro published various images of marginal discharges (a study of streamer formation) from malignant tissues.

These preliminary considerations occasioned us to carry out an experimental study of the electronographic images of malignant tumours. When studying experimental tumours animals were compared with normal control batches. This research resulted in electronographic examination of 105 animals with experimental tumours. The electronographic investigations which have provided the experimental material on which our observations are based can be summed up as follows:

1. Research on experimental cancers of an orientating character (solid and semi-solid tumours, i.e. leukaemias). Stage I (38 animals).
2. Research on experimental tumours producing ascites (Erlich tumour). Stage III (30 animals).
3. Research on experimental solid tumours. Stage III (25 animals).
4. Microelectronography on tumour cells from malignant Erlich ascites.
5. Electronographic examination of known human tumours, confirmed both clinically and pathologically.

18.2 Orientative electronographic research on solid and semi-solid tumours (Dumitrescu, Celan)

In the initial stage batches of normal mice and rats were investigated electronographically, then groups with localised inflammation were used to compare the results.

The composition of the batches and sub-batches was as follows:

1. Experimental tumours (38 cases of which 22 were solid tumours, 7 were leukaemias and 9 mixed types).

2. 10 were localised inflammation due to bacterial abscesses or irritant substances (aseptic abscesses).
3. Control animals of the same race, a total of 20.

After obtaining electronographic images, the animals were killed and examined both macro- and microscopically and the results of this examination were correlated with the electronographic findings. The pathological examination established the apparent and real spread of the tumour; the frequency of cell deviation from the norm; and the stage of evolution of the tumour.

In order to increase the contrast and brightness in tumour zones, we resorted to intra-peritoneal injection or intra-arterial injection of a luminescent substance with maximal activity in the ultra-violet band, thereby obtaining better-quality images.

The electronographic images showed unique electrical behaviour in neoplastic tissue. The analysis of this behaviour has been possible due to technical adjustments which facilitate the analysis of the image according to the characteristics of the applied electric field.

In all animals with transplanted malignant tumours, we noted electronographically malignant structures which differed from case to case from the electronographic images of the normal control animals and from animals with inflammatory processes.

The main characteristics of malignancy as shown by these investigations are as follows:

1. Increase in light emission from the neoplastic zones. Tumours show as the brightest area of the image, surrounded by dark concentric zones. In the case of leukaemias, the whole body surface appears intensely illuminated. Alternating bright and dark peripheral zones indicate changes in electrical properties between tumour tissue and the surrounding zone.
 Inside the tumour zone interactions between the tumour and the surrounding tissue can be seen. Also inside the tumour, circular, concentric, nuclei with increased brightness are seen.
2. The size of the image and the specific details exceed the macroscopic limits of the tumour; often tumour-specific electrical characteristics appear in apparently normal tissue. The homogeneity and shape of the luminous zones differ with each type of tumour, showing peculiarities of electrical behaviour.
3. The discontinuity of the luminous contour of the body and the

presence of the contour of the tumour structure proper; sometimes its presence alone is a sign of neoplastic proliferation.
4. The appearance of round, bright blotches, often occurring in bunches of different sizes.

Inflammatory processes do not show a well-defined structure (they are diffuse), they are less bright than tumour tissues and sometimes do not appear at all in the electronographic image.

18.3 Research on electromorphous effects in tumours producing ascites

The electromorphous effects on batches of Wistar race rats (males) inoculated intra-abdominally with malignant Erlich ascites, have been studied.

The study undertaken had as its aim, both the distinction of the electronographic aspect of semi-solid tumours, and especially the evolution of the tumour as shown by this method of examination (fig. 18.1, 1, 2, and 3).

Starting from day four of intra-abdominal inoculation with malignant ascites, by using a series of electronographs, we have followed the development of abdominal tumours on a daily basis. The electronographs were obtained by exposure in a device provided with a screen by placing the body of the animal under investigation on the electronographic source table.

The electronographic exposures were carried out at a tension of 27 kV with a single negative impulse.

As well as the above-mentioned batch, three other control batches of six animals each were examined in an identical manner.

The control batches contained:

(*a*) rats in which a reactive ascites was introduced by intraperitoneal injection of an irritant;
(*b*) rats which were injected intraperitoneally with physiological serum;
(*c*) pregnant rats.

The electronographic images showed the appearance in the tumour tissue of a bright zone, appearing on the eighth day, which increased progressively in intensity and volume as the malignant tumour developed.

Examination of Experimentally Induced Malignant Tumours

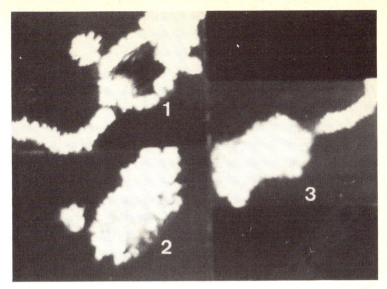

Fig. 18.1. 1, 2, and 3. The increase in intra-abdominal brightness in rats when inoculated with the malignant ascites, as it develops. 1 after 4 days, 2 after 8 days, 3 after 12 days (original images).

Colour films have shown the colour red in zones with light emission. The series films show the passage from the blue light of the electromorphous effect to the red light characteristic of malignant Erlich ascites.

The images obtained on the control rats suffering from an inflammatory ascites differ completely from images obtained on rats suffering from malignant Erlich ascites by the brightness of the abdomen and by the predominance of blue in the electromorphous effect.

An image comparable to the electronographic image of malignant tumours is also seen in pregnant rats. Both the marginal discharges and the electromorphous effect in the electronographic image are similar to a malignant tumour.

18.4 Research on experimental solid tumours

In this phase, we followed up the electronographic behaviour of solid tumours at different stages of evolution.

A batch of 25 rats grafted with the Walker sarcoma were subjected to repeated electronographic exploration. We used an impulse source with a fixed amplitude of 29 kV with positive and negative polarity, the applied pulse having an ascending slope duration of 1.5 µs. We used a fluorescent screen and a phosphorescent screen, as well as a device of the complete condenser type, in which the animal was insulated on the electrode plates by two 6 mm dielectric crystals.

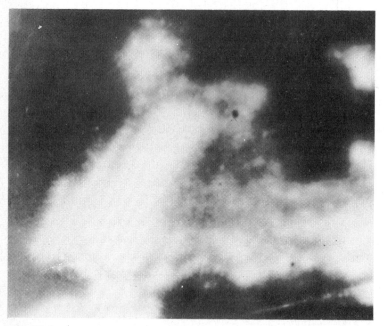

Fig. 18.2. Carcinoma 755; details of the tumour structure (original image).

The animals observed were introduced to the exposure device. Black-and-white images were obtained on radiological film, as well as on a negative and also on reversible colour film.

In the electronographic exposures used for this experiment, the grafted tumours became visible on the ninth day after grafting. The final image is characterised by marginal discharges (pellicular effect) differing from those obtained on healthy tissue. The tumour image is surrounded, over an area exceeding the limits of the tumour, by an electromorphous effect, which can be shown more clearly by

exposing the animals in a recording device of the complete condenser type (fig. 18.2). This surrounding zone of diffuse luminescence appears on colour films in red.

The described effects increase progressively as the neoplastic process develops, thus enabling tumour evolution to be studied.

The images in the three types of recording devices were different according to the quality of the phosphor used.

18.5 Microelectronographic research on malignant Erlich ascites cells

By using microelectronography, we have experimentally investigated the behaviour of neoplastic cells.

We prepared plates with malignant ascitic cells from animals inoculated with these cells.

The live cells were spread in a single cell layer, and covered with a photosensitive emulsion and were then electronographically exposed, developed and fixed. The preparation thus exposed was examined under a microscope and compared with the normal.

If the Erlich tumour cells are differentiated in the normal microscopic image, but the electroluminescent image shows the existence of functional differences which describe different electrical activities within the cells, they are assumed as being cells which will turn into morphologically recognisable cancer cells. Thus, some of the cells show an intense perimembraneous brightness, demonstrating the existence of intense electrical activity at this point. Also luminescence appears in the cell nuclei.

These observations justify our conviction that tumour cells show numerous functional differences although, on the face of it, they have the same morphological characteristics. When they are examined as a mixed group the malignant cells can be picked out due to their different electrical characteristics.

The appearance of differences in luminescence between the same type of cells could be due to variations in electrical impedance of cell membranes; these variations resulting from the existence of modified transmembraneous ionic transfer.

Chapter 19

Electronographic Exploration of Human Cancer

Within the framework of electronographic examination in various fields of pathology, we have investigated over 5,000 normal human subjects (control group), as well as 171 malignant tumours in different localisations.

The tumours were as follows:

1. Abdominal malignant tumours (84 cases).
2. Breast cancers (21 cases).
3. Lung cancers (4 cases).
4. Other malignant tumours (17 cases).
5. Skin malignant tumours (45 cases).

In this general study, we investigated the electronographic characteristics of malignant tumours in order to determine their distinctive characteristics as compared to other pathology (i.e. inflammation, benign tumours, injuries, etc.).

The finding of images with different characteristics obtained in these two groups led to the search for image characteristics specific for particular tumours. Although our research, up to the present, does not exhaust the possibilities of electronographic investigation of malignant tumours, we propose to present, in summary form, our main findings.

19.1 Characteristic images resulting from electronographic examination of human malignant tumours

Electronographic investigation of malignant tumours has shown in the majority of cases (62.3% – representing 103 out of a total of 171 cases), that the malignant process differs from the rest of the image of the organism by changes in the image overlying the tumour or, in some cases, by changes outside the area.

Electronographic Exploration of Human Cancer 243

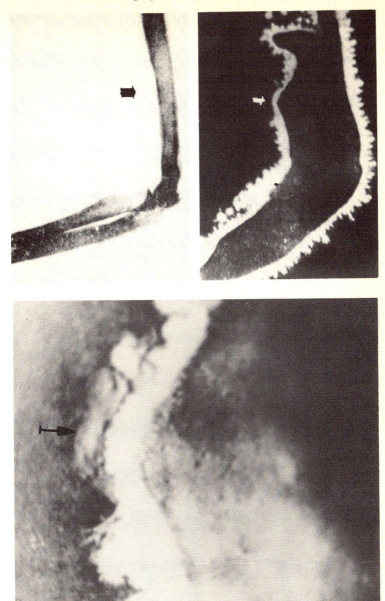

Fig. 19.1. (a, b, and c) Myosarcoma of arm (original). (a) X-ray image. (b) Electronographic image. (c) Electronographic image in detail.

As distinct from the radiological image of a malignant tumour, the electronographic image shows the electrical characteristics of the tumour (fig. 19.1a, b, and c).

The electronographic characteristics which indicate the existence of a malignant tumour are direct or indirect signs of a change of local or general electrical behaviour. Direct signs means that the recordings show image characteristic of the tumour under investigation, these changes appearing over the tumour. Indirect characteristics are regarded as changes of the image in the vicinity of the tumour, or at a distance from it, showing the existence of certain non-specific electrical characteristics. We shall present in the following the main characteristics of electronography pertaining to malignant tumours. The most significant finding indicating the existence of a malignant change is the appearance of an intense, bright electromorphous effect in the red or ultra-violet spectral band.

The intensity of light emission is determined by the size of the tumour, by the depth at which it is found in the body, by its consistency and delimitation, as well as by the characteristics of the investigating technique (i.e. the energy of the applied impulse), the position of the tumour in the investigating circuit and the sensitivity and selectivity of the screen used for visualising the image.

In 26% of the tumours investigated, we could not demonstrate an electromorphous effect to the extent of being able to confirm the presence of a tumour.

The bright image produced by most tumours has an increased intensity as compared with electromorphous images produced in the remainder of the body. It can be well defined, being surrounded by its own dark zone, or it can be formed by the combination of non-homogeneous zones with a patchy brightness of differing intensity and colour. The image can sometimes be represented by a non-homogeneous brightness which includes dark zones inside this, or by bright zones at a distance from the tumour.

In soft tissues an x-ray generally cannot localise the tumour except through associated signs. In three cases of muscle sarcoma, the electronographic image showed the tumour, whereas the x-ray was normal in all three cases. Colour images of the electromorphous effect have shown radiations in red and ultra-violet in malignancy.

In skin malignant tumours (carcinomas, epitheliomas, malignant melanomas, etc.) a constant appearance of intense red radiation in the region of the tumour, or in the dark zones, was seen; this was not

found in basal cell carcinomas (a relatively benign tumour), which only in rare cases showed this finding. The emission of red light by malignant tumours can be explained by the phenomenon of breaking of streamers which lose some of their initial energy when they meet a barrage of potential.

19.1.1 Modifications of the pellicular effect

In the tumours of all the cases investigated a change in the marginal discharges, both from the point of view of polarity and brightness, was found (fig. 19.2a and b).

An interesting observation connected with the characteristics of the pellicular effect is the phenomenon of polarity conversion of the streamers. When applying an impulse which forms positive and negative streamers, there appear in the region of the tumour, or in its vicinity, streamers with the opposite polarity. This finding was made in highly malignant tumours and is seldom found in benign tumours (fig. 19.3a, b). From a spectral point of view, this polarity inversion corresponds to a predominance in the red part of the spectrum. (Colour plate number 11.)

Its interpretation is bound to the electrical processes in the area affected by the malignant tumour, and requires further study with the use of electrical investigation in the diagnosis of malignant tumours in order fully to understand these findings.

19.1.2 Points and zones with electrodermal activation

A non-specific diagnosis can be made by the presence of active electrodermal points or of zones of electrodermal activation.

These changes are non-specific and indicate a process of irritation in a viscerotome with circumscribed activation in the corresponding dermatome(s) (in the case of correlative activation), or a process of autonomic irritation (so-called distributive activation) (figs. 19.4, 19.5 and 19.6).

Malignant change can produce effects through both of the above mechanisms producing electrodermal activation. Numerous electrodermal points often signify diffuse tumours, as for instance in the case of peritoneal irritation due to secondaries. Localised points are rarely found in neoplasms of internal organs. Sometimes there is even a

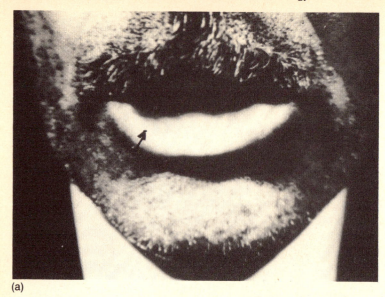

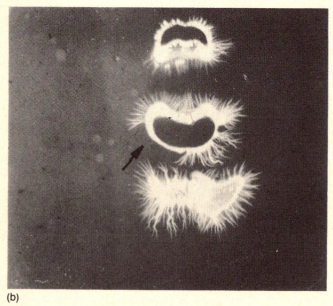

Fig. 19.2. Electronographic image of epithelioma of the lip. (a) Photographic localisation. (b) Electronographic image. Colour plate No. 11 is a colour electronograph of this case.

(a)

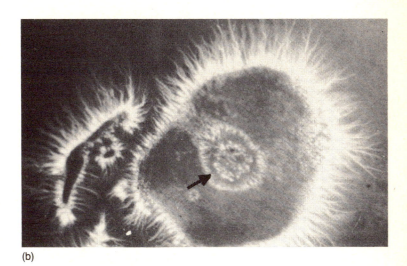

(b)

Fig. 19.3. Basal cell epithelioma on the face. (a) Photographic localisation. (b) Electronographic image.

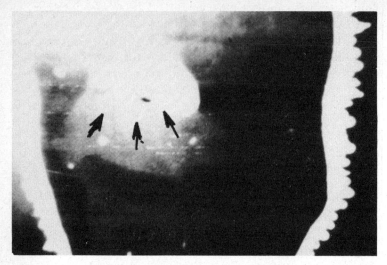

Fig. 19.4. Malignant hepatoma (original).

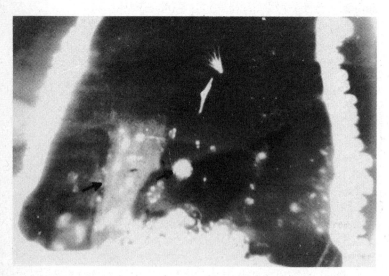

Fig. 19.5. Uterine cancer with abdominal metastases (original).

tendency for the absence of all points at a distance and the appearance of false electrodermal points near the tumour.

Just as in the case of electrodermal points, zones of cutaneous activation appear (more frequent in abdominal tumours). The zones of activation differ from zones generated by the electromorphous effect in that they have precise limits and are less bright.

19.1.3 The adherent aeroion layer

Another presumptive sign of a malignant tumour is the disappearance of the adherent aeroion layer normally situated around a healthy subject.

The disappearance of the layer of proximal aeroions around the hands has been found in patients with skin cancer. This phenomenon is identical with that generated by exposing the hand of a healthy person to ultra-violet radiation.

Observations made on spectrography by electroluminescence showed that the streamers from palmar discharges in patients with malignancy show increased violet radiation as compared to normal subjects, or to patients with benign tumours.

19.2 Differential diagnosis

At the present stage electronography is not a reliable method for differential diagnosis, but the preliminary data obtained enable us to state:

1. The localisation of the tumour either by abnormalities in the image or by the appearance of indirect signs such as electrodermal points and zones of activation, enabling the site of the tumour to be worked out (figs. 19.7 and 19.8).
2. The presumptive diagnosis of a malignant tumour is based on the appearance of bright zones with the characteristics as described above. As distinct from these characteristics, inflammatory processes show themselves as zones and points of activation. Benign tumours can also show zones of electromorphous effect, but they are well defined and have less brightness as compared to the images taken over malignant tumours (fig. 19.6).

The research work presented in this limited framework shows that

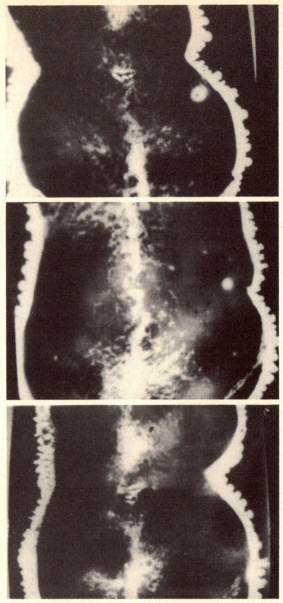

Fig. 19.6. Sigmoid tumour with predominating electromorphous effect (original image). (a) Before surgery. (b) One month after surgery. (c) Three months after surgery.

Electronographic Exploration of Human Cancer 251

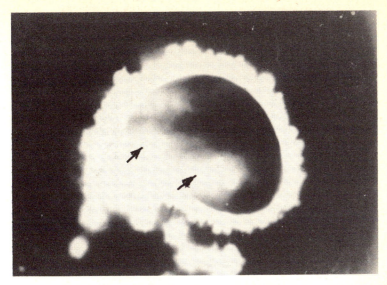

Fig. 19.7. Breast cancer (original).

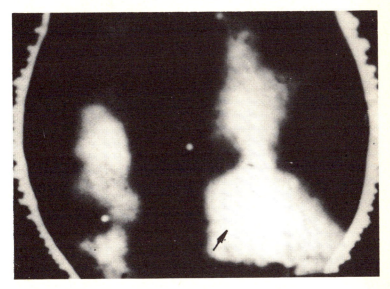

Fig. 19.8. Sigmoid carcinoma (original).

it is possible to use electronography in the investigation of malignancy in relation to the electrical behaviour of cancer (fig. 19.8).

Recordings obtained by us show that malignant tumours differ from healthy tissues not only in having different electrical impedance, but also due to the active phenomena of absorption of the electromagnetic radiation generated by a violent variation of the exploratory field to which they are exposed in the electronography device. We believe that these electronographic effects are of great importance in the study of the pathogenic mechanisms of neoplastic disease.

The dependence of the electronographic effects on the parameters of the high tension impulse used in the experiments was found in all the cases studied. The effect is optimal at a certain energy level, active slope and luminophore used, all these being determined by the characteristics of each type of tumour and by each anatomical localisation.

We believe that at present, the use of electronography in the study of the biophysical behaviour of tumours is a more important aspect than simply the diagnosis of malignancy. We have pursued our research along these lines. Electrical modifications at the tumour site are not isolated within the organism. The disappearance or reduction in the layer of detectable adherent aeroions is a phenomenon which can be explained through the perturbations secondary to those produced by the tumour on the biological electric medium. These perturbations translate either into diminution of ionisation capacity of air in the vicinity of the body, or into diminution of attraction exercised by the organism on the structured aeroions, or through a combination of both phenomena. Therefore, the question of malignant tumours acting as a radiation source becomes a possibility.

This behaviour suggests the possibility of the existence of biological radiation in the ultra-violet region which is more intense in areas of neoplasia. These observations allow us to revert to the hypothesis made by Gurwich some 40 years ago, when he demonstrated the influence of malignant experimental tumours on the growth of vegetable tissues. Recent research carried out in the USA and the USSR has lent support to Gurwich's observations.

PART V

ELECTROGRAPHIC TECHNIQUES

Chapter 20

Principles of the Electrographic Technique and the Electronography Apparatus

20.1 General principles of electrography

We have accepted the term 'electrography' in the etymological meaning of the word, believing it to be improper to attribute it exclusively to high tension photography. Thus, electrography is a transposition in images of the electrical characteristics of an object under investigation. The most general scheme for producing an electrograph is the one shown in fig. 20.1. The electrical source A acts energetically upon object B through systems which pick up, convert, and produce the image C.

According to the application, the amplitude of the signal can vary from very low tension to very high tension, and the same applies to the frequencies. Electrical power varies in general, within narrower limits. Object B, subjected to the action of electrical source A, can be solid, liquid or gaseous, live or inanimate.

The system C for picking up, converting and producing the image differs greatly according to the image size.

Fig. 20.1. General principle for an electrographic scheme (original).

At the inlet of system C, and eventually on the electrograph, information will be obtained containing the parameters of the electrical signal of source A and the parameters of the subject. The effects of the electric current will therefore be recorded, such as magnetic effect, thermal effect, effect of electroluminescence, weight-motor effect, drift discharge effect, electrostatic polarisation effect, etc.

The importance of the study of electrography consists in knowing the parameters of the signal, and from this it is possible to estimate, from the images, certain parameters of the object, and conversely, knowing the behaviour of the object, the parameters of the signal can be likewise deduced.

We shall describe in the following, various electrographic techniques, specifying, on each occasion, details of the electrical source signal, the object being investigated, and the system for picking up, converting and producing the image.

20.2 Classical methods of electrography

20.2.1 *Clidonography*

The oldest method of electrography was invented two centuries ago, by Lichtenberg. A high tension impulse is applied between the two electrodes of the experimental device being used. The powder used as the sensor will move (pondero or weight-motor effect) and will acquire a characteristic shape which has been called the Lichtenberg figure. Later, instead of powder, a photographic plate was used, impressed by the drift discharge with luminous effect which appeared on the upper surface of the dielectric.

The method of obtaining the figure was called Clidonography, and the device, a clidonograph.

Fig. 20.2. Basic scheme for Clidonography.

Electrographic Technique and the Electronography Apparatus

The size and the shapes of Lichtenberg figures are easily explained by an identical mechanism with that for the development of positive streamers.

If the impulse is negative, the electrons are repelled by the electrode and leave behind a positive charge which will not branch out any more and will be attracted by the electrode.

The clidonograph consists of an electrical source which produces a single high tension impulse. The object subjected to this is gaseous; the air from the surface of the dielectric. The system of picking up, converting and producing the image is based either on the weight-motor effect, or on drift discharges with luminous effect recorded by a photographic technique. The image will depend thus on the shape

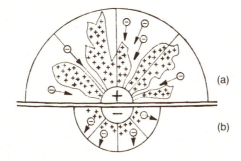

Fig. 20.3. Mechanism for forming Lichtenberg figures.

and amplitude of the single impulse, on the qualities of the powder; sizes, weight, electrical mobility, as well as on the quality of the photographic plate (fig. 20.3).

If one arranges for the amplitude of the impulse to be the only variable, then the study of Lichtenberg figures leads to the establishment of a correlation between the radius of the figure and the amplitude of the impulse.

The purpose of clidonography is to determine the amplitude of the impulse by measuring the radius of the figure thus obtained.

20.2.2 *Electrography in defectoscopy*

The use of high tension impulses when testing electrical apparatus such as transformers, switches, rotating electrical machines is well known. The study of the behaviour of materials subjected to a high

tension impulse is also used in defectoscopy for detecting the point where the penetration of the insulation of a coil winding has taken place. Subsequently, electrography by electroluminescence has proved to be useful in non-destructive defectoscopy.

The image recorded on the film in the arrangement shown in fig. 20.4 depends, amongst other things, on the state of the surfaces of the two electrodes (their flat surfaces) as well as on the surfaces of the dielectric and its homogeneity. In this way, given two known

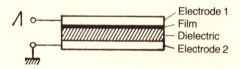

Fig. 20.4. The use of electrography in defectoscopy (original scheme).

elements, for instance the flatness of one of the electrodes and of the dielectric, the flatness of the second electrode can be studied.

20.2.3 *Electrophoresis*

In 1807 Reiss noticed the movement of a liquid in a porous body placed in an electrical field. In 1853 the first studies on the separation of substances with the help of electric current (Hitorff) was carried out. The term electrophoresis was first used in England in 1899 and signifies in general the migration of colloidal particles in an electric field.

Electrophoresis is an electrographic method. The electrical source generates direct current with intensities in the order of milliamps up to tens of milliamps and tensions of between tens and hundreds of volts. The object under study is made up of colloidal particles. From the point of view of the system picking-up, transducing and producing the image (SC TPL) there are two aspects in electrophoresis which correspond to ways of producing migration of colloidal particles. Devices were developed for migration in a porous body (filter paper, glass powder, etc.), such as Tiselins apparatus.

The result of electrophoresis is an image from which can be deduced the properties of the body under study, like mobility; the relative and absolute quantity of components electrophoretically separated, and the homogeneity of the fractions.

Electrographic Technique and the Electronography Apparatus

The process of paper electrophoresis has gained the greatest acceptance in the medical field through the work of Durrum, Wielaw and Grosman.

A strip of filter paper, soaked in a buffer solution, is introduced into an enclosed space. The serum to be analysed is applied onto the paper in the form of a droplet under the influence of the electric current applied at the end of the tape. A migration and disintegration into fractions will occur. By inserting the tape into a staining solution the fractions are pinpointed and then remain as dots.

The evaluation of the resultant fractions can be done directly or by cutting off the dots and introducing them into an elution liquid which is then subjected to colorimetric batching. A radioactively marked colouring agent can also be used, the evaluation being done by readings on a scintillation counter.

20.2.4 Other electrographic techniques

The electrographic technique lies at the basis of some photographic reproduction techniques of the Xerox type.

Lately, there have been carried out numerous methods and techniques for recording the radiological image and their reproduction by means of electrographic techniques.

In relation to Kirlian photography there have been several variants that have been described in specialist papers.

We mention in this regard the equipment developed by D. Faust, V. Inyushin, E. Igenberg, Thelma Moss and collaborators, H. S. Denkin, A. Lerner.

As far as Kirlian photography is concerned we consider that these papers are representative.

That is the simple reason why what follows will be a presentation of a series of technical and theoretical aspects concerning electronography equipment.

20.3 High tension impulse generators in electronography

The apparatus for generating high tension impulses makes it possible to obtain, in a laboratory, certain aperiodic waves with a front duration from a few microseconds to hundreds of microseconds.

The basic design for this apparatus contains at least two energy accumulators; either two condensers, or a condenser and an

inductance. There are also designs with four energy accumulators (two condensers and two inductances) meant mainly for the study of the effect of switching supertensions in electrical installations. In fig. 20.5 a few of the basic schemes for an installation for generating high tension impulses are shown. The impulse condenser C_1 is charged from an installation of continuous tension up to a value U_0 when the penetration of the space between the spheres of the spark gap primer *IS* takes place; the impulse condenser C_1 discharges onto the charge impedance made up from capacity C_2 and resistance R_2 through the

Fig. 20.5. Basic scheme of high tension impulse installation.

damping resistance and the front resistance R_1. The selection of the parameters of the scheme enables the impulse voltage U_2 to be obtained with precise form of its wave shape.

In order to demonstrate the criteria for selecting elements of the scheme for a high tension impulse apparatus, the phenomena taking place should be followed, taking into account the layout of figure 20.5c. (In fact scheme C enables the problem to be treated in a more general way; as in fact, the diagram in fig. 20.5a derives from diagram 20.5c if $Ra = 0$.) Generally speaking, in order to study the transitory rating of a linear circuit, several methods can be used, for instance, the method of direct integration of the Kirchoff equations, the operational method (or of the Laplace transformation), the spectral

Electrographic Technique and the Electronography Apparatus 261

analysis method (or of Fourier's integral), or the method of transitory response. We shall adapt the operational method, in accordance with which for a variable function f(+) called 'original' Laplace transformation of the Laplace image is defined:

$$F(p) = \mathscr{L}[f(t)] = \int_0^\infty f(t) e^{-pt} dt, \qquad (20.1)$$

where $F(p)$ is a function of complex variable p.

In order to determine the original, the first form of the development theories of Heaveside is applied for a Laplace transformation, equal with the relation of two full functions of p, $F(p) = P(p)/Q(p)$ and the result is:

$$f(t) = \sum_k \frac{P(p_k)}{Q'(p_k)} e^{p_k t}, \quad Q(p_k) = 0, \quad k = 1.2 \qquad (20.2)$$

where $p_k \neq 0$ are the roots of the function $Q(p)$, therefore the poles of Function $F(p)$.

The equation value for time t, after the firing of the spark gap ES, is written:

$$\begin{cases} U_0 - \dfrac{1}{C_1} \displaystyle\int_0^t i_1 \, dt = R_a i_1 + R_2(i_1 - i) \\[1em] R_2(i_1 - i) = R_1 i + u_2 \\[1em] i = C_2 \dfrac{du_2}{dt} \end{cases} \qquad (20.3)$$

By eliminating currents i_1 and i, and solving the system of equations, in relation to u_2, the following is:

$$\frac{R_2 C_1 + R_a C_1 + R_1 C_2 + R_2 C_2}{R_2 C_1} u_2 + \frac{C_2}{R_2}(R_a R_2 + R a R_1 + R_2 R_1)\frac{du_2}{dt} +$$

$$+ \frac{1}{C_1 R_2} \int_0^t u_2 \, dt = U_0. \qquad (20.4)$$

By applying the Laplace transformation, and bearing in mind the initial conditions: $t = 0$, $u_2 = 0$, one obtains:

$$F(p) = \mathscr{L}[u(t)] = \frac{P(p)}{Q(p)} = \frac{kU_0}{ap^2 + bp + 1}, \qquad (20.5)$$

in which the notations

$$k = C_1 R_2$$
$$\begin{cases} a = C_1 C_2 (R_a R_2 + R_a R_1 + R_2 R_1) \\ b = R_2 C_1 + R_a C_1 + R_1 C_2 + R_2 C_2 \end{cases} \quad (20.6)$$

have been used.

If we introduce the following notations:

$$\begin{cases} \theta = \sqrt{a} \\ \alpha = \dfrac{b}{2\theta} \end{cases}$$

the relation (20.5) becomes

$$F(p) = \mathscr{L}[u(t)] = \frac{k U_0}{\theta^2 p^2 + 2\alpha \theta_p + 1} \quad (20.8)$$

According to the first form of the development theorem, in which the poles of function $F(p)$ take part:

$$p_1 = \frac{-\alpha + \sqrt{\alpha^2 - 1}}{\theta} ; \quad p_2 = \frac{-\alpha - \sqrt{\alpha^2 - 1}}{\theta} \quad (20.9)$$

by also introducing the notation:

$$\eta = \frac{b}{k} \quad (20.10)$$

the original function $u_2(t)$ results in:

$$u_2(t) = \frac{\alpha U_0}{\eta \sqrt{\alpha^2 - 1}} (e^{-(\alpha - \sqrt{\alpha^2 - 1}) t/\theta} - e^{-(\alpha + \sqrt{\alpha^2 - 1}) t/\theta}). \quad (20.11)$$

The relation (20.11) therefore represents tension u_2 at the terminals of the charge impedance, resulting in an aperiodic wave as a result of the combination of two exponential functions, one of which bears a minus sign, whilst the other, a plus sign. In electrography, tension $u_2(t)$ applies to the system made up from the live structure under investigation, in the chosen configuration, which also contains photographic film; a dielectric screen, luminous material and electrodes, the parameters of the double exponential wave (tension impulse) are established experimentally, in correlation with analytic modelling based on an equivalent scheme.

The parameters of the impulse wave; maximum value (amplitude),

Electrographic Technique and the Electronography Apparatus

conventional duration of the front, τ_f and the conventional duration of the semi-amplitude τ_s, are achieved by adopting corresponding values for the elements of the diagram for a high tension impulse set-up and for the supply tension U_0.

In the main, the duration of the wave front, τ_s, is determined by the series resistance R_1, by the damping resistance R_a and by the capacitance C_2 (fig. 20.5c).

The duration of the semi-amplitude τ_s is determined by the impulse capacity C_1, and by the discharge resistance R_2.

When evaluating the performance of a high tension impulse installation, of great importance is the utilisation factor, defined by the relation:

$$C = \frac{U_{2M}}{U_0} \quad (20.12)$$

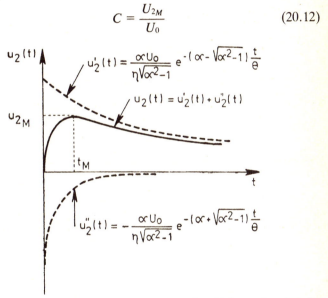

Fig. 20.6. The form of the outlet tension of a high tension impulse installation.

therefore, by the relation between the maximum value of the tension produced at the terminals of the charge impedance and the continuous tension U_0.

The impulse tension given by (20.11) can be written in a simplified form, as follows:

$$u_2 = AU_0(e^{-\gamma_1 t} - e^{-\gamma_2 t}) \quad (20.13)$$

whose maximum value is obtained at time t_M given by the relation:

$$\frac{du_2}{dt} = AU_0(-\gamma_1 e^{-\gamma_1 t} + \gamma_2 e^{-\gamma_2 t}) = 0, \qquad (20.14)$$

from which it results that:

$$t_M = \frac{\ln \dfrac{\gamma_2}{\gamma_1}}{\gamma_2 - \gamma_1} \qquad (20.15)$$

or, taking into consideration the expressions for γ_1 and γ_2:

$$\gamma_1 = \frac{\alpha - \sqrt{\alpha^2 - 1}}{\theta} \quad (20.16); \qquad \gamma_2 = \frac{\alpha + \sqrt{\alpha^2 - 1}}{\theta} \quad (20.17)$$

One calculates:

$$\xi = \frac{u_{2M}}{U_0} \eta \qquad (20.18)$$

from which it follows that:

$$\xi = \frac{\alpha}{\sqrt{\alpha^2 - 1}} \left[e^{-\frac{\alpha - \sqrt{\alpha^2-1}}{2\sqrt{\alpha^2-1}} \ln \frac{\alpha+\sqrt{\alpha^2-1}}{\alpha-\sqrt{\alpha^2-1}}} - e^{-\frac{\alpha+\sqrt{\alpha^2-1}}{2\sqrt{\alpha^2-1}} \ln \frac{\alpha+\sqrt{\alpha^2-1}}{\alpha-\sqrt{\alpha^2-1}}} \right]$$

$$(20.19)$$

The expression $\xi = \eta\, u_{2M}/U_0$ can be determined only according to α. In any case, by dividing the expression by η, the utilisation factor C for the circuit can be obtained.

Evidently, the parameters of the scheme must be selected in such a way that as great a utilisation factor as possible is obtained. But in fact the most important condition imposed when calculating the scheme of the impulse generator used in electronography is obtaining a particular predetermined wave.

The scheme of an impulse generator is perfectly well defined if we know the three parameters: α, θ and η. By looking at relation (20.11), one notices:

(a) parameter α determines the shape of the impulse wave, in other words, the relation between the conventional duration of the wave front τ_f, and the conventional duration of the amplitude τ_s;

(b) parameter θ defines the conventional durations of the front and of the semi-amplitude;

(c) parameter η determines the amplitude of the impulse wave or the utilisation factor of the scheme.

If one accepts as given the parameters α, θ and η, the parameters k, a and b can be determined (relations 20.6), following which, values for the elements of the scheme can be established. The analytical solution of the problem is impossible (a system of three equations with five unknown quantities). This is why one goes on to adopt certain values for the impulse condenser C_1 and condenser C_2 as a result of ensuring the availability of the energy required by the set-up for carrying out the tests (depending on the structure being investigated), and obtaining the best possible utilisation factor for the equipment.

The system of equations (20.6) therefore becomes perfectly compatible, and by solving these, the series resistance R_1, the damping resistance R_a and resistance R_2 can be determined. The time constant $R_a C_2$ is adopted in a much smaller quantity than the time constant $R_2 C_1$ so that the effect of the charge capacity disappears once the wavefront has been produced.

From a technical viewpoint, in order to establish the parameters of an installation for high tension impulses, calculus monographs are used. In fig. 20.7 we present the variation of the utilisation factor C in accordance with the relation C_2/C_1. It is noticed that as far as the normalised wave 1.2/50 wave is concerned, the relation C_2/C_1 can vary between the limits 0.05 and 0.2 in order to obtain a utilisation factor $C > 0.8$ (fig. 20.7).

The analysis of the processes in the generator design becomes very complicated if when calculating the stray capacitance C_p of the circuit and the inductance L_p of the discharge circuit is considered. The difficulties which appear when analysing the complete circuit make it necessary to work with simplified schemes as in fig. 20.5. If when constructing the resistances and condensers, measures to reduce to a minimum their own inductances are taken, the inductance of the discharge circuit is relatively small. The oscillations which appear because of this inductance are damped by resistance R_1. In these conditions, the effect of the inductance of the discharge circuit on the shape of the tension wave is negligible and therefore one can operate with the simplified circuits as in fig. 20.5a, b, c. In fact, the high tension impulse generator at the high tension laboratory consists of several stages, in which the impulse condensers are charged in

Electrographic Methods in Medicine and Biology

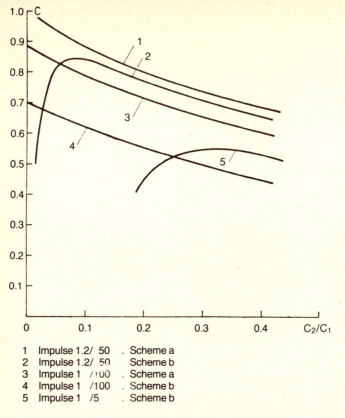

1	Impulse 1.2/ 50	.	Scheme a
2	Impulse 1.2/ 50	.	Scheme b
3	Impulse 1 /100	.	Scheme a
4	Impulse 1 /100	.	Scheme b
5	Impulse 1 /5	.	Scheme b

Fig. 20.7. Utilisation factor C depending on C_2/C_1.

parallel and then discharged in series. The modification of the configuration of the circuit is done with the help of firing dischargers.

In fig. 20.8 we present the multistage installation, having as a basic scheme, the one in fig. 20.5c.

The charging of the condensers nC_1 in the high tension impulse installation is done from a continuous tension source U_0, through charging resistances R_0. When the tension at capacitances nC_1 exceeds the penetrating tension of the interval between the spheres of the firing discharges ES, the condenser nC_1 discharges according to the circuit shown in fig. 20.5c.

When studying the phenomena taking place when charging the

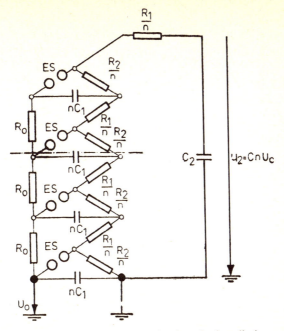

Fig. 20.8. Multistage high tension impulse installation.

high tension impulse installation, a scheme with uniformly distributed parameters is adapted (fig. 20.9). A chain of n quadripoles of l length with uniformly distributed resistances and capacitances is considered.

For the scheme in fig. 20.9, the following relations can be written:

$$\mathcal{U}_1 = \mathcal{U}_0 - r\mathcal{I}_0 \tag{20.20}$$

$$d\mathcal{U}_x = \frac{nR_0}{l} dx \cdot \mathcal{I}x \tag{20.21}$$

$$d\mathcal{I}_x = p\frac{n^2 C_1}{l} \cdot dx\,\mathcal{U}_x \tag{20.22}$$

The relations: $\mathcal{L}[u] = \mathcal{U}$ and $\mathcal{L}(i) = \mathcal{I}$ are used. From relation (21) and (22), there results:

$$\frac{d^2 \mathcal{U}_x}{dx^2} = \frac{nR_0}{l} \cdot p \cdot \frac{n^2 C_1}{l} \mathcal{U}_x \tag{20.23}$$

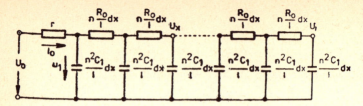

Fig. 20.9. Circuit scheme for the charging circuit of a high tension impulse installation.

with the solution:

$$\mathcal{U}_x = A e^{-\gamma x} + B e^{\gamma x} \tag{20.24}$$

where:

$$\gamma = \frac{n}{l}\sqrt{p n R_0 C_1} \tag{20.25}$$

The constants of integration A and B result from the conditions at the limits, written as follows:

- for $x = 0$ $\mathcal{U}(0) = \mathcal{U}_1 = \mathcal{U}_0 - r \mathcal{I}(0)$ (20.26)
- for $x = 1$ $\mathcal{I}(1) = 0$

Because from relation (21) one obtains:

$$\mathcal{I}_x = \frac{n R_0}{l} \cdot \frac{d \mathcal{U}_x}{dx} \tag{20.27}$$

it results that:

$$\mathcal{I}_x = \frac{l\gamma}{n R_0}(-A e^{-\gamma x} + B e^{\gamma x}) \tag{20.28}$$

and therefore:

$$\mathcal{I}(0) = \mathcal{I}_0 = \frac{l\gamma}{n R_0}(B - A) \tag{20.29}$$

and:

$$\mathcal{I}(l) = \frac{l\gamma}{n R_0}(-A e^{-\gamma l} + B e^{\gamma l}) \tag{20.30}$$

From the first equation, one deduces:

$$A + B = \mathcal{U}_0 - r \frac{l\gamma}{n R_0}(B - A) \tag{20.31}$$

or:
$$A\left(1 - \frac{rl}{nR_0}\gamma\right) + B\left(1 + \frac{rl}{R_0 n}\gamma\right) = \mathcal{U}_0 \qquad (20.32)$$

and from the relation (20.30) it results that:
$$A e^{-\gamma l} - B e^{\gamma l} = 0. \qquad (20.33)$$

Relations (20.32) and (20.33) enable the integration constants to be determined. After doing the calculations, it resulted that:

$$A = \frac{\mathcal{U}_0 e^{\gamma l}}{2 ch\gamma l - 2\dfrac{l\gamma}{nR_0}\gamma sh\gamma l}$$
$$B = \frac{\mathcal{U}_0 e^{-\gamma l}}{2 ch\gamma l - 2\dfrac{lr}{nR_0}\gamma sh\gamma l} \qquad (20.34)$$

Tension \mathcal{U}_x will present a variation from form:
$$\mathcal{U}_x = \frac{ch\gamma(l - x)}{ch\gamma l - \dfrac{lr}{nR_0}\gamma sh\gamma l} \cdot \mathcal{U}_0 \qquad (20.35)$$

If one notes:
$$\gamma l = n\sqrt{pnR_0 C_1} = \Phi \qquad (20.36)$$

and if one takes into consideration the fact that in a discrete system, the relaxation x/l can be replaced with i/n where i is the grade of the stage being considered, relation (20.35) can be expressed in its final form:

$$\mathcal{U}_x = \frac{ch\Phi\left(1 - \dfrac{i}{n}\right)}{ch\Phi - \dfrac{r}{nR_0} sh\Phi} \cdot \mathcal{U}_0 \qquad (20.37)$$

The passage in the time range is done by using the formula of the development theorem (when one considers the supply from a continuous source, one has to replace U_0/p and if one considers the supply from a rectified source of tension the corresponding expression of tension in the Laplace image range is introduced). The calculations, carried out in the case of connection to a continuous

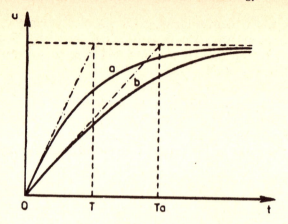

Fig. 20.10. The charging of condensers in the tension impulse installation.

tension source, show that in the case of the last impulse condenser, the time constant of the charging process can be given by the relation:

$$T = \frac{4n^3 R_0 C_1}{\pi^2} + rn^2 C_1. \qquad (20.38)$$

In the case of a tension impulse installation with six stages, having $R_0 = 20\,\text{k}\Omega$, $C_1 = 0.1\,\mu F$ and $r = 50\,\text{k}\Omega$, a charging constant $T = 0.35\,\mu s$, results (fig. 20.10 curve a). In practice, charging is done from a continuous tension installation obtained by the rectification of an alternating tension. Because of this, the charging of the last condenser in the installation is carried out according to curve b of fig. 20.10 with a time constant T_a greater than the theoretical value T. When using the tension impulse installation, bear in mind the necessity that the interval between two successive impulses should be greater than the charging constant T, so that when the space between the spheres of the discharge ES is sparked, all impulse condensers of the installation will be charged to the same tension value.

The tension impulse installation can function in self-firing conditions, or in controlled firing conditions. When installations function in firing conditions, the discharge process starts when the tension at the terminals of the impulse condensers exceeds the penetration tension at the interval ES (fig. 20.12).

Due to the chance nature of the firing phenomenon, the interval

between two successive impulses, as well as the amplitude of the tension thus obtained, cannot be precisely controlled. Because of this, when functioning in conditions of self-firing, the tension impulse installation is not used in practice.

The installation for the controlled release of the impulse is governed by using an auxiliary control electrode E, mounted on the firing discharger in the first stage (fig. 20.11). The distance between the firing dischargers ES is regulated in such a way that the penetration tension of the interval between the spheres is slightly greater

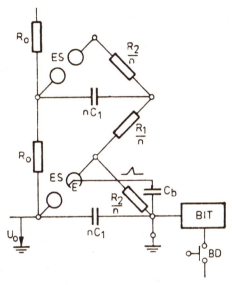

Fig. 20.11. Circuit diagram for controlled release of the tension impulse installation.

than the charging tension U_0. At the desired moment (manually or from a remote control panel) the release button BD is pushed. The high tension electronics (block BIT, fig. 20.11) leads to the formation of a reduced duration impulse (of the order of microseconds) with an amplitude of 10–20 kV which transmits to the auxiliary electrode E through the terminating condenser C_b. A space of a few millimetres between the auxiliary electrode and the sphere of the firing discharger ES is penetrated and the local discharge which appears leads to the firing of the main discharge. The role of condenser C_b is not to

272 *Electrographic Methods in Medicine and Biology*

Fig. 20.12. Installation for producing a perfect very high voltage impulse.

allow the loading of block *BIT* by the high tension appearing on the upper sphere of the installation after the firing of the main discharge. A discharger is installed for the protection of block *BIT*. The central discharge for small electronographic devices can be made by the discharge of capacitors by high-voltage thyristors. One very elaborate device can be carried out by means of a sparking device by ionisation in ultra-violet rays or with the help of lasers.

20.4 Equivalent scheme for the investigation equipment

The question of adopting an equivalent scheme for the purpose of determining the optimal parameters of the equipment comes down to the modelling of living tissue through a circuit, which although of simple shape and constructed on the basis of numerous approximating hypotheses, should be able to serve as an accurate model for study on a computer of different configurations of electrode-insulator-organic structure.

Our previous research has shown that the qualitative and quantitative study of passive electrical properties (the resistance explored in

continuous current, requiring in the measurement circuit an exosomatic source, the impedance and capacitance determined in A.C.), and of active electrical properties (electrical potential) of biological systems, require the use of the phenomenological theory of electromagnetism applied in a general fashion, referring to the electric field in a volume conductor produced by a certain density of applied current and accepting conventionally the existence of a linear, infinite, homogeneous isotropic medium characterised by electrical conductance, magnetic permeability and dielectric permittivity.

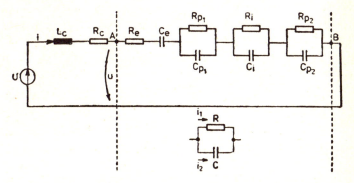

Fig. 20.13. Circuit diagram broadly equivalent to a living biological system.

The biological sources of potential are to be found in the electrolytes of a complex character, whose non-linearity and variability in time is one of the functional peculiarities of biological systems.

The difficulties of mathematical modelling of the real characteristics of living organisms, which act as volume-conductors, nonhomogeneous, with electrical anisotropy, composed of a multitude of independent sources of potential which interfere spacio-temporarily, and in a variable way, with any circuit diagram, are many and it remains a problem to design an equivalent mathematical scheme for biological systems.

In the following we shall adopt, for the living organism, the Bordier scheme, which derives from the Freiberger scheme by considering a capacitive component of internal tissues. In fig. 20.13 we present the equivalent scheme of the investigating equipment. In this scheme are interposed: the parameters of the connections between

the tension impulse generator and electrodes – inductance L_c and resistance R_c – the parameters of the protecting zone, air and insulating screen – resistance R_e and capacitance C_e – parameters of the living organism – the resistances of the cutaneous covering Rp_1 and Rp_2, the resistance of internal structures R_i, the capacitances of the cutaneous covering Cp_1 and Cp_2, the capacitance of internal organs C_i. In order to determine the expression for the calculation of the tension at the AB terminals, the installation is operated with an equivalent resistance R and an equivalent capacitance C.

The first problem to be solved is the adoption of a configuration of study in which the inductance of the connections doesn't produce oscillations at terminal A. For this purpose, an equivalent circuit RC for the insulating screen is adopted, and the differential equations for the scheme of fig. 20.13 are written as for applying one tension impulse.

$$\begin{cases} U = L_c \dfrac{di}{dt} + R_c i + u \\[6pt] \dfrac{di}{dt} = \dfrac{di_1}{dt} + \dfrac{di_2}{dt} \\[6pt] i_1 = \dfrac{u}{R} \\[6pt] i_2 = C \dfrac{du}{dt} \end{cases} \qquad (20.39)$$

From the equations (20.39), it follows that:

$$CL_c \dfrac{d^2 u}{dt^2} + \left(R_c C + \dfrac{L_c}{R}\right)\dfrac{du}{dt} + \left(\dfrac{R_c}{R} + 1\right) u = U \qquad (20.40)$$

The solutions of the differential equations are:

$$u = kU\left[1 - \dfrac{e^{-\xi \omega_n t}}{\sqrt{1-\xi^2}} \sin\left(\omega_n \sqrt{1-\xi^2}\, t + \arctg \dfrac{\sqrt{1-\xi^2}}{\xi}\right)\right] \qquad (20.41)$$

for $\xi < 1$:

$$u = kU\left[1 - \dfrac{e^{-\xi \omega_n t}}{\sqrt{\xi^2-1}} \sh\left(\omega_n \sqrt{\xi^2-1}\, t + \arcth \dfrac{\sqrt{\xi^2-1}}{\xi}\right)\right] \qquad (20.42)$$

for $\xi > 1$:

Electrographic Technique and the Electronography Apparatus

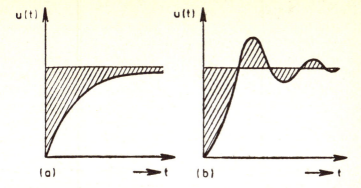

Fig. 20.14. Transitory response occurring when a single high tension impulse is applied. (a) Aperiodic response. (b) Damped oscillatory response.

The following equations were used:

$$\xi = \frac{R_c C + \dfrac{L_c}{R}}{2\sqrt{CL_c(R_c/R + 1)}} \ ; \quad \omega_n = \sqrt{\dfrac{\dfrac{R_c}{R} + 1}{CL_c}} \ ; \quad k = \dfrac{1}{\dfrac{R_c}{R} + 1}.$$

(20.43)

In fig. 20.14 the transitory response of the configuration consisting of insulating screen and living tissue is given for a single high tension impulse. The response time of the scheme is proportional to the hatched area in figs. 20.14a and b.

The parameters of living tissues vary according to the area under investigation; this correlates with the values of resistance and capacitance of the tissue and changes the tension and thereby the intensity of the electric field which will differentially excite the photosensors and the luminophore layer.

20.5 Analytic estimation of the influence of the test scheme parameters on the intensity of the electric field applied to the body under investigation

The analysis undertaken was carried out on the basis of the equivalent circuit shown in fig. 20.15 in which the following notations were used, L_c and R_c, the inductance and the device respectively, in which

276 Electrographic Methods in Medicine and Biology

the study takes place, R_e and C_e the resistance and capacitance respectively of the protecting zone (air interval and electro-insulating screen) and C_v and R_v, the capacitance and equivalent resistance of the living organism under study.

In the calculation the reactive elements of the scheme (capacitances and inductances) were replaced by an equivalent electrical component calculated with the aid of the trapezium method. The

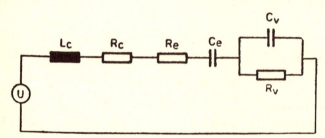

Fig. 20.15. Equivalent scheme of the experimental configuration.

calculating circuit is shown in fig. 20.16 where the following notations were used:

$$I_1(t-\Delta t) = i(t-\Delta t) + \frac{\Delta t}{2L_c}[u_A(t-\Delta t) - u_B(t-\Delta t)]$$

$$I_2(t-\Delta t) = -\frac{2C_e}{\Delta t}[u_C(t-\Delta t) - u_D(t-\Delta t)] - i(t-\Delta t)$$

$$I_3(t-\Delta t) = -\frac{2C_v}{\Delta t}[u_D(t-\Delta t)] - i(t-\Delta t) + \frac{1}{R_v}u_D(t-\Delta t)$$
(20.44)

The calculus scheme gives the following relations:

$$\begin{cases} i(t) = \frac{\Delta t}{2L_c}[u_A(t) - u_B(t)] + I_1(t-\Delta t) \\ i(t) = \frac{2C_e}{\Delta t}[u_c(t) - u_D(t)] + I_2(t-\Delta t) \\ i(t) = \frac{1}{R_c + R_e} \cdot [u_B(t) - u_c(t)] \\ i(t) = \frac{2C_v}{\Delta t}[u_D(t)] + I_3(t-\Delta t) + \frac{1}{R_v}u_D(t). \end{cases}$$
(20.45)

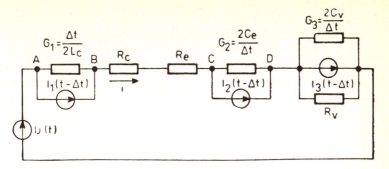

Fig. 20.16. Scheme for calculating the configuration being studied.

On the basis of calculus relations (20.44) and (20.45) the tension, and, implicitly, the intensity of the field to which the body is subjected have been calculated with the aid of a programme of calculations, and within this framework of calculations one has borne in mind that the relation (20.45) leads to:

$$u_D(t) = \frac{1}{\frac{1}{R_v} + \frac{2C_v}{\Delta t}}[i(t) - I_3(t - \Delta t)], \qquad (20.46)$$

where:

$$i(t) = \frac{1}{K}u_A(t) + \frac{1}{K}\left[\frac{2L_c}{\Delta t}I_1(t - \Delta t) + \frac{\Delta t}{2C_e}I_2(t - \Delta t) + \right.$$
$$\left. + \frac{1}{\frac{1}{R_v} + \frac{2C_v}{\Delta t}}I_3(t - \Delta t)\right]. \qquad (20.47)$$

In relation (20.47) the notation has been used:

$$K = \frac{2L_c}{\Delta t} + R_c + R_e + \frac{\Delta t}{2C_e} + \frac{1}{\frac{1}{R_v} + \frac{2C_v}{\Delta t}} \qquad (20.48)$$

When the analysis was carried out, the applied tension was considered to be in the following form:

$$u_A(t) = A(e^{-t/T_1} - e^{-t/T_2}), \qquad (20.49)$$

where the time constants T_1 and T_2 depend on the shape of the applied impulse and the constant A on the amplitude of the applied tension.

The calculation interval Δt has been chosen so as to obtain a sufficiently precise calculation. Thus, in the studies carried out with short impulses (the duration of the wave front being about $1\,\mu$s), Δt was taken to be equal to 50 ns and in the case of long impulses (a wavefront duration of about $100\,\mu$s), Δt was equal to $5\,\mu$s.

The tensions at the various points of the circuit are calculated bearing in mind the known current in the circuit and the tension $u_D(t)$ determined from relation (46):

$$\begin{cases} u_c(t) = u_D(t) + \dfrac{2C_e}{\Delta t}[i(t) - I_2(t - \Delta t)] \\ u_B(t) = u_c(t) + (R_c + R_e) \cdot i(t). \end{cases} \quad (20.50)$$

In the calculations carried out as a first approximation, it was considered that the source has a large power (the internal impedance of the source being practically zero). In the case of sources with reduced power it is necessary for the impedance of the source to be included in the calculation.

By adopting a number of variants regarding the configuration of the measurement system, the optimal parameters of the insulating screen (material, dimensions, lay-out in the electromagnetic fields) have been obtained in correlation with the applied impulse, where the amplitude and duration of the wave front and of the amplitude according to the zone of the living organism being investigated can be varied.

20.6 Apparatus for electronography

The electronography apparatus is, as generally accepted, a linear microparticle accelerator in which the luminous effect is obtained by accelerating electrons and positive ionic structures which react by recombining with the electrons, like luminous tracers, generating the pellicular effect and, at the same time, through the interaction of the particles thus accelerated with substances which achieve phenomena of differential electrono-optical conversion, according to the exploratory field.

The acceleration space can be virtual (direct contact between the surface of the organism under investigation and the recording

Electrographic Technique and the Electronography Apparatus

device), or mediated through a medium with minimum resistance to the electrons or the accelerated particles (vacuum tube). The electronographic image appears thus as an instantaneous image determined by a flux of microparticles directed and controlled, and has a controlled and specific energetic value.

In principle, when constructing such an apparatus, it is possible to delimit a source of very high tension impulses with quantifiable characteristics, modifiable according to the requirements of the investigation, but reproducible in the same conditions, achieving a measured and controllable cold electronic emission. The second essential element is the exposure and recording device. The living organism is introduced into this device in the conditions required by the method used, either in the dielectric space of a condenser, or as a component part of one of the electrodes, itself made up of electrical non-homogeneities which will determine non-homogeneous distributions of the applied electromagnetic field. An essential requirement for the electronography device is the achievement of a perfect isotropy of the dielectric field; the only anisotropy being produced in the exposure device is by the biological medium being investigated.

An important conceptual element of the exposure and recording device is an electrono-optical conversion layer which transforms the energy of the exploratory field into images differing as regards their brightness. This energy depends on the differential attenuation to which the electromagnetic field is subjected, due to the structure being investigated. The luminous phenomena on the electrono-optical conversion layer can be fed into a separate light sensor, or superimposed on the primary electroluminescence phenomena determined, to a large extent, by the driving back of the electromagnetic field through minimum impedance zones of the biological volume-conductor being explored. The two components of the electronographic image will generate the electromorphous effect and the pellicular effect (corresponding to the skin effect).

We must stress here that other biological or inert structures can also become luminescent when the value of the electrical tension reaches certain thresholds. Thus, glass generates luminescent nuclei according to its composition at tensions in excess of 45 kV. These limits demand that electronography should be carried out at tensions below 40 kV and that one should use crystals with a high degree of purity. Depending on the values of the applied tension of the impulse, and on the sensitivity of the converting substances, the

electromorphous and pellicular effects can be obtained either separately or superimposed. Also, depending on the placing of the photosensor and its sensitivity, the two distinct effects can be reproduced either separately or together.

The sources of electronography are generators of unipolar single impulses with amplitudes between 1 kV and 40 kV.

The characteristics of the impulse are:

(a) the polarity of the impulse: positive or negative;
(b) the time of tension increase, which is lower than $5\,\mu s$;
(c) the return slope must have a sufficiently long duration so as not to generate phenomena of luminescence (values in excess of $50\,\mu s$);
(d) the amplitude of the impulse: 1 kV–40 kV.

The shape of the impulse is triangular, and its polarity is not determined by its geometry, depending on the zero potential line, but by the direction of the active slope (maximum drift) as against the base line. (Given these conditions, the triangular impulses, as proposed by Inyushin for improving the Kirlian technique, can act differently for the same shape if the orientation of the active slope is different.)

In conditions when one looks at the electrical behaviour of biological structures, we have used impulses of the type shown in fig. 6.5d. This type of impulse is useful, provided the values of the two components (positive and negative) are symmetrical and equal.

An important component of the electronographic source is the impulse-forming circuit, which brings the impulse to within the parameters required by the method (fig. 20.17 and 20.18, which have been largely described in section 20.3).

The block circuit for the high tension equipment used in electronography (fig. 20.17) shows that this circuit also serves for obtaining the IT discharge of a condenser (5) on the primary of a transformer of IT (7). The charging of the condenser is done from a rectifier (4) which, at the inlet, has a tension obtained either from transformer (3) activated by the inverter cc–ca (2, 3) supplied by a battery (1) or from the tension obtained from a mains transformer. The one thing which differentiates this high tension from all the others previously given is the impulse shaper IT8, which brings the impulse to the required shape and amplitude. Switch (6) can be mechanical or electronic, with single operation for one exposure (single impulse for electrono-

Electrographic Technique and the Electronography Apparatus

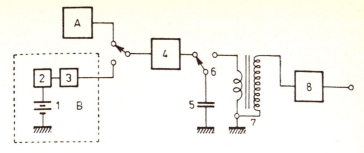

Fig. 20.17. Block diagram of the electronograph installation (original).

graphy) or activated at a certain frequency (impulse trains for electroluminescent spectrography). (The numbers in brackets in this paragraph refer to the numbering shown on fig. 20.17.)

In order to obtain images of areas in the vicinity of the heart with mono-polar impulses with high amplitude (40 kV), equipment has to be used (Dumitrescu and colleagues) with which one single electronographic impulse can be generated with controllable retardation as

Fig. 20.18. Electronography apparatus (original).

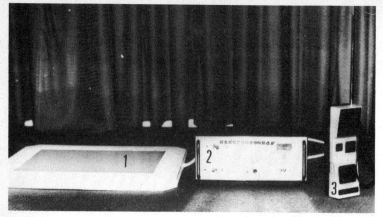

Fig. 20.19. Electronography equipment (original). (1) screen; (2) very high voltage impulse source; (3) radio command device.

against the systolic wave by 0.06 and up to 0.12 S. Thus, one eliminates the possibility of electronic release causing possible ventricular fibrillation, by releasing the impulse in the absolute refractory period of the myocardium.

The block scheme of this electronographic machine (fig. 20.19) contains, at the inlet, three electrodes E1, E2, E3, which will be placed respectively on the left arm, on the right arm, and the mass electrode E3 placed anywhere. There follows a pre-amplifier AM for recording the ECG, the differentiating circuit D, the high-pass filter FTJ, the absolute value amplifier AVA, the multivibrator M, the impulse shaper F1, the circuits for retardation control CR1, the logic gates CL1 and CL2, the single-impulse control button BCM and the high tension circuit CIT.

The smooth operation of the equipment is shown by the control lamp which lights synchronously with the heart beat. It is possible to see the ECG wave on an oscilloscope, as well as the retarded control impulse.

The recording device used for the electronographic technique is chosen according to the distribution of the electromagnetic field or by a way in which the living organism is introduced into the exploratory field. Thus, the living organism can be introduced into the dielectric space between the armatures of a flat condenser, to which the exploratory electrical tension is applied, or the contact surface of the organism constitutes one of the armatures of the condenser in which

the non-uniformity of the field is induced by the armature. In the first case an anisotropic dielectric is produced, and in the second case an anisotropic armature is formed.

The electrono-optical converter layer can be made up of luminescent chemicals with fluorescent or phosphorescent properties or of thermostable liquid crystals sensitive to the variations of the electromagnetic field. The essential characteristics of the electrono-optical conversion layer are:

- the value of the tension of lighting;
- the tension gradient between partial and total lighting of the luminescent substance;
- spectral turning between the sensitivity of the luminescent material and that of the photosensor.

In the electronographic technique, we have used luminescent substances of the metallic sulphide type, metallic halogens and selenium metallic derivatives, with activating and inhibiting impurities.

In the case of biological investigation at microscopic level, a recording device is used which is a device of the capacitive type in which the light sensor can be placed on each of the two surfaces. The dielectric can be distributed symmetrically or asymmetrically against the structure under investigation. As a rule, the device with symmetrical distribution of the dielectric is used, thus achieving conditions of field uniformity. The armatures completely cover the surface of the exposed body, so that field distortions are avoided through marginal losses.

When exposing the body the device is used through a screen in which the body is considered to be one of the armatures of a condenser. The biological armature completes a metallic armature covered with a dielectric. In this device, the distribution of the electromagnetic field, achieved by different impedance zones and under the action of biological electromagnetic fields, is projected onto the surface of the skin having regard for a geometrical distribution, determined by the metallic electrode of the exploratory screen. This distribution of the electromagnetic field determines a distribution of charged micro-particles on the surface of the biological armature (the body) which is printed correspondingly onto the reverse surface of the dielectric, with an orderly movement determined by the field variation rating, generating thus, in the scintillation layer, the differential excitation of its component

molecules. The luminous excitation of the converter layer is taken over, through the transparent dielectric, by photosensitive emulsion when this is applied by interposing it between the living organism and the dielectric of the recording screen. By reversing the orientation of the photosensitive emulsion, the luminous discharges determined by the pellicular effect can be obtained on its own. In this way, by the way in which the photosensitive film is positioned, the electromorphous and pellicular effects can be differentiated.

The electronographic screen is therefore a device partially completed by a photosensitive film, as light sensor, and by the living organism, as biological armature. This screen provides the luminous image corresponding to the electromagnetic field as propagated through the living organism.

Fig. 20.19(1) shows an electronography screen. In order to record an image by electroluminescence, at cellular or tissular level, the use of the condenser type of device is preferred, thus ensuring an exposure uniformity for the explored structure. The usual type of electronography screen can be replaced with an electrono-optical device for obtaining the image. This consists of a vacuum chamber in which the flux of particles from one of the sides of the chambers is transformed into a cold, local emission of electrons which are focussed and projected onto a scintillation screen, placed at a particular distance, there existing the possibility of electronic processing of the image.

Electronography, with its numerous technical variants, commonly uses as light sensors, black-and-white or colour photosensitive film, which is processed by photographic processes adapted for this purpose. Some of the most commonly used films are the orthochromatic ones, of the radiological type, which are suitable for luminescent substances with conversion into blue, green and violet but which do not provide images for conversion into red. The panchromatic and orthopanchromatic films can be used, with particular indications regarding the luminescent materials.

Agfa-Gevaert or Kodak colour films of normal size or larger size provide the best images if there is a sufficiently sensitive layer of luminescent substances which provides a bright enough light emission.

Colour films have a limited sensitivity. Highly sensitive films with normal or fine grain able to reproduce fine details are to be preferred (400 ASA).

Electrographic Technique and the Electronography Apparatus

When using the electronographic technique, we have tried over the past few years to replace the light sensor with a camera in a closed-circuit TV system.

In this case the electronography screen must be a transparent screen with a thin conductive metallic layer made either by layering organic silicone deposits, or by layers of transparent gel or a liquid conductor introduced inside the dielectric.

The technique using a TV camera has been called electronovision, having its equivalent in the better-known thermovision techniques.

In order to transpose the electronographic images into TV images, taking into account the principles on which electronography is based, two distinct processes have to be borne in mind:

1. Obtaining an electronographic image and its retardation, with the aid of a luminescent layer with remanence (static electronovision). In this way the images obtained in the TV circuit are instantaneous electronographic images which change by memorising a new image.
2. Synchronising the TV image with the release of the exploratory impulse and using a luminescent substance without remanence, in which, within a one-second time interval, 25 consecutive images can succeed one another.

This process has the disadvantage of disturbing the normal electrical activity of the structure being investigated, but makes possible the fine analysis of the way in which the tissue exposed to this exploration reacts; each image can be memorised in a magnetic video system and analysed through an image intensifier.

As far as light sensors are concerned, a particularly interesting perspective is opened up by the use of liquid crystals in which the image can be obtained through special plates which achieve, simultaneously, both differential electrono-optical conversion and the memorisation of the images thus obtained. Such a liquid crystal plate can be used in repeated examinations providing black-and-white or colour images.

20.7 Processing and interpretation of the electronographic image

The electronographic image obtained on film can be interpreted directly or processed through a photographic or electrono-optical process.

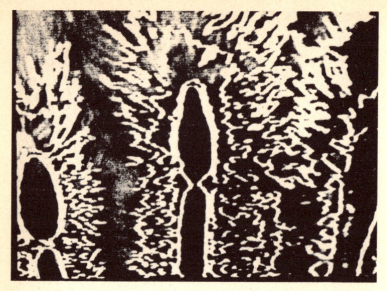

Fig. 20.20. Electronic processing of electronographic image with display of luminous equidensity lines (original).

At present, negative images can be developed quickly, and recorded. The copying of the negative image onto paper ensures its preservation and the differentiation of detail, depending on the exposure method and on the quality of the photographic paper, and on how the photograph is processed.

One of the simplest methods of processing an electronographic image is photographic processing; methods can be used in order to bring out certain details of conventional tonings to show details by tone or colour contrast. The methods of photographic processing are laborious and often they are not reproducible for a large number of electronographs.

A highly interesting possibility is processing with the help of TV circuits, with which differentiation by contrast can be achieved, and also electronic processes for mediating the signal and differentiating it from background noise can be used (fig. 20.20).

Another image-processing possibility is obtaining pseudo-relief which allows the differentiation of some details and the reproduction of their natural significance (fig. 20.21).

Electrographic Technique and the Electronography Apparatus

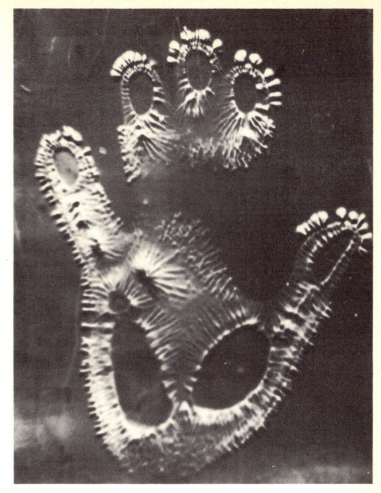

Fig. 20.21. Electronic processing in relief of the electronographic image (original).

Electronic processing can be applied to the images obtained at different functional moments of the organism, as well as by varying the parameters of the exploratory impulse, obtaining, for instance, different depths of impulse penetration.

A possibility for the future is the use of image processing, and its use for comparative interpretation of images, as well as for enlarging

the images by taking out the chance signals which disturb the image (especially in microelectronography).

Transposing the images in a TV circuit has the advantage that video-magnetic memorisation can be used of these images which can then be processed using a computer.

Chapter 21

Risks in Electrographic Investigation Techniques and Safety Precautions to Protect Against These Risk Factors

The use of high tension current in electrographic examination necessitates safety measures, both for the subjects investigated and for the operators of the equipment. In order to be able to choose protective measures which ought to be used in experimental research with electrographic techniques, the risk factors have to be identified:

1. High tension current (5–100 kV) produces intense ionisation along conductors and especially at their free extremities, therefore there is a danger of unexpected discharges.
2. Electric shocks produced by the exploratory impulse, or by impulse trains, without necessary protection measures can produce dysfunction in various organs, and especially when the heart or the cranium are being examined using electrographic techniques.
3. Soft x-ray emission is negligible, but could possibly accumulate due to repeated exposures with potential secondary effects on the body.
4. The emission of ultra-violet radiation can cause retinal damage, especially when directly observing electroluminescent phenomena. A high proportion of high frequency ultra-violet radiation can cause, especially in the case of electroluminescent electrographic exposures, pigmented erythematous skin lesions or in some cases chronic degenerative lesions.
5. The rich ionised air content of the medium in which repeated discharges take place can also cause bronchial irritation. Nitric oxides released due to the intense ionisation around the exposure screen, especially in the case of Kirlian photography, can have toxic effects.

6. Excessive and repeated exposure of the body to long investigations using impulse trains or with high frequencies, as in the case of the Kirlian technique, predispose to excessive ionisation of the circulating blood in the exposed part of the body, with as yet unknown consequences.

These possible risks of exposing living organisms in order to obtain electrographic images can be prevented by a series of measures for protecting the subject under investigation, and also to protect the personnel carrying out the examination. We shall return to each risk outlined here and outline procedures to eliminate these risks:

1. The high tension sources used in electronography have an important advantage compared to high frequency electrographic methods: the impulse is single, with an efficient duration and very little energy. The image obtained is thus very much a 'snap shot'. In all devices constructed by us, we have used as a general method for protecting the human subject, earthing of the high tension armature through an insulated cable according to safety measures usually used in high tension techniques.

The connection of the high tension source to the exposure screen must be done with a single cable with insulation made of Teflon or other material valid for tensions of 80 kV in alternating currents of 50 Hz.

The distance between the conductor plate of the screen and the free side of the dielectric crystal must be at least 50 mm for tensions of 40 kV, and the space between the insulating dielectric and the dielectric for protection of the electrode onto which the high tension impulse is applied, should be tightly bonded with epoxy resin or other insulating material resistant to very high tension impulses.

In the case of experimental electronography or microelectronography, when devices of the complete condenser type are being used, the two conductor cables must be used in the same conditions, and both cables must be screened. It is important to have efficient earthing of the metal frames and other metal components with which the patient or operator could come into contact during electronographic exposures.

The conductor cables must be as short as possible, avoiding twisting or crossing with other conductor cables or metallic components.

Risks and Safety Precautions in Electrographic Techniques

When carrying out research using the weight-motor effect, powders which could become conductors at high tension should not be used like carbon or graphite powder: non-conductive organic powders are to be preferred. The high tension sources which generate single impulses or impulses at different frequency should generate minimum intensity currents, and these should be within the limits set by international standards laid down for electrical equipment. In order to reduce the stimulating effect of the impulse, it must have an ascending slope as fast as possible ($= 1.5\,\mu S$) and be of a duration of between 50 and 100 μS, without other waves resulting from oscillations in the exposure device.

2. In order to avoid noxious effects due to exposure of the body, it is necessary to comply with the following procedures:

 (a) One must always use the protection provided by grounding the proximal region of the exposed limb, and if one or more limbs are being examined at the same time, then an additional ground is required for each additional limb investigated; this ground being applied to the proximal region of each additional limb. Contact through the high tension electrode must be made through a lead sheet with a covering dipped in an electrolyte solution, or through a larger surface electrode applied 20–30 cm above the region under investigation, avoiding motor points of muscles in the area under study.
 When examining the abdomen, it will be placed on the recording screen but the screen should not be placed above a line passing 2 cm below the tip of the xiphoid process. An identical upper limit for the edge of the screen should be observed in the case of exposures taken on the back.

 (b) Transthoracic exposures should be avoided unless the electronography equipment is fitted with a device for cardiac protection by ECG controlled discharge. Transcerebral discharges should be avoided, particularly over the area of the brain stem. Grounding electrodes must never be applied over the carotid sinus or regions with rich nerve supply.
 In order to obtain cardiac electronographs, equipment for auto-controlled release of the high tension impulse during the absolute refractory period of the myocardium should be used.

 (c) Cardiac patients, hypersensitive patients and those fitted

with pace-makers should not be examined by transthoracic electronography.

(d) In order to avoid stimulation of deeply situated organs and tissues, the current of the high tension source should be limited to a maximum of 0.02 mA. Above this limit, ventricular fibrillation occurs if this current is directly applied to the heart through electrodes placed on the myocardium.

3. The danger of radiation from electronographic exposure is much less than that from x-ray examination. X-rays which are theoretically released in very high tension electrographic exposure are, in practice, of very low intensity and without biological effects because the electron emission is of the cold type, and the current is of very weak intensity and also braking resistance for electrons is reduced in living tissues, whilst the exposure time is of the order of microseconds. In spite of all this, it is advisable to avoid repeated exposure.

As far as the personnel operating the equipment are concerned, measures for radiation protection should be applied, especially because in these people there appears to be a cumulative effect, the total ionising radiation being associated with the effect of the air ionisation in the room where examinations are carried out.

4. Ultra-violet radiation during prolonged exposure is a potentially harmful factor, especially when observations of luminescent phenomena are carried out on transparent screens. It has been noticed, both in experimental animals and in the research workers who were observing these phenomena directly, that retinal lesions have sometimes appeared, all of which have been reversible.

Kirlian techniques have been shown to produce retinal lesions in experimental animals.

In order to protect the eyes protective glasses should be worn which absorb ultra-violet radiation.

In the case of prolonged exposure, skin irritation has been noticed over the exposed zones due to ultra-violet radiation.

5. The effects of intense ionisation, with the release of high concentrations of ozone and the appearance of nitric oxides, can cause bronchial irritation. Concentrations of more than $0.5-1 \cdot 10^{-6}$ ozone are considered as harmful and the working-time in these conditions must be reduced and the room should be well ventilated.

Risks and Safety Precautions in Electrographic Techniques

6. Although the electronographic method experimented with on a large number of laboratory animals and human subjects has proved to be harmless, the exposure of the human subject still requires care. It is contraindicated to examine the pregnant uterus electronographically.
7. Besides noxious factors already described, exposure to radio-frequency electromagnetic fields near the high frequency sources and cables can cause autonomic disturbances and should be taken into consideration.
 Protection which must be taken in such cases consists of good screening both of the source and of the conductors of electric current.

Electrographic methods will enjoy development in the future in many branches of biology, medicine and industry. They will prove to be of real help in ensuring a safe, functional, examination of biological systems, provided the stated principles are adhered to.

Selective Bibliography

Adamenko, V. G., *Biological Electrostatics*, Nekotorie Vaprosy Bioclinemiki i Bioenergetiki Organizma v Bormainii i Patologii, Alma-Ata, 1972.
Adamenko, V. G., Doktorovici, V. A., Kirlian, S. D., *Digest of I Intern. Congr. of Psychotronic*, vol. I, Praga, 1973.
Becker, S. R., *Theory and Interpretation of Fluorescence and Phosphorescence*, Wiley Interscience, New York, 1969.
Born, Max, *Atomic Physics*, Ed. stiintifica si enciclopedica, Bucuresti, 1973.
Boyer, D. C., Tiller, W. A., *On Corona Discharge Photography*, Standford University, California, 1975.
Bratescu, G., *Plasma Physics*, Ed. Didactica si Pedagogica, Bucuresti, 1970.
Cristea, A., Tamas, E., Olinescu, R., *Bioenergetic processes and enzymatic reduction-oxidation*, Ed. stiintifica, Bucuresti, 1973.
Dankin, H. S., *High Voltage Photography* – second edition, H. S. Dankin, Washington.
Deleanu, Fl., III Intern. Congr. on Psychotronic Res., Tokyo, 1976.
Dumitrescu, I. Fl., *Man and the electric medium – Bioelectric surface phenomena*, Ed. stiintifica si enciclopedica, Bucuresti, 1976.
Dumitrescu, I. Fl., *Digest of Intern. Congr. of W.A.S.A.*, Montreal, 1975.
Dumitrescu, I. Fl., *Contributions to the study of electrodermal activity*, Doctorate Thesis IMF Bucuresti, 1972.
Dumitrescu, I. Fl., *Science and Technical Review*, 5, 1976.
Dumitrescu, I. Fl., Invention Patent No. 83440, OSIM, Bucuresti, 1975.
Dumitrescu, I. Fl., Celan, E., Invention Patent No. 81143, OSIM, Bucuresti, 1975.
Dumitrescu, I. Fl., Golovanov, Carmen, Danila, T., *Electrodermal Explorations in Diagnosis, Digest of XI Intern. Congr. of Bioeng.* Dresda, 1973.
Dumitrescu, I. Fl., Golovanov, Carmen, Golovanov, N., Celan, E., Invention Patent No. 82556, OSIM, Bucuresti, 1975.
Dumitrescu, I. Fl., Celan, E., Invention Patent No. 82222, OSIM, Bucuresti, 1975.
Dumitrescu, I. Fl., Nitulescu, H., Invention Patent No. 82429, OSIM, Bucuresti, 1975.
Dumitrescu, I. Fl., Bujor, E., Bibisi, M., Invention Patent No. 87610, OSIM, Bucuresti, 1976.
Dumitrescu, I. Fl., Bolintineanu, C., *Digest of Intern. Congr. of W.A.S.A.*, Philadelphia, 1974.

Dumitrescu, I. Fl., Herivan, Rela, Portocala, R., *Rev. Roum de Biol.* 1, 1, 1976.
Dumitrescu, I. Fl., Bibisi, M., III Intern. Congr. on Psychotronic Res., Tokyo, 1976.
Dumitrescu, I. Fl., Constantinescu, G., III Intern. Congr. on Psychotronic Res., Tokyo, 1976.
Dumitrescu, I. Fl., III Intern. Congr. on Psychotronic Res., Tokyo, 1976.
Dumitrescu, I. Fl., *Electronography* – Brosura ed. IPAC, MIch, 1977.
Dumitrescu, I. Fl., Constantin, D., *Modern Scientific Acupuncture*, Ed. Junimea, Iasi, 1977.
Dumitrescu, I. Fl., *Psychotronic*, 1, 1977.
Dumitrescu, I. Fl., *Yoga – Belge*, 146, 147, 1976.
Dumitrescu, I. Fl., Bujor, E., Invention Patent No. 87099, OSIM, Bucuresti, 1975.
Dumitrescu, I. Fl., *Psychoenergetic Systems*, 1978, vol. I.
Dumitrescu, I. Fl., *Rev. Ital. d'Acupuncture*, 7, 17, 1970.
Embode, W., Moss, Thelma, *The Osteopathic Phys.*, 43, 1976.
Gabovici, M. D., *Physics and the technique of ion sources with plasma*, Ed. stiintifica si enciclopedica, 1976.
Galateri, L., *Parapsichologia ed effecto Kirlian*, Sugar. Co. Ed. 1978.
Georgescu, L., Petrea, I., Borsan, D., *Liquid State Physics*, Ed. Didactica si Pedagogica, Bucuresti, 1976.
Greenler, R. G., Mailmann, A. J., *Science*, 176, 1972.
Greguss, P., Ajandoc, E., *Proposal to use Longwave Holography to Study Acupuncture*, National Institute of Health, Proceedings NIH Acupuncture Research Conference, Washington, 1973.
Guja, Cornelia, III Intern. Congr. on Psychotronic Res., Tokyo, 1976.
Hortopan, G., *Impulse technique in the high tension laboratory*, Editura technica, Bucuresti, 1965.
Iniusin, V. M., *On the Biological Essence of the Kirlian Effect*, Kazakh. State Univ., Alma-Ata, 1968.
Iniusin, V. M., Kirlian, S. D., Kirlian, Valentina, *Digest of I Intern. Congr. of Psychotronic*, vol. I, Praga, 1973.
Kirlian, S. D., Kirlian, V. Kh., *J. of Scientific and Applied Photography*, 1961, 6, 397–403.
Kirlian, S. D., Kirlian, Valentina, *Digest of I Intern. Congr. of Psychotronic*, vol. II, Praga, 1973.
Krippner, S., Rubin, D., *Galaxies of Life. The Human Aura in Acupuncture and Kirlian Photography*, An Interface Book, Gordon and Breach, New York, 1973.
Krippner, S., Rubin, D., *The Energies of Consciousness*, Interface Book, Gordon and Breach, New York, 130, 1975.
Lane, E. E., *Electrophotography*, And Or Press, 3431, Rincon Annex, San Francisco, 1975.
Loeb, L. B., *Electrical Coronas*, Univ. of California Press, Berkeley, 1955.
Luca, E., *Elements of Modern Physics*, Ed. Junimea, 1976.
Miller, R. A., *Bioluminescence, Kirlian Photography and Medical Diagnostics*, R. A. Miller, Seattle, 1974.

Modreanu, M., Mamulas, I., III Intern. Congr. on Psychotronic Res., Tokyo, 1976.

Moss, Thelma, Paper at the International Congress on Scientific Acupuncture and Applied Technology, Bucharest, 1977.

Moss, Thelma, Plonsey, R., *Kirlian Photography and Acupuncture*, Film 16mm, Bioelectric Phenomena, McGraw-Hill Book Company, New York, 1969.

Prat, S., Schlemer, I. *J. of the Biol. Phot. Ass.*, Julie, 1939.

Revici, E., *Research in Physiopathology as Basis of Guided Chemotherapy*, D. van Nostrand Com. Inc., N.Y., 1961.

Sahleanu, V., Guja, Cornelia, III Intern. Congr. on Psychotronic Res., Tokyo, 1976.

Smirnov, B. M., *Introduction to Plasma Physics*, Mir Publishers, Moscow, 1977.

Sofron, E., Taraca St., *Optoelectronic devices with liquid crystals*. Ed. technica, Bucuresti, 1976.

Taper, C., Hutchinson, *Canadian J. of Plant. Sci.* 43, 1963.

Targ, R., Cohen, J., *Kirlian Video Photography*, Standford Research Institute, Menlo Park, CA 94025, 1974.

Tektronix Inc., Tektronics Products 1974, P.O. Box 500, Beaverton, OR 97005, 1974.

Tiller, W., *Digest of I Intern. Congr. of Psychotronic*, vol. II, Praga, 1973.

Udriste, O., *The ancestral gene and the origin of Cancer*, Ed. stiintifica si enciclopedica, 1978.

Vasilescu, I., Vasilescu, M., Dumitrescu, I. Fl., III Intern. Congr. on Psychotronic Res., Tokyo, 1976.

Glossary

Activation zone – zone with a minimum electrical impedance and high electric potential, which appears on the surface of the skin through neurofunctional projection processes (reflexes) during a localised visceral or somatic pathological process.

Aeroions – layer of microparticles in dynamic equilibrium, resulting from the processes of tissue respiration and perspiration adherent to the living body. It is composed of 'biological' water vapour, ionised biological microparticles and free ions. The layer of adherent aeroions can be demonstrated by the electronographic method in the immediate vicinity of living organisms (electronographic aspect).

Biofield – field of specific action of living organisms, in which energetic phenomena of an electromagnetic nature interfere with bioenergetic phenomena.

Biological interference radiation – zone of high frequency luminous radiation which appears during electronographic exposure in the zone of interaction between two living organisms, different from the low frequencies emitted by each single organism.

Convertography – original method for memorising and transposing into images the effects of a transitory electromagnetic field, with the aid of high frequency radiation (x-ray or uv) on a special screen for electrono-optical conversion.

Electrodermal point – point on the skin which appears due to neurofunctional projection phenomena, and which from an electrical point of view is characterised by minimum electrical impedance and increased potential in relation to the surrounding skin. In the electronographic image the electrodermal point shows up as a dark central point surrounded by a discontinuous luminous aura.

Electrography – Methods for the exploration of a physical body with the aid of an electric current, through which the electrical and non-electrical characteristics of the structures being investigated are translated into their electrical phenomenological equivalent and demonstrated graphically.

Electrography by blocking the secondary light emission – electrography which uses an effect of switching off of a phosphorescent light source through a complementary flux of electrons or other charged or neutral particles.

Electrography by electrochemical effect – electrographic method in which the exploratory electrical field causes changes in the chemical structure of certain substances used as image transducers. The effect is obtained in the absence of a luminous image (or independently of photochemical effects).

Electrography by electroluminescence – the electrographic method which makes use of the photographic effect generated by the impressing of a photosensor with luminous radiation, obtained during very high tension discharges through the electrostatic charging of a screen made of conductor material.

Electrography by sparking – electrography in which the graphic effect is achieved by the luminescent discharge produced between the body under investigation and a high tension source.

Electrography by weight-motor effect – electrography which makes use of the migration of charged or neutral microparticles in an electric field, presenting, thus, the spatial distribution of the electric field.

Electromorphous effect – specific effect encountered in electronography resulting from the differential sparking of an electrono-optical converter (luminous), generated by the non-uniform distribution of the electromagnetic field through the medium of a living organism under investigation.

Electronography – electrographic method by electroluminescence in which the image is produced by a controlled emission of electrons (very high tension single impulse, quantified) and electrono-optical conversion with the aid of luminescent chemicals.

Electrono-optical conversion – the transformation of electromagnetic phenomena into optical phenomena through substances with properties which allow specific energetic transformation (luminescent chemicals, scintillators, liquid crystals, etc.).

Electronovision – processing of electronographic images in a TV circuit.

Free aeroions – ionised air resulting from respiration, dispersed into the environment.

Kirlian photography – electrographic method using very high tension and high frequency conditions.

Liquid Crystals – type of substance with special structure and properties which exhibit states of intermediary aggregation (mezzo-phases) between the liquid isotropic state and the solid crystalline state.

Luminescent chemicals – inorganic or organic chemical substances which can transform one kind of energy (the energy of radiation fluxes, mechanical, electrical, chemical, thermal energy, etc.), into luminous energy.

Microelectronography – method for obtaining images by electroluminescence at cellular and tissue level.

The 'occlusion-fenestration' phenomenon – the phenomenon of reducing and increasing the active surface of an electrodermal point, in functional and pathological conditions.

Pellicular effect – electronographic effect resulting from the surface distribution of the streamers generated by a single impulse. The repeated superimposition of the pellicular effects generates the 'aura' characteristic of Kirlian photography.

Proximal electric medium – the electric medium found in the vicinity of living organisms, at which level takes place the main phenomena of energetic exchange between the organism and the electrical environment, and in which occur manifest electrical actions generated by biological activity.

Spectrography by electroluminescence – the spectral analysis of the light emission from electric discharges.

Streamer (from the English streamer – beam, pennant) – formation of ionised particles which is formed by avalanche processes during electrical discharges in gases at atmospheric pressure.

Surface electric phenomena – electrical phenomena characterising covering membranes in biological structures (membranes, mucosae, skin).